WATERCOLOR
TECHNIQUES
FOR ARTISTS & ILLUSTRATORS

WATERCOLOR
TECHNIQUES
FOR ARTISTS & ILLUSTRATORS

Penguin Random House

Consultant Artist	Grahame Booth
Senior Art Editor	Emma Forge
Project Editor	Shashwati Tia Sarkar
Editors	Katie Hardwicke, Megan Lea, Nikki Sims, Diana Vowles
Designers	Tom Forge, Karen Constanti
US Editor	Megan Douglass
Editorial Assistant	Kiron Gill
Senior Jackets Creative	Nicola Powling
Jackets Coordinator	Lucy Philpott
Senior Producer, Pre-Production	Tony Phipps
Producer	Rebecca Parton
DTP Designers	Rajdeep Singh, Satish Gaur, Anurag Trivedi
Pre-Production Manager	Sunil Sharma
Senior Editor	Alastair Laing
Managing Editor	Dawn Henderson
Managing Art Editor	Marianne Markham
Art Director	Maxine Pedliham
Publishing Director	Mary-Clare Jerram

First American Edition, 2020
Published in the United States by DK Publishing
1450 Broadway, Suite 801, New York, NY 10018

Copyright © 2020 Dorling Kindersley Limited
DK, A Division of Penguin Random House LLC
20 21 22 23 24 10 9 8 7 6 5 4 2 1
001–316724–Sep/2020

A catalog record for this book
is available from the Library of Congress.
ISBN: 978-1-4654-9233-3

Printed and bound in China

For the curious
www.dk.com

Contents

The basics

Techniques

Beginner techniques

Intermediate techniques

Subjects

The basics

Why watercolor

DISCOVER A WATERY WORLD OF COLOR

Watercolor has existed for thousands of years but artists are still enjoying experimenting with techniques and exploring new ways of using this medium. Discover how something as simple as a mix of pigment and water can give so much pleasure and delight when wielding a brush. Learn from other artists to develop your unique style.

Watercolor creates transparent layers of color that result in a freshness, clarity, and glow that no other medium can match. Watercolor also offers an immediacy to the artist as well as a certain amount of unpredictability–often watercolors are best when allowed to go their own way, creating beautiful and unexpected subtle blends.

The appeal of watercolor

Watercolor painting is incredibly accessible since it's the simplest medium to use in terms of the materials needed: a few paints, a couple of brushes, a sketchbook, and you are good to go. Compared with oil paints or acrylics, watercolors are cheap, easy to use, portable, and dry in minutes.

They use exactly the same pigments as oils or pastels, which gives the paints rich and reliable color, but with a unique luminosity.

Some people perceive watercolor purely as a sketching medium, but this idea could not be further from the truth. Many of history's finest artists, in fact, have used watercolor palettes to create paintings that are every bit as exciting and enduring as those in other media. And, as you'll see from the range of examples across the book, contemporary artists and illustrators continue to experiment, explore, and utilize watercolor to produce artworks in an inspirational variety of painting styles and effects.

Capturing wildlife
Some subjects are never still, and the fluidity of watercolor is perfect for conveying energy and movement. This painting captures a moment in time as the birds come in to land and settle.

Colorful illustration
A contemporary take on a still life with flowers, this line-and-wash painting simply pops out of the page with its dynamic, expressive lines and intense colors.

Architectural scene
Watercolor allows for a loose, impressionistic style that is ideal for complex subjects, such as St. Mark's basilica in Venice.

Building confidence

The techniques explored within this book show you what is possible with watercolors—from capturing crashing waves and portraying skin tones effectively, to fitting figures into a scene and experimenting with abstraction—but it is only with practice that you will develop the confidence to get the most from them. This is not the confidence that what you paint will be perfect, rather the confidence that it won't matter when it is not.

The pleasures of painting in watercolors range from manipulating loose, vibrant washes of color to using precise and energetic brushwork.

What's more, no subject matter is out of bounds—the more traditional landscapes, seascapes, and buildings remain popular, but so, too, are still lifes, portraits, and animals.

Getting started

From outfitting yourself with the basics (and not buying too much) to learning a few essential "rules" that will reinforce the authenticity of your paintings, this first chapter holds your hand while you take your initial steps along what will probably be a lifelong journey of pleasure and discovery. Enjoy!

Contemporary portrait
Layers of color create a dramatic but convincing portrayal of a person in this portrait. Colors can be abstract but still look harmonious in the final piece.

"Every watercolor is an adventure—an exciting journey into the unknown."

Watercolor paint

GETTING TO KNOW YOUR PIGMENTS

Watercolor paint is arguably the oldest painting medium. Natural earth pigments mixed with water were used to produce crude but effective painted images that, in some cases, have lasted for thousands of years. Earth pigments are still used today, but modern chemistry has given rise to a vast array of reliable, synthetic watercolor pigments that give consistent results for contemporary artists to add to their palettes.

What is watercolor?

Watercolor paint manufacture is a complex process and involves mixing color pigment and water with other ingredients that include gum arabic, glycerin, and sugar syrups, such as honey. Gum arabic is a binder that holds everything in suspension, ensuring the pigment particles give an even spread of color instead of clumping together. Glycerin prevents the dried paint from cracking, allowing easier mixing and rewetting. Sugar syrups act as a moisture retainer that prevent the concentrated paint from drying out too much. Some people think that fillers are added as an economy, but the filler actually helps create the buttery texture of tube watercolor paint, and ensures the consistency of the paint across a range.

Pans vs tubes

Traditional watercolor is available in tubes or as semi-hard cakes known as pans. They share identical pigments, are used in a similar way, and can be mixed together, but most artists prefer tubes.

Moist tube paint makes it easier and quicker to create mixes, particularly very dark or intense washes. To use tube paint, simply squeeze into the wells of a palette or paintbox and add to water to achieve the desired intensity of color. Tube paint left on a palette will dry and harden, but can be rewetted. You can use tubes to replenish depleted pans in this way.

The pigment numbering system

Watercolor paint is labeled with pigment numbers. This is a standard system used worldwide and allows you to check which pigments and how many are in a particular paint. Confusingly,

Pans
Pans are compact and convenient, and are ideal for a traveling paintbox.

Student-quality pigment

different manufacturers can use different pigments for a paint with the same name, and similar pigments for paints with different names. PB15:3, for example, is known as Winsor blue green shade (GS), phthalo blue, primary blue, phthalocyanine blue, intense blue, and manganese blue hue depending on the paint manufacturer.

Pure colors and hues

Hue is simply another word for color, but has another meaning when a paint is labeled with "hue" after its name. This means that the paint has been formulated to match the color of the named paint, usually a historically important pigment—for instance, "cobalt blue hue" rather than the pricier "cobalt blue." There are many reasons for not using the original pigment—there may be a safety concern, the original pigment may not be lightfast, or it may simply be too costly.

Student vs artist quality
The swatch on the right is student-quality cadmium yellow hue. On the left is artist's quality cadmium yellow. The difference is minimal, although the pure, artist's color is perhaps a little fresher.

Tubes
Tubes are generally available in a greater variety of colors than pans. The moist paint makes mixing color washes really quick and easy.

Pigment number

Pigment identification
The name of a paint often gives little guidance to the pigments used. Pigment numbers are standard.

Color cards
These cards, produced by some paint companies, contain small samples of the actual paints by a manufacturer, allowing an artist to compare many different paints at a modest cost.

Other water-based media

DIFFERENT WAYS OF APPLYING COLOR

Traditional watercolor paints are not the only types of water-based media available. From liquid watercolors and acrylic inks to watercolor pens, markers, crayons, and pencils, there is an ever-increasing array of water-based possibilities and effects. Gouache is opaque watercolor that can be mixed with traditional transparent watercolor.

Inks and liquid watercolors

These intensely colored liquids provide an instant hit of pure color. Liquid watercolors and inks can be freely intermixed and diluted with water. The vibrancy of their color makes them popular with illustrators, and you can choose between pigment-based lightfast ink or a dye-based ink that will fade. Similarly, water-soluble drawing inks can be used to create washes or for adding calligraphic marks when used with dip pens. India ink is mixed with a shellac binder and is unsuitable for use with fountain pens. It can be diluted

and leaves a lightfast, waterproof mark. Acrylic inks are also an option but, unlike watercolor, they dry to a water-resistant finish that can't be lifted from the paper (or a palette).

Watercolor pencils and crayons

Unlike regular pencils and crayons that leave hard lines, watercolor pencils and crayons react with water to offer a softer effect when washed over. If you do not like to see drawn pencil lines in a finished painting, consider using either a watercolor pencil or a water-soluble

graphite pencil instead, as either will blend with your watercolor as you paint. Watercolor pencils can be used dry and then washed over, or on wet paper they will produce a diffused line.

Use a pencil sharpener or file to create dust from a pencil and allow this to drop onto wet paper to give an unusual soft, speckled effect. Although watercolor pencils are not ideal for large washes, they can be used alongside conventional watercolors. Many urban sketchers simply use watercolor pencils and a water brush (see p.19) with their sketchbook as a

Watercolor pencils
You can sketch, draw, and lay color as normal with watercolor pencils.

Washing over pencil
When water is brushed over the lines of watercolor pencil, it creates a wash. The wash will never be as pure as watercolor paint wash and some remnant of the pencil lines will still be visible.

Washing over crayon
Washing water over the watercolor crayons releases the underlying color. As with the pencils (see left) there may still be a suggestion of crayon lines remaining.

Watercolor crayons
A soft, waxy crayon means you can lay large areas of color with broad strokes.

India ink

Liquid watercolor

Mixing ink and watercolor
Both liquid watercolors and acrylic inks will mix with watercolor, but often in a slightly different way. Above, India ink repels the watercolor, pushing out to form an interesting edge.

USES OF GOUACHE
An alternative name for gouache is "body color," which perfectly describes the opaque effect produced when white gouache is mixed with water and conventional watercolor. The resulting wash is ideal where you feel the paint needs more substance. It is perfect for painting cloudy skies and to capture the warm, rich sky color at dawn and sunset.

Tube of gouache
Gouache looks very similar to watercolor, but the pigment is modified to produce opacity when the paint is undiluted.

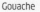

Gouache Watercolor

Diluting gouache
Its opacity reduces dramatically when water is added. Diluted gouache (above, left) becomes almost as transparent as the watercolor on the right.

convenient sketching kit. Watercolor sticks and marker pens are a relatively recent innovation and both have high pigment loads ideal for producing swathes of dramatic color.

Gouache paint
Unlike conventional transparent watercolor paint, gouache is an opaque watercolor. Gouache paint contains larger, more tightly packed pigment particles, which is what creates its opacity. The opaque nature of this paint offers the ability to paint light over dark, unlike watercolor.

White gouache straight from the tube is perfect for adding bright highlights in the final stages of your painting. What's more, it can also be mixed with conventional watercolor and water to produce interesting semi-opaque washes.

Some watercolor traditionalists abhor the use of gouache, but they may be surprised to find that certain watercolors, such as lilac, pink, Naples yellow, and lavender, all contain white paint in their formulation. Gouache was also included in the palettes of great watercolorists, like J.M.W. Turner.

Watercolor marker pens
Use watercolor marker pens to create a variety of lines using different nibs, from fine to brush.

Washing over marker pen
Containing highly pigmented ink, marks from a watercolor marker pen will retain their vibrancy when washed. Use for subjects where bold colors are desired.

Using white gouache
Watercolor mixed with varying amounts of opaque white gouache has been used to paint the flowers, allowing the petals to be rendered with freshness and freedom.

Paper and other supports

THE CHOICE OF SURFACES

Almost all watercolor painting uses paper as its primary support. Watercolor paper has been specially treated to control the absorption of the paint, hence the choice of paper, more than anything else, will influence the appearance of your final painting. Other more unusual supports are also becoming available.

What is watercolor paper?

Paper is essentially a pressed, dried mat of plant fibers. The most expensive watercolor papers are made using 100 percent cotton fibers or a mix of cotton and linen. Although some handmade paper is still manufactured, popular papers, such as Saunders, are nowadays made by machine.

Less-expensive papers are made from cellulose pulp derived from wood with the lignin removed, which prevents the paper from yellowing. Watercolor papers also undergo a process known as "sizing," which controls how much of the watercolor wash is absorbed into the paper, as well as adding surface strength. All paper from high-quality paper mills is designed to last for hundreds of years without discoloring or falling apart.

Surface texture

You can choose from three basic textures of watercolor paper: smooth, rough, and something in between.

Hot press paper has a beautifully smooth surface created by passing the paper through heated steel rollers. Such paper is popular with illustrators because of how well such a surface takes a pen line, but color washes are a little more difficult to apply.

Rough papers have an uneven surface texture created by pressing the paper between woolen felts, rather than heated steel rollers. This surface will often be chosen by the loose, impressionistic painter where detail may not be such an issue.

Passing rough paper through cold steel rollers removes some but not all of the textural surface, to produce cold press (CP) paper or NOT paper. Cold press paper has a texture in between

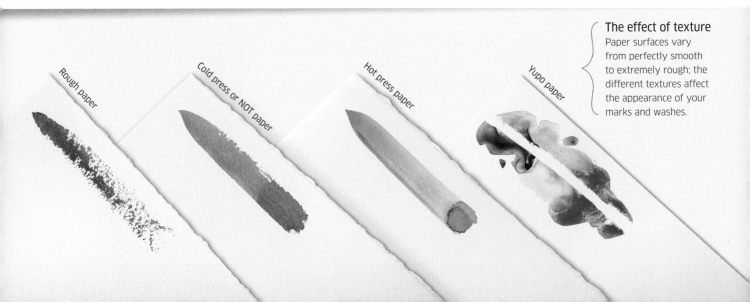

Rough paper

Cold press or NOT paper

Hot press paper

Yupo paper

The effect of texture
Paper surfaces vary from perfectly smooth to extremely rough; the different textures affect the appearance of your marks and washes.

Sketchbooks
Heavy weight drawing paper sketchbooks can be used for watercolor. Paint economically because overly wet areas will degrade the paper.

A watercolor block

hot press and rough, and is probably the most common paper chosen by watercolor artists.

A paper's weight
Individual sheet paper thickness is designated by a pound weight of 500 imperial-size sheets (lb) and as grams per square meter (gsm). Common sheet weights are 140 lb (300 gsm) and 300 lb (640 gsm). The heavier the weight, the thicker the paper. Lighter papers under 140 lb (300 gsm) will need stretching first (see below) to prevent them from cockling when wet.

Watercolor blocks
As well as cut sheets of paper, you can also buy watercolor paper as rolls and in more expensive books or blocks. Blocks are glued all around and although the paper will cockle when wet, it will dry perfectly flat as long as it is not removed from the block until it is dry.

Sketchbooks
A huge variety of paper from watercolor paper to heavy drawing paper and even kraft (brown) paper, can be bound up as a sketchbook. All are suitable for wet painting but papers

other than watercolor paper will be more easily damaged and are more likely to exhibit "bleed through" and so are best used for quick studies only.

Yupo
This synthetic paper is made from polypropylene plastic. It produces effects akin to hot press paper and is ideal for experimental techniques as, uniquely, the paint is not absorbed. This gives time to manipulate the paint and, if the effect is not to your liking, color can be completely removed even when dry; simply wipe off and start again.

Stretching paper

Step 1
Submerge a whole sheet of paper under water. For 140 lb (300 gsm) paper, soak for 15 minutes; less for lighter papers. Lift out and drain.

Step 2
Place the paper on a flat wooden board. Towel-dry the excess water from the edges; if the edges are too wet, the tape will not stick.

Step 3
Dampen some gummed paper tape and immediately place it along the edge of the paper, allowing at least ⅓ in (1 cm) overlap.

Step 4
Roll a rubber roller over the edges to make sure the tape is well pressed down. Then, leave in a horizontal position until dry.

Brushes

YOUR CHOICE OF TOOLS

Brushes are by far the most common way of applying paint to paper. They come in a huge variety of sizes and hair types. Although the most common are round or flat soft-hair brushes, there are also a number of shaped brushes designed for particular tasks. You don't need to spend a great deal on brushes—most experienced artists use only a few.

Brush shapes

The shape of a brush will largely determine the shape of the mark produced on the paper (see pp.20-21 for examples of mark-making with different shapes of brush). Artists generally use round brushes, flat brushes, or a mixture of both for almost all of their painting.

You may prefer to use a flat brush where you want to make a specific angular mark, whereas the marks produced by round brushes are less characteristic and perhaps more suited to general work. The chisel edge of a flat brush is good for creating straight lines, while the point of a round brush is perfect for fine, undulating lines (see also below and below right for specific brushes for achieving fine lines and other painterly effects).

Hair used for brushes

Traditionally sable was and is used for the best-quality and most expensive brushes. Sable hair brushes have a good balance of softness and spring, as well as holding a huge amount of paint mix for their size and releasing it in a smooth, consistent way.

Squirrel hair, too, is extremely fine and many artists favor squirrel mop brushes for their carrying capacity for laying large washes, as well as for their fine points. The hair is much softer than sable with virtually no spring.

Modern synthetic brushes are becoming extremely popular, partly on environmental and ethical grounds, and the quality and results of these synthetic brushes are improving all the time, with the best now rivaling natural

Round or flat?
By far the most common brush shapes are rounds and flats. These are made from a wide variety of hair types, both natural and synthetic.

No. 7 round synthetic brush

No. 14 round sable brush

⅓in (10mm) flat sable brush

¾in (20mm) flat sable brush

Fine-line brushes
Some brushes are made specifically to produce fine lines. A rigger is a standard small, round brush with extra-long hairs. The reservoir brush is a fine sable rigger surrounded by a squirrel reservoir. The unusual-looking swordliner is designed with a long tapering point.

Sable rigger

Reservoir brush

Swordliner

Types of hair
The three most common hairs used for brush making are sable, squirrel, and synthetic.

½in (13mm) sable flat brush

No. 24 squirrel and synthetic flat brush

No. 18 synthetic round brush

> "No matter what shape or size, a brush must be able to lay watercolor on to paper gently and smoothly."

hair. Older synthetic brushes had a rather unnatural strong spring but the more recent types seem to have been designed to control this.

Unfortunately, all brushes (even expensive sable ones) will eventually wear out, particularly the fine points on round brushes. You can increase their life span by caring for your brushes, washing them well after each use, and storing them upright so that the hairs are not bent. If the hairs on natural brushes do become bent they will often straighten if they are dipped into very hot water for a couple of seconds and then left to dry.

Which size of brush?

In general, flat brushes and mops are sized according to their diameter, but round brushes have no standard sizing method except that larger brushes have larger numbers, and vice versa. A round brush in the range of size 10–14 will suit most painters for most parts of their painting, with a smaller brush in the 4–7 range for completing the more detailed parts.

Lifting out color
Highlights can be lifted from a watercolor by scrubbing gently with a brush. Sable or synthetic are best as spring is required. Stiff hog hair brushes are often recommended but can soon abrade lighter-weight papers.

An array of brushes
Mop brushes can hold a lot of water for easy coverage on paper. Fan brushes can produce convincing grasses and fur, while stipplers are great for foliage. Water brushes are handy as they hold water within a squeezable cavity. Chinese brushes hold good points, and the Japanese hake brush is a versatile mark-maker.

Squirrel mop brush

Stipple brush

Synthetic fan brush

Goat-hair mop brush

Water brush

Set of Chinese brushes

Hake brush

Applying paint

EXPLORING PAINT EFFECTS

For the most part, applying paint to paper means using paintbrushes. But you can experiment and try out other alternatives to brushstrokes that offer a better likeness of a texture or add some randomness or dynamism. Almost anything goes. If something works for you (and the painting), there's no need to be concerned that it might not be the usual way of doing things.

■ Brushstrokes

Each brush produces a different type of mark—from the delicate, broken marks of a fan brush to flat, solid strokes of differing widths. Use the largest brush suitable for the effect you wish to achieve, then you'll need to use fewer strokes. Practice mark-making by holding the brush at different angles.

No. 7 soft-hair round brush

No. 14 soft-hair round brush

No. 7 soft-hair flat brush

¾in (20 mm) soft-hair flat brush

No. 1 reservoir brush

No. 2 synthetic fan brush

STAMPING AND SPONGING

Widening your painting arsenal from just brushes (see pp.18–19) gives you access to a world of textures and shapes that would be hard to achieve otherwise. Use a variety of stamping tools to apply paint directly to paper—no brush required! Enjoy experimenting with an out-of-date credit card, plastic comb, or mat board.

A "no brush" watercolor painting

Explore the world of mark-making and create a painting without lifting a brush. Here, edges of mat board were used to convey the tree trunks, fence, and foreground, while sponging with a natural sponge gives just the right impression for the tree canopies, and cotton balls created the cloudy sky.

Watercolor stamping

Do-it-yourself stamping tools—bottle bases and wine corks, for instance—are all around you. Non- or less-absorbent stamps will require a paint mix with less water.

Textural sponging

Natural sponge, cotton balls, and scrunched-up paper all describe great textures. Use two or three paint mixes for variety and use sparingly to avoid overly "spongy" marks.

CONSISTENT LINES

When only lines of a consistent width will do, get to know how to use a ruling pen. This tool is highly adjustable and uses watercolor paint or ink.

All widths of lines

A ruling pen is excellent for producing consistent lines of an even width. The width of the line can be adjusted by turning the knurled wheel.

A simple refill

Unlike a pencil or pen, using a ruling pen allows you to stay within the realms of watercolor. Simply stroke a full brush against the edge of the blade to refill.

Ruling pen

Street scene

Vertical telegraph poles punctuate a run of terraced houses in this scene of an everyday street. Here, a ruling pen was used to draw the convincing telephone wires.

SPLATTER AND SPATTER

Flicking paint onto the paper without touching it adds a sense of playful energy to your work. Splatter (large blobs) and spatter (tiny speckles) create a certain randomness and texture in a painting.

Paintbrush splatter

Use a regular paintbrush to create random arrays of paint blobs; the size of the brush will determine the rough size of the splatter. Experiment on a separate piece of paper to judge the effect before you work on your painting.

Toothbrush spatter

A toothbrush rubbed with a finger creates a very fine spatter—much finer than the splatter of paintbrush blobs. You can use such tiny particles of color for describing intricate textures, such as sand on a beach.

Using splatter effects

Splatter can be very useful in suggesting random arrangements of objects. In this painting, leaves, stones on the lane, and grass are all partly applied by splatter, which gives a more natural appearance as well as being much quicker to apply than individual marks.

Pencils, pens, and mediums

MAKING MARKS, ADDING EFFECTS

Pens and pencils are primarily used for the preparatory sketch before painting, although many artists also use them as an integral part of the finished work. Pen and wash is a traditional approach, where the pen forms the main structure of the painting and the watercolor washes are used to add color and decoration to the drawing.

Pencils

A pencil drawing is by far the most common start to a watercolor. The purpose of the sketch is to plan where to put the washes, and so normally the drawing is fairly simple. It is important to use a pencil that feels comfortable in your hand as well as creating the type of marks you want.

The traditional wooden pencil comes in a range of hardness levels, but requires constant sharpening with a sharpener or sharp knife; if you sharpen with a knife, you can vary the lead length. Many artists prefer a carpenter's pencil with its flat lead for producing a greater variety of lines while others favor a solid graphite stick.

Clutch pencils are convenient, requiring only the press of a button to advance the lead. Again, there is a good range of hardness but just as useful is the variety of lead diameters available. Each pencil is made for only one lead diameter. There is no "ideal" diameter; an artist will have their own preference. Diameters range from 0.2mm to 5.6mm; 0.9mm is a good choice. Anything below this size breaks very easily and anything above requires sharpening, either with the built-in sharpener that many of these pencils have, or with a separate lead sharpener.

Pens

A pen drawing goes superbly well with watercolor. A disposable or technical pen is convenient and you can find one that suits your needs since they come in a wide range of nib widths. They suit precise drawing but the nib can feel a little unresponsive.

A pen with a traditional metal nib gives a beautiful variety of line. The simplest of these pens is the dip pen,

Graphite grades
Graphite comes in several degrees of hardness, represented by H = hard and B = black. HB would be considered average hardness and blackness, but most artists prefer 2B or 3B—soft enough not to dent the paper but not so soft that the graphite smudges to a large extent.

4B 2B B HB H

ENGLAND DERWENT

Graphite drawing tools
Graphite is usually used for the preliminary drawing ahead of the painting. Choose from a wide variety of hardnesses and widths, with options ranging from the thick graphite stick that produces broad strokes, to a clutch pencil that gives a fine, constant line.

Pen types
Pens can be used for sketching and also for pen and wash. Your choice of pen will depend on the type of ink you use and the variety of line required. Technical drawing pens give thin, consistent marks; nib pens provide calligraphic options.

Disposable brush pen

0.8 mm technical pen with waterproof ink

Traditional fountain pen with fude nib

Traditional fountain pen

Traditional dip pen

which is available with interchangeable nibs so that you can vary the width of the line. Its only disadvantage is the need to constantly dip into the ink. This is the only pen that can be used with India or any other shellac-based ink. These inks may be beautiful but will quickly destroy a fountain pen.

For those wanting to draw with a fountain pen, water-soluble inks, or special inks that are water soluble in the pen but dry water resistant, are the best choice. A special nib with an upward bend known as a fude nib gives the ultimate variety of line.

Watercolor mediums
Specially designed watercolor mediums are great for experimentation. Primer mediums, or ground, allow watercolor to be painted on almost any surface (such as canvas) and can be used to add opaque whites for texture. Binding mediums, including gum arabic (see box below), work with the paint to create a glossy appearance, add shimmer, and enhance luminosity. Granulating medium (such as salt) encourages the paint to separate and clump, creating a speckled effect; some artists use granulation to bring delicate textures and variety to washes.

Water-soluble graphite
Use these pencils to create drawings with a simple wash. Their lines disappear in the finished watercolor, so are popular with artists who don't want the pencil to remain.

2B solid graphite stick

6 mm clutch pencil

2 mm clutch pencil

0.9 mm clutch pencil

2B traditional wooden pencil

USING GUM ARABIC
Gum arabic is a popular binding medium that limits the flow and bleed of colors, keeps a painting wetter for longer (extending your work time), and enhances the transparency and vibrancy of the colors. You can paint it undiluted onto damp paper, mix it in a 1:1 ratio with water and apply that as a wash, or mix it with the paint itself, depending on the effects you're after.

Observational skills

THE ART OF SEEING WHAT WORKS AS A PAINTING

Developing a painterly vision is not the same as simply opening your eyes and looking around you. Observing with a painter's eye means learning to see what elements make a good painting, a skill that becomes easier with practice. As an artist, you have the freedom to interpret what you see and express it in your own way.

Find the interest
The striking shapes of these windmills in Mykonos, Greece, instantly attract attention. But this view has a lot of distracting details that pull the focus away from the windmills.

Select a viewpoint
Getting up much closer to the windmills affords a view with a more interesting interaction between the buildings and a better overall composition (see also pp.26-27).

Choosing the crop
You are in complete control of what you paint; you get to decide what to move, omit, or emphasize for the best painting.

The dashed line is the chosen crop for the painting below

Noticing key elements

When you learn to really look at a potential subject—weighing up its tones and shapes, considering its color scheme, and thinking about which parts to include and which to crop out—you'll start noticing the detail in everything around you. Whether you're capturing the reflections on a vintage car in the sunshine, architectural flourishes on buildings, the myriad of colors in a fruit still life, or clouds scudding across a stormy sky—all such details will help you decide whether the subject merits a sheet of watercolor paper.

Avoid the beginner pitfall of looking for a "pretty" subject. A subject can be pretty but this should play only a small part in your considerations. A pretty

The tree now extends into the painted scene

The car from the original scene is cropped out

Your artistic license
As well as cropping out distracting details (such as road signs) to create an interesting composition, you can play with any details that enhance and evoke the right atmosphere for your painting.

Look for shapes
The compositional beauty of this painting lies in the stark, bold shapes presented by the windmills. A simple way to find the main shapes is to squint your eyes, which blurs the detail so that the shapes are revealed.

The rounded shapes of the windmills stand out against the clear sky

subject will not necessarily result in a good painting. Instead, you must learn to look for other attributes that will excite you as you paint and add visual power to the finished piece.

Shapes and viewpoint
Unusual or dramatic shapes make for intriguing and powerful paintings, so look for those in your subject. A subject may not be obvious at first glance; investigating angles and heights of viewpoints can completely change how you see a subject and reveal the most pleasing shapes.

View a potential subject from all angles before settling on the one that you consider to be the most impactful and interesting. A still-life scene gives

you ultimate control; arrange all the elements from different viewpoints, and adjust the lighting to achieve a pleasing composition of tonal shapes.

Tonal range and color
With few exceptions it is the contrast of tones—the light and darkness—that gives a painting structure, impact, and excitement. Look for a subject with a

simple array of a few interesting tonal shapes, ranging from very light to very dark. Adjust the lighting of your setup, or your orientation to the subject if outdoors, until you manage to capture the best tonal contrast.

Color helps create atmosphere but don't try to copy colors from real life. Instead use your imagination to adjust colors to suit the mood.

A tonal study
This painting captures a wide range of interesting tonal shapes. And the unidirectional light reveals great tonal contrast.

Dramatic lighting creates a great contrast between the darks and the lights

Look differently
Shapes, not things, create a painting. Here, the hand connects to the face to give one large overall shape with interesting edges. The lighting emphasizes the tonal differences.

Perspective and composition

PORTRAYING THREE-DIMENSIONAL SPACE

Knowing the key points of composition and perspective will help your pieces
have balance and a sense of reality. Linear perspective—how parallel lines appear
to converge in the distance—is key to creating depth and distance in paintings.
Composition, the arrangement of objects and shapes in a pleasing way, also
has some easy-to-understand "rules" that you can employ.

PERSPECTIVE

The rules of linear perspective can be observed in many
subjects, and are especially useful in landscapes along
with those of aerial perspective. Linear perspective can be
a little challenging but following the rules makes accurate
drawing easier; extending horizontal lines to converge at
a point on the horizon—the vanishing point—is key.

> "Emulating aerial perspective can help add the dimension of depth to your painting."

Vanishing point

Eye level
(horizon)

Vanishing
point

Eye level
(horizon)

Vanishing
point

One-point perspective
In this view down a flight of steps,
horizontals from the walls, railings, and
houses all converge at one vanishing point.

Two-point perspective
As the bridge in this photo is at an angle to the viewer, both sides are affected by
perspective and so there are two vanishing points on the horizon. To help place
them, remember that the horizon line always relates to the eye level of the viewer.

Aerial perspective
Another way of indicating
perspective in a landscape
is to imitate the effect of
atmosphere on distant
objects. The haze of the
atmosphere makes objects
appear less detailed, less
colorful, and less tonal the
further away they are.

Fading tones in background

Less detail in middle ground

Bright foreground

COMPOSITION

How you compose a scene or still life can spell success or disappointment for the finished piece. There are a few pieces of advice or "rules" that can shape a good composition, working alongside a sense of depth from perspective. There may be occasions when such rules can be broken, but if you understand them first you will be in a better position to decide if or when to break them.

Focal point

Many paintings are created with the idea of a single focal point–a figure in the distance, as here. You can emphasize a focal point by having the strongest dark and lightest light or perhaps a strong color contrast there. You can also have a series of focal points on a path (see below).

C-shaped path of focal points

Here, the "C" shape draws the eye along the foreground, across the bridge and along to the main tree. The tree is positioned at the intersection of thirds (see left), as is the gable of the building to the left of the tree and the bridge itself.

The rule of thirds

This useful compositional aid divides a subject into thirds both vertically and horizontally so that you end up with four lines and four crossing points. The main parts of a composition should be located around the lines, with the crossing points being the strongest focal points.

Path of focal points

Ideally, the different focal points of a painting should follow a path rather than be placed in a random way. Paths in the shape of C, L, U, S, and Z (and their mirror images) are considered to be good compositionally. Such shapes allow the eye to gently explore a painting. Elements of the painting itself can also direct the eye to a focal point, such as the branch of a tree, a ripple on the water, or a road.

"L" shape

"S" shape

"U" shape

Drawing basics

PORTRAYING SCALE AND PROPORTIONS

If you can write your name or trace an image then you can draw. You can learn to produce a perfectly adequate drawing for reference and as the base of a painting. Accuracy is only part of the process, of course, as a good drawing will always convey something of the elusive "feel" of the subject.

◼ Measuring from life

Learning to use a pencil to measure is key for accurate drawing. Hold a pencil at arm's length and at eye level (note, a bent arm will skew measurements). Close one eye, look along your arm, lining up one end of the pencil with one end of the subject. Slide your thumb along the pencil to mark off the length and then transfer this to your paper.

Look for key lines and angles
You want to get down enough information so that you know where to put the paint. Focus on the main parts of the subject; it's best to avoid too much detail.

Transfer this length to your sketch once you've measured

Measuring lines
Choose one line to use as the base of the drawing. You can build a sketch in the right proportions by measuring how other lengths relate to this.

Measure angles by comparing against verticals and horizontals

Measuring angles
Hold your pencil as above while turning your hand to line up with the angled line in the scene, so you can draw it in the sketch.

◼ Measuring figures

Hold your pencil and use it as a measuring tool as described (see left). Measure the head and use this length to plot the height of a person and where the limbs start and end. Becoming practiced in measuring people in this way will also allow you to check how they fit in a scene—you don't want people taller than doorways, for instance.

A head as a unit of scale

The belly button sits 2 "heads" down from the shoulders

An arm is roughly 3 "heads" from shoulder to fingertip

The kneecaps are 5 "heads" down

Using the head as a unit

The head can be a really useful unit of scale when drawing people to get a body's proportions right. Knowing that a standing person measures 7-8 heads tall, as well as a few key lengths (above), can mean your figures' limbs and torsos are in proportion.

◼ Looking for relationships

When you observe a subject it is crucial to look at relationships within an individual object and between different objects. Look for these even before putting pencil to paper.

The bottom of the window is almost in line with the bottom of the pub's roof

Diagonal relationships are useful—see how the angle of the roof relates to the street corner

Useful heights and angles

Look at this scene. Can you see how the height of the pub door is the same as the height of the shop window? With practice, you notice all kinds of useful relationships.

Compare this measurement to that in the foreground

Measuring shows that the shop front is twice the height of the building at the end of the street

Dealing with depth

Always measure to check proportions. In this street scene, the height of the shop front and the building at the end of the street appear about the same to the eye. However, when measured (see the red lines), you can see that this isn't the case.

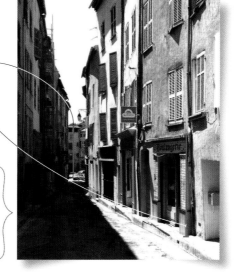

CONTOUR DRAWING

Being able to see the main shapes of a scene helps improve your drawing. In contour drawing you keep your pencil on the paper and follow edges rather than objects. Where one object touches another, continue along the edge of the combined shape rather than completing the object.

Windowsill still life The contour drawing

"With a little practice, contour drawing is generally more accurate and helps us see the subject as shapes."

Sketching and planning

HOW TO WORK BEST WITH YOUR REFERENCE MATERIAL

Many visual artists always carry a sketchbook, since you never know when the perfect subject may present itself. Once you've captured a quick sketch, dashed down any color suggestions, and taken any supporting photos, it's time to sketch out, plan, and execute your painting.

■ Sketching on the move

Being able to dash down quick sketches is a great skill to develop and one that will improve with practice. It's surprising to see just how much you can leave out and still capture the essence of the subject. Limit your time to force speed of working, or try sketching looking out from a bus or train.

Strokes of magenta and green with a splatter of color on top neatly conveys the bougainvillea

Recording things quickly
This sketch of bougainvillea took 10 minutes and doesn't include every detail—it doesn't need to. A splash of magenta records the main color and replaces a multitude of pencil marks. The result is both quicker to do and more descriptive.

Painting shadows is much quicker than drawing them

A door is described simply, for speed

■ From real life to a painting

Watercolor is a spontaneous medium and the process is easier if you have an indication of where to place your paint. Creating a tonal study will help you plan a successful painting. When it is time to paint, your preparatory sketch should map out only the main features of your subject or, even better, the main tonal shapes. Avoid shading and use a soft pencil (2B or softer) so as not to dent the paper's surface.

1 Observing the subject
Painting is all about the effects of light. Look for a good range of tonal variety and strong compositional elements. A photo can provide extra information for your painting.

2 A tonal (value) study
This type of sketch helps plan the areas of light and shade you will paint. Draw or paint this quickly; do not focus on details. Aim for a few big interesting tonal shapes.

■ Photos—the whole picture

While it is useful to take a photograph of your subject (using a smartphone or a compact camera is fine), rarely does one photo offer enough to render a successful painting. Painters need more information, so take photos from different viewpoints as well as wide-angle and zoomed-in detail shots. However, a photograph cannot substitute the information you will gain from sketching.

Taking and using photos

PROS
- Is quick and simple
- Provides accuracy and detail
- May be the only option if the viewpoint is awkward or dangerous

CONS
- Cannot filter which elements of a scene excited you most
- Is poor at indicating depth
- Is no substitute for careful observation

1 Take some photos
The pattern of these three boats and their sharp shadows in the sunshine is sure to appeal to many. While the buildings in the background appear equally bright in the photograph, the eye is drawn more to the boats.

2 Sketch tonal areas
While the camera records everything, in a sketch you can focus on what catches your eye. Now is the time to decide what is the main focus, what to omit, and adjust accordingly. Quickly record the tones that will inform your painting.

3 Refer to all sources
Working from your sketch helps keep the painting simple, but it's good to have the photograph to refer to for color information, to check relationships of objects within the scene, and to ensure the shapes are properly rendered.

3 Preparatory sketch
Before applying paint, lightly draw the boundaries of the painted areas. It is best to leave a few scribbles rather than risk erasing and possibly damaging the watercolor paper.

4 The final painting
Notice how this finished painting closely mirrors the tones in the tonal study. Tone is your most powerful weapon in constructing a painting. Details come far behind.

> "You will learn more from a single sketch than from taking a hundred photographs."

Color theory

UNDERSTANDING COLOR RELATIONSHIPS AND TONE

When it comes to painting, the three primary colors are red, yellow, and blue. In theory, all other colors could be mixed from the three primaries, but in practice additional colors are often used to extend the possible range.

▦ The painter's color wheel

The traditional painter's color wheel is based on one designed by Isaac Newton and its purpose is to show a logical relationship between the different colors of the painter's spectrum. The color wheel is a representation of how any color interacts with others. Only 12 colors are shown, when in reality, of course, there will be almost infinite subtle variations. The more colors that are added the duller a mixture gets.

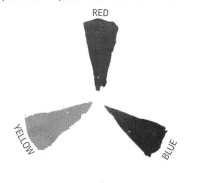

Primary colors
Red, yellow, and blue are primary colors. You cannot create primary colors using any other colors.

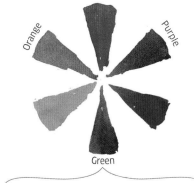

Secondary colors
If you mix two primary colors (such as red and yellow) you create a secondary color (orange). These sit between primary colors.

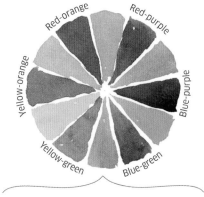

Tertiary colors
If you mix a secondary color (such as purple) with an adjacent primary color (say, blue), you create the tertiary color blue-purple.

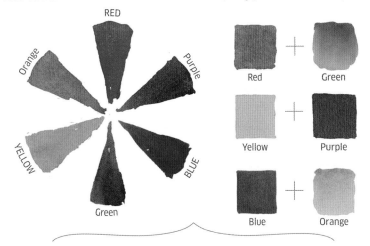

Complementary colors
Colors that sit opposite one another on the color wheel—red and green, say—are known as complementary. They brighten each other when placed alongside but dull each other on mixing.

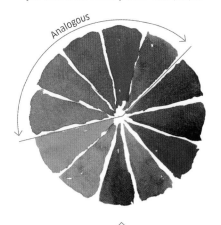

Analogous colors
Colors that sit next to one another in groups of three to five are said to be analogous. They create harmonious color schemes.

The tone of a color

Tone (also known as value) refers to the measure of the lightness or darkness of a color. A good range of tone makes for a realistic representation of light and 3-D form. The range of tones you can mix using watercolor is much less than what you see in nature. Effectively the darkest tone of any color is a pure dark (black) and the lightest tone is pure light (white).

A range of tones
All of these objects are white, but under this controlled lighting a full range of tone is evident. Your eyes see their 3-D forms as varying tones; in this monochrome scene, these go from white to dark gray.

The bright white of the bottle meets the darker background at an edge

See how edges disappear when the tone is the same, either side

Graduating tone indicates the form of this sphere

Shadows make up the darkest tones

| Tone 1–light | Tone 2–medium | Tone 3–dark | Tone 4–black |

Tonal map to recreate the scene
For this tonal exercise, first draw the connected tonal shapes–lights, mediums, and darks–while ignoring the boundaries of objects. Paint all areas with a light wash (1); next paint areas 2 with a medium wash, then apply a dark wash to areas 3. Finally, add black for the darkest darks (4).

A medium wash will be applied to areas 2

Only a light wash covers areas 1

Adjusting the tonal value

Adjusting the lightness or darkness of a color, either by altering the saturation or adding a darker hue, alters its tone or tonal value. The exercise above uses only a small range of values, yet the forms are perfectly described through just four variations of one color.

Darkening a color
We can extend the range of tones available by adding a dark to the pure color. When the color is darkened, its tonal value is lowered.

Lightening a color
In watercolor, rather than adding white to lighten a color (as with other paints), water is used to produce a graduation of strength of color (saturation).

Properties of color

LEARNING MORE ABOUT HOW COLORS WORK

Playing with color can be a little like modern alchemy. Each pigment has specific characteristics that will affect how it mixes with water and how it flows on the paper. When different pigments blend, the results can be spectacular—with new colors and beautiful effects, such as granulation.

■ Color temperature and bias

Colors have "temperature": those within the red, yellow, and orange spectrum are generally referred to as "warm" while those spanning purple, blue, and green are "cool" (see pp.120–121).

In addition, there are warm and cool versions of a color—a cool lemon yellow vs. a warm cadmium yellow. In this respect, warm and cool refer to "color bias." A blue biased toward purple is seen as warm, whereas a blue biased toward green seems cool.

Warm color wheel
This traditional color wheel, made from a warm red, a warm yellow, and a warm blue, produces colors that are rich and warm. Warm colors appear to advance in a painting.

Cool color wheel
This modern color wheel results from mixing cool versions of red, yellow, and blue. The mixed colors are bright and cool. Cool colors appear to recede in a painting.

■ Color harmony

You can enhance paintings to no end by the colors you choose to use. With a little thought, you can create some brilliant color relationships in your work. It's a good idea to start thinking about your color scheme beforehand and try out various combinations; once you've settled on a palette, stick with it and don't start adding colors as you paint. Various approaches, shown on the right, help artists make a painting more harmonious.

A limited palette
Painting with a limited palette of just a few colors results in mixes that have a common basis, producing works with great harmony.

An analogous color scheme
Evoke a gentle feel by choosing colors (the purples above) that are adjacent on the color wheel; the yellow pop offers a strong contrast.

■ Pigment properties

There are certain pigment characteristics to consider when choosing colors that affect how they adhere to the paper and their strength. They are either staining (leave pigment when lifted out) or non-staining, and appear transparent, semi-transparent, semi-opaque, or opaque. Some pigments tend to granulate—a feature that can be exploited to add texture to a sky, for instance.

Also consider the issue of permanence. Some pigments, such as alizarin crimson, fade in light; others, such as aureolin, darken. Hue versions are more permanent.

Undiluted paint is transparent — Undiluted paint is opaque

Diluted paint is transparent — Diluted paint is semi-transparent

Transparent

Opaque

Transparency and opacity
Some pigments, such as alizarin crimson (far left), are transparent even when used straight from the tube, while others are opaque, such as cadmium red (left), which is opaque enough to cover black when undiluted but not when diluted.

Staining

Non-staining

Staining power
It's good to know how staining a pigment is when choosing a color scheme in case you want to lift out highlights. Phthalo blue (far left), for instance, is staining while French ultramarine (left) is non-staining.

Equal strength mixes

Different strength mixes

Ability to merge
Generally pigments will merge depending on their relative mix strengths. Color mixes of equal water content will tend to just blend (far left), but a mix with more water will tend to bloom into a mix with less water (left).

Cobalt blue

Terre verte

Cerulean blue

Cadmium red

Light red

French ultramarine

Granulation potential
Watercolor paint is a mixture of pigment and binder, such as gum arabic. Some pigments will separate from their binder and water, creating a grainy texture when dry. Certain pigments (see left) readily granulate.

A complementary color scheme
Complementaries sit opposite each other on the color wheel (the red and green above) and produce vibrancy when side by side.

A warm atmosphere
Painting with predominantly warm colors creates warmth. To avoid too much coldness, use warm colors when painting a cool subject.

Repeated colors
Repeating colors in different parts of a painting creates harmony. Conversely, using an isolated color will draw attention.

Color mixing

USING COLOR THEORY TO MIX PAINTS

You can create an almost infinite variety of hues from just a few basic colors. Using a limited palette to mix your own colors will help give your painting a harmonious, coherent feel. Watercolor dries lighter than the wet color on the paper, so make your mixes slightly stronger to compensate.

WET MIXING METHODS

These two common methods will produce a smooth or a variegated color. Don't rinse your brush between picking up colors, which can dilute the mix too much.

Mixing in a palette
This is the general method, and produces an evenly mixed color.

Mixing on paper
This method creates more interesting but less controllable results.

1–Blend paint with water

1–Apply first color

2–Add second color

2–Add second color

3–Blend colors together

3–Blend wet colors

Even color

Variegated color

■ Accounting for color bias

All colors have variations in undertone, known as color bias. We describe these biases as "warm" or "cool," depending on whether they lean toward the warm or cool half of the color wheel (see pp.120–121). For example, a warm blue is biased toward purple, whereas a cool blue is biased toward green. Color bias will affect your mixes, so include a warm and cool version of each primary color in your palette for versatility.

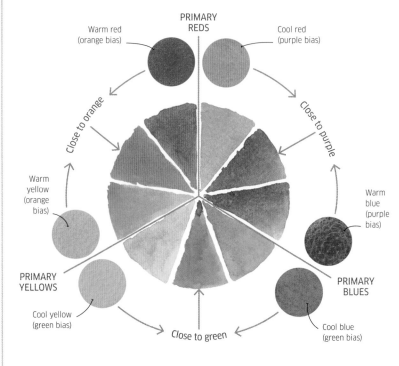

PRIMARY REDS

Warm red (orange bias)

Cool red (purple bias)

Close to orange

Close to purple

Warm yellow (orange bias)

Warm blue (purple bias)

PRIMARY YELLOWS

PRIMARY BLUES

Cool yellow (green bias)

Cool blue (green bias)

Close to green

Twin primary system
This color wheel shows a warm and cool "twin" for each primary color. Each is placed near the secondary color it is biased toward. Using six primary colors will allow you to mix both bright and muted secondaries.

Mixing bright secondary colors

Combining two primary colors that are biased toward the same secondary color creates vibrant hues. For example, a blue with a green bias and a yellow with a green bias will make a bright clear green, often needed for flowers, still life, or sunny landscapes.

Mixing muted secondary colors

If you mix two primaries that do not have the same bias you will create muted secondary colors. These colors are often useful for naturalistic landscapes. For example, a blue with a purple bias and a yellow with an orange bias will produce a soft, dull green.

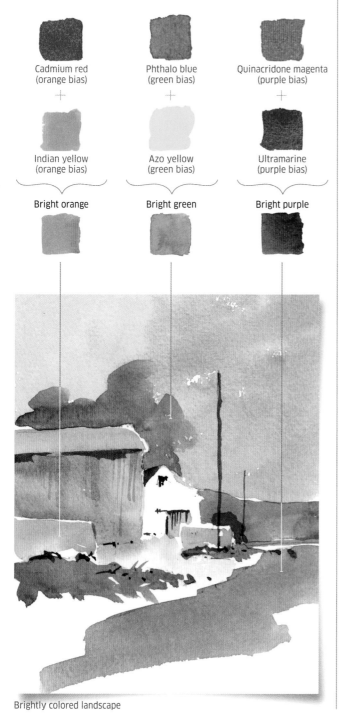

Cadmium red (orange bias)

+

Indian yellow (orange bias)

Bright orange

Phthalo blue (green bias)

+

Azo yellow (green bias)

Bright green

Quinacridone magenta (purple bias)

+

Ultramarine (purple bias)

Bright purple

Brightly colored landscape

Quinacridone magenta (purple bias)

+

Azo yellow (green bias)

Muted orange

Ultramarine (purple bias)

+

Indian yellow (orange bias)

Muted green

Cadmium red (orange bias)

+

Phthalo blue (green bias)

Muted purple

Muted landscape

■ Mixing neutrals and darks

Neutral and dark colors are essential in a well-balanced painting. Without dark colors and tones your painting will lack impact, and many colors in real-life subjects are actually quite muted and neutral.

Grays and blacks that you can buy premixed can sometimes look flat and boring, whereas neutrals and darks that you mix yourself will have undertones of other colors. A gray with a color bias always looks much more natural in a painting.

There are two ways to create neutrals and darks: by mixing complementary colors (see p.32) or by mixing three primaries together. To neutralize any color, simply add its complementary color. For example, adding a touch of red to a bright green will dull it; the more you add, the more gray the color becomes. Mixing three primaries will create a huge range of neutral hues—any primaries can be used. Adding more paint to the mix makes it darker and stronger, but there are also some quicker mixes for strong darks.

Lively neutrals

Mixing three primaries together produces various shades of gray. Depending on the chosen primaries and the amounts of each in the mix, these grays can have hints of warm red or brown, cool purple or green, and other colors, as shown in the examples below.

> "Mixing color is the closest an artist gets to magic."

Cadmium red + Ultramarine + Indian yellow

Quinacridone magenta + Azo yellow + Ultramarine

Ultramarine + Indian yellow + Quinacridone magenta

GRAHAME BOOTH

Vibrant darks

There are several two-color combinations that readily create strong, useful darks. Here, phthalo blue's strong green bias neutralizes cadmium red, and makes an extremely dark green with burnt sienna. Ultramarine (a blue) and burnt sienna (an orange) gives the most neutral mix.

Cadmium red
+
Phthalo blue (green shade)

Ultramarine
+
Burnt sienna

Burnt sienna
+
Phthalo blue (green shade)

Color reference charts

Painting color charts is an excellent way to practice how to make specific hues. This involves painting your mixes on a grid to record the results, which you can keep and refer to later. You may be surprised to see that adding even small amounts of another color can change the original completely.

Pairing primaries

One useful scheme for a chart is to explore the variety of bright and muted secondary hues we can mix from six twin primary colors (see also p.37). Don't feel you must use these specific colors; every artist has their own particular choice of colors.

1 Make a chart
Draw a grid on a piece of watercolor paper, allowing 10 squares per row.

2 Plot first color
Working from the left of the row, paint a strong, pure mix of the first color. Add increasing amounts of a second color to the mix to paint the next four squares.

3 Plot second color
Then, working from the right of the row, repeat the process with the second color, adding the first color in increasing amounts. This will give you 10 colors mixed from just two paints.

Rows show gradual mixes from one color to another

Indian yellow → Cadmium red

Quinacridone magenta → Ultramarine

Azo yellow → Phthalo blue (green shade)

Cadmium red → Phthalo blue (green shade)

Indian yellow → Ultramarine

Azo yellow → Quinacridone magenta

Bright secondary color mixes

Muted secondary color mixes

Optical color mixing

Layering colors wet-on-dry creates a different type of color mixing. The original colors remain intact (unlike with physical mixes) and the white paper also shines through. The eye registers all the layers at once to create an optical color mix, much like how it perceives the dots of color used in printing.

Layered color chart
Paint rows of each color, then wait for them to completely dry before painting columns of color on top. Notice that the colors appear clear and vibrant compared to physical mixes, which can be duller. Layered colors are harder to predict, so making a reference chart is useful.

Rich gray optical mix of cadmium red and phthalo blue

Choosing a palette

HOW TO SELECT AND WORK WITH COLORS FOR YOUR NEEDS

The term "palette" can refer to the actual choice of paints—such as a palette of blues—as well as to the physical container you use to store and mix your watercolor paints (also called a paintbox). With more than 250 different hues available, there is no shortage of choice in watercolor, so consider and research what you need before you start buying.

▨ Your basic color palette

A considered, core palette of primary colors can make your life as a painter easier because it will enable you to mix a huge range of hues. You can create many types of painting using primary colors as your foundation, as shown in the examples below. (See also pp.32–39.)

Warm primary colors

Cadmium red

French ultramarine

Indian yellow

Cool primary colors

Quinacridone magenta

Phthalo blue

Azo yellow

Core primary colors

With this set of warm and cool primary colors you can mix almost any hue imaginable. Other primary colors that are similar in hue to this selection will also be suitable. When choosing paints, do check for permanence or their likelihood to fade.

Blue left as pure color

Orange—a secondary mix of yellow and red

Dark brown mixed from three primary colors

Pure primaries and secondary mixes

This abstract piece uses a bold limited palette of warm primary colors for impact. Cadmium yellow, cadmium red, and azure blue are applied wet-in-wet to create vibrant secondary colors.

Neutrals mixed from primaries

Here, warm yellow raw sienna, cool alizarin crimson, and warm ultramarine blue are combined with touches of burnt sienna and burnt umber to mix a full range of skin tones for a realistic portrait.

Useful additional colors

While you can mix similar versions of popular colors such as burnt sienna, having premixed colors in your palette can be more convenient. Neutral tint (a strong dark) and titanium white gouache for highlights are both useful. You may also favor certain types of color depending on your preferred subjects.

Yellow ocher

Burnt sienna

Light red

Sap green

Earth colors and greens

Green gold

Cadmium orange

Rose madder genuine

Dioxazine violet

Vivid flower and foliage colors

Titanium white gouache

Opera pink

Aqua green (liquid watercolor)

Neutral tint

Black, white, and brights

Useful colors for landscapes

As you would expect, muted, slightly dull earth colors are a worthwhile addition for a landscape palette. Pigments such as ochers and siennas were originally literally made from the earth.

Useful colors for flowers

To encapsulate nature's vivid color schemes, still-life painters often favor the freshest and brightest colors and will also include secondary colors in their palette. Painters tend to form firm favorites.

Useful colors for illustration

For illustration, black and white are useful additions to reinforce bright spots and shadows. Liquid watercolors, such as aqua green, provide illustrators with concentrated pigments for an immediate hit of color.

Container choices

For ease of working, choose a paintbox or palette that can both store your squeezed paint or pans and provide good mixing areas. Palettes vary dramatically in price and construction, so choose something that fits your needs and your budget. All palettes should have deep paint wells to fit a full pan, or the equivalent in squeezed paint. There should also be a number of deep mixing areas that will hold at least ½fl oz (15ml) of mixed paint.

Closed palette

A versatile palette

This palette is convenient and easy to store and transport—ideal for *plein air* painting. Its generous paint-holding wells can be filled and topped up as needed, without waste.

Your painting setup

THE RIGHT EQUIPMENT WHEREVER YOU PAINT

Some artists prefer to practice their skills in the comfort of their own home or studio, surrounded by secondary sources and reference photos; others will attest that there is nothing like painting *en plein air* in front of a subject to help capture the depth that's easier to see in real life. Whichever location you prefer, be sure to make painting easier with the right setup.

Painting indoors

There's no need for a dedicated studio space for indoor painting. Watercolor paint is easily removed from hard surfaces and has no smell, so many painters happily work at the kitchen table. What is important is to make sure you have everything you need within reach and to set up your workspace in exactly the same way every time (see below for an example setup). You don't want to be searching for anything in the middle of an important wash.

A table-top easel is a useful addition to your painting kit: as well as holding your paper securely, it allows you to adjust its tilt, vital in directing the flow of washes down the paper. Wherever you set up your indoor workspace, choose somewhere with good natural

You will need (indoors)

- Container of water
- Paper towel
- Watercolor paper
- Board for holding paper
- Tape or clips to affix paper to board
- Watercolor paints and palette
- Selection of brushes
- Table-top easel (optional)
- Spray bottle (optional)

Easel or table with paper on a board at an angle. Easel not needed if working flat

Brush container

Paper towels for blotting and lifting out

Paintbox

Water pot

A right-handed setup

It is natural to go from water to paint to paper. Such direction of work avoids the common problem of dripping water onto a painting! Always arrange paints in the same way in your palette, so you know exactly where the colors are.

USING A TRIPOD AS AN EASEL

If you have a camera tripod already, there's no need to buy a field easel to enable your *en plein air* painting. Follow these steps to modify what you have.

1 Adapting the tripod plate
Screw the existing tripod plate to a 4½in (11cm) square of wood. Stick four strips of self-adhesive Velcro to the other side of the wood, and reinforce the strips with staples.

2 Affixing the board
For the painting board, use a piece of ⅓in (10mm) corrugated plastic. Two strips of Velcro are enough to hold it firmly on the tripod, yet allow it to be easily removed when needed.

3 Ready for paper
This painting board is sized for a quarter-sheet of paper, but the wooden holder on the tripod will work just as well with a half-sheet size. Clips are handy to secure the paper to the board.

daylight, if possible, but avoid the sun shining directly onto your paper because the glare can be tiring to the eyes. There are now inexpensive daylight bulbs and LED lamps available that provide a strong and even light, enabling you to paint anytime.

Working flat or at an angle?

Every artist will have a preferred angle for painting. Working flat is often preferred for wet-in-wet painting (see pp.52–55) as this allows paint to flood and merge easily. Working at an angle encourages washes down the paper, resulting in a fresh and even color; a very steep angle allows drippy runs.

Outdoor painting

Plein air painting is made much easier when you have the right equipment; and exactly what that is depends upon what suits you as a painter. There's no need to rush out to buy all manner of special equipment. As long as you can hold your paper steady, have all your paints and brushes on hand, and a source of water, you have all you need for a productive painting session. Over time and repeated sessions of painting outdoors, you'll refine what you take and source lightweight versions, as necessary. It's a good idea to carry all you need, and the bag itself can steady the setup.

A field easel
Lightweight and portable, easels are available with their own carrying bag (below). These easels are totally adjustable for working outdoors.

A customized outdoor setup
This plastic tray has cut-outs for a water container and brush case with space for the palette. A straightened-out wire coat hanger underneath adds stability. You don't have to buy an expensive easel setup; make practical adjustments to a basic setup over time.

You will need (outdoors)

- Field easel or modified tripod
- Container of water that can be attached to your easel and a source of more clean water
- Watercolor paper
- Lightweight board to hold paper
- Tape or clips to affix paper to board
- Watercolor paints and palette
- Selection of brushes in a holder
- Paper towel
- Spray bottle

Displaying your paintings

HOW BEST TO PRESENT YOUR WORK

A painting almost always looks better and more impressive when well presented with a mat within a quality frame. The opposite holds true, unfortunately, when work is shoddily mounted or poorly framed. To celebrate the fruits of your labor, take some time to consider exactly how you want to present your watercolor paintings.

The difference a mount makes

The traditional method of framing a watercolor is first to mount it within a beveled cut-out mat board. To give the painting enough space, use a minimum mount width of at least 3⅛in (8cm), even for small paintings. With larger pieces of, say, half-sheet size (15 x 22in/38 x 56cm), at least a 4in (10cm) width would be needed.

Mounts are cut using a special cutting device that maintains the 45-degree angle of cut and ensures there is no overcutting or undercutting. Even the simplest of these cutters is an expensive investment and most painters will use their local framing shop or online service to ensure a perfect and professional-looking result.

A double mat uses two mat boards with offset cut-outs to show a ⅕–⅖in (0.5–1.0cm) step and leads the viewer's eye into the painting; triple mounts are also available. The best mat board has a white, acid-free core and backing. Acid-free boards and paper resist darkening with age.

Choosing the right frame

A picture frame is constructed from material known as "molding." Such molding comes in a vast range of colors, widths, and materials. Any frame should enhance rather than compete with your watercolor painting, and so the most popular moldings are fairly simple shapes in natural wood; these can be finished, painted, or stained in a white or light color. Other classic moldings are brown and black, and a gilt finish appeals to many artists.

Be aware that some moldings are more prone to damage, so if you plan to reuse frames (a sustainable approach), a natural hardwood frame in oak or ash is less likely to show nicks.

Glass or acrylic?

Keep your painting fresh with clear picture glass or, ideally, glass with a UV coating to stop fading; most framers can offer both. Quality, clear museum glass is nonreflective and absorbs UV light, but is more expensive. Acrylic– often supplied with frames bought online–is very light but also prone to scratching.

Single mount

Double mount

Triple mount

Picture mats

Picture mats are generally single, double, or more rarely, triple. As well as creating a gentle space around the painting, the mat also prevents the painting touching the glass, which could cause damage.

Wet-in-wet (see pp.52–55)

A frame gallery

Watercolor paintings often work best within a simple frame. Here are a few examples to give you an idea of how to frame your next masterpiece.

Toward abstraction (see pp.162–165)

Creatures in motion (see pp.240–243)

Still water (see pp.182–185)

Showcase painting (see pp.142–143)

Floating mount

A painting can be made to appear as if it is "floating" above the mount by affixing it first to foam core board. The frame needs an inset to keep the mount and painting away from the glass.

Edge of painting raised above the mount

Cutting a mat

It is hard to make a beveled cut without special mat-cutting equipment; even then, proficiency requires a lot of practice.

Deckle edges

Float-mounting often looks best when the painting has a deckle edge. Turn the painting over and simply tear off the edge of the paper by pulling it up against a steel ruler, or use an inexpensive deckle edge ripper.

Mat-cutter

"Don't skimp on framing. Nothing will hurt your painting more than a poor frame."

Techniques

Watercolor **techniques**

As a medium, watercolor is incredibly versatile, taking you from simple flat washes to mixed media and textured surfaces that suit many painting styles and subjects. The fluid, transparent nature of the paint makes it easy to apply with expressive strokes, producing paintings where colors blend and merge seamlessly with sparkling luminosity.

On the following pages, you will find 45 techniques to practice and develop your skills. They are grouped into three sections designed to build your repertoire and hone your style, from core techniques such as layering washes in the beginner section, to using theories of color and composition in the intermediate section, to experimenting with mixed media in the advanced section. Showcase paintings in each section bring numerous techniques together.

1 Beginner techniques

■ See pp.50–89

The first section explains how to lay your base washes, working from light to dark in either wet-in-wet or wet-on-dry applications, along with tips on how to remedy mistakes.

2 Intermediate techniques

■ See pp.90–127

In the second section, develop an understanding of color theory to use warm and cool colors, aerial perspective, and complementary and analogous colors to best effect, with techniques such as glazing.

Beginner showcase painting (see pp.64–65)

Softening edges (see pp.94–95)

Watercolor paint flows easily and this unpredictable nature is part of its appeal. Learning to control this characteristic is fundamental to working with watercolor, from laying an even wash to incorporating runbacks into your work. Allowing the paint to merge wet-in-wet produces subtle blends and effects. In contrast, you can also work wet-on-dry, to add crisp detail and controlled edges.

A wash is a great starting point for understanding watercolor; practice laying different types of washes, from graduated to the more advanced separating washes. When working from light to dark, you need to consider how to convey highlights, using techniques that either retain lights, from using masking fluid to wax resist, or remove color through lifting out with a brush, or the more advanced effects of using bleach and salt.

To imbue your painting with light, exploit the transparency of the paint to lay color in layers, using glazing to build depth or adjust the color or tone of a wash.

A versatile approach

The range of techniques and approaches available in watercolor make it an ideal medium for many styles of painting. Loose and abstract marks can be complemented with splattered effects or added gouache highlights. Pen and wash is ideal for working in a sketchbook but also adapts to a more illustrative style. Combining watercolor with mixed media opens up myriad options, with applications for illustration and design using detailed drawings and pattern making.

3 Advanced techniques

■ See pp.128–167

In the final section, find out about the principles of linear perspective and focal points, and how to combine special effects or mixed media—from gouache to charcoal—to develop your style further.

Linear perspective (see pp.134–137)

Wet-on-dry

CONTROLLING BRUSHSTROKES AND EDGES

When wet paint is applied onto dry paper, or onto areas of dry paint, the pigment will spread less than if you apply paint on a wet surface. This gives you more control over your brushstrokes and produces crisp edges, allowing you to achieve precise shapes, definition, and detail.

■ Controlling the marks

To maintain crisp edges when working on dry paper, always let the first wash dry and don't overwork your washes. For varied effects, use different brushes, from Chinese to mop and rigger, and learn how to control them to build up a vocabulary of marks.

Correct: wet on dry paper

Incorrect: overworked washes

Wet on dry paper

For crisp details on dry paper, the paint shouldn't flow beyond the dry edges of the shape. If you keep adding and pushing more paint beyond the intended area it will mix and you risk diffusing the edges.

No. 10 soft-hair mop

No. 6 soft-hair mop

No. 000 soft-hair mop

Chinese long brush

Brush marks

Hold the brush close to the ferrule, and use the tip for controlled, detailed marks. Holding the brush higher up will produce looser, feather-like strokes. Use the side of the brush for thicker lines and marks.

In this detailed scene, the wet-on-dry technique is used to create leaf shapes in several colors, which vary in tone and intensity. Layers of color built up over dry underwashes create the reflective water.

You will need

Pure yellow Green gold Permanent rose Caput mortuum violet Manganese blue Indanthrene blue Indigo Neutral tint Phthalo green (blue shade)

- Selection of Chinese brushes
- No. 10 and no. 000 soft-hair mop brushes
- 13 x 19 in (33 x 48 cm) hot press 300 lb (535 gsm) watercolor paper

River scene

1 Apply wash for sky and water
On dry paper, paint washes of manganese blue with a no. 10 mop. Pull the brush across to create lines, leaving highlights of dry, white paper.

2 Foliage shapes
Apply lightest green for foliage and grasses. With a light touch, slightly fan a Chinese brush to hint at different shapes. When dry, return to fill in gaps.

3 Refine the trees
Use different brushes in as many ways as possible to build up layers of color and tone. Remember to let each wash dry, since earlier laid washes are easily disturbed.

4 Add mid tones
Build up the scene by adding mid tones for the distant trees, river bank, and water, drying in between strokes. Don't be tempted to go back and fiddle; always let the wash dry.

5 Dark tones and details
Add darkest tones and shadows, keeping a balance of light and shade. Use the brush tip to shape leaves and the flat side of a small Chinese brush to pull lines for reflections.

Wet-in-wet

NATURAL BLENDING EFFECTS

By applying paint to wet paper, or into a wet wash, watercolor pigments will merge and blur together naturally in a way that no other paint medium can achieve. You can use wet-in-wet to blend washes, mix a third color, or achieve subtle tones in one color. It is ideal for subjects where subtle changes are required, such as skies or reflections.

▣ Encouraging blends

The trick with wet-in-wet is to allow natural transitions and blends to happen—try not to interfere in the blending process with a brush, as the colors will continue to merge as the paint dries. You can impose some control by adjusting the dampness of the paper and choosing which paints to apply together.

Wet paper
The damper the paper the more the wash will spread, leaving tonal variations.

Natural blends
Apply loose drizzles of different colors to wet paper and allow them to blur and blend together.

Adjacent color blends
Paint an even wash of two separate colors side by side on wet paper and leave them to touch and spread together where they meet.

Dominant blends
With a stronger (more pigmented) wash of alizarin crimson added to a weaker one of ultramarine, the crimson dominates as it blends.

Wet-in-wet blends are used here to create soft undulations in the water as well as gentle variations in color on the birds. The fluid nature of the technique mirrors the sense of calm and tranquility.

You will need

Raw sienna · Raw umber · Cadmium red · Alizarin crimson · Van Dyke brown · Prussian blue

- No. 16 and no. 8 soft-hair round brushes
- 2 in (5 cm) hake brush
- Masking fluid and craft paintbrush
- 20 x 27½ in (50 x 70 cm) cold press 140 lb (300 gsm) watercolor paper

Flamingos

1 Reserve white areas
Using a craft brush, apply masking fluid (see pp.100–101) to the bodies of the flamingos to retain their silhouettes when the initial paint washes are applied. For the water, use swift horizontal strokes to create crisp ripples around their feet, and the end of the brush to splatter spontaneous splashes.

Ripples created with masking fluid

2 Background variegated wash
Use a hake brush to thoroughly wet the paper with washes of Prussian blue and Van Dyke brown, leaving odd chinks in denser tones around the flamingos' feet.

3 Lifting out
Tilt and tip the board to encourage the direction of blend. As the wash dries, lift out the reflected shape of the flamingos' necks with an almost dry brush.

4 Remove masking fluid
Leave the painting to dry slightly propped up so that gravity will encourage the color to flow downward and dry paler at the top. Once fully dry, rub off the masking fluid.

5 Apply water

Wetting each flamingo in turn with clean water, use a varied mix of raw sienna, cadmium red, and alizarin crimson to paint in their form. Dab bolder strengths of the mix into the shadowed areas. While still wet, apply a thicker and more intense mix of cadmium for deeper reds, and a mix of cadmium red and Prussian blue for the black on the wings and beaks. The softened blends will reflect the natural transitions of tones in the birds' feathers.

6 Add reflections

There are both shadows and reflections on the water. A reflection naturally extends toward the viewer, whereas the length and direction of the cast shadow is dependent on the angle of the sun. Wet the foreground water slightly, then paint in the reflections loosely with a gentler tone of the flamingo pink. Allow them to fade with soft edges. In contrast to the sharp-edged form of the flamingos, their soft-edged reflections emphasize the effect of the water.

7 Blend shadows

Paint the shadows under the flamingos in touches of Prussian blue, with deeper sharp shadows cast across the water to anchor the flamingos on the lakeshore. Introducing the same Prussian blue from the background into the shadows on the flamingos and foreground water will help bring the whole painting together. The colors will harmonize, lending a feeling of tranquility to the scene.

Deep Prussian blue shadows

Touches of raw umber are used in the shallows

8 Splattered texture
Finally, add some splatter (see pp.98–99). Using previous color mixes, splatter over the retained white marks around the beaks and legs. This adds a touch of spontaneity and liveliness.

Dry brush

PAINTING BROKEN MARKS

Dry brush refers to a technique where marks are made with a sparsely loaded brush, resulting in broken edges and textured effects. Simply by varying the angle and direction of the brush you can represent complex subjects such as foliage, the texture of rock or bark, and broken light. Work on rough paper for optimal effect.

■ Angling the brush

Start with the right ratio of pigment to water in your palette; not too wet that it drips and not so dry that it leaves streaks. Load the brush fully and then use the direction of your brush marks to describe the object you are representing, changing the angle of the brush to control the size and shape of the marks. Choose different brushes, from round to flat, for variety.

Pulling up
Quickly pull the tip of your brush upward to represent thin subjects like grass, leaving broken marks at the top of the stroke. Either replenish your brush or continue for drier texture. Vary the density of the line with different pressure.

Thin, dry strokes

Splaying bristles
A flat brush is ideal for linear subjects. Press near the head of the brush to splay and flatten the bristles, then quickly drag in the direction of your subject; for example, vertically for grass or horizontally for light sparkles on water.

Broken linear marks

PUTTING IT INTO PRACTICE

A soft, wet-in-wet underpainting provides a base for working dry brush to convey the complex fall foliage of the tree and hedgerow, using light directional brush marks at a shallow angle.

You will need

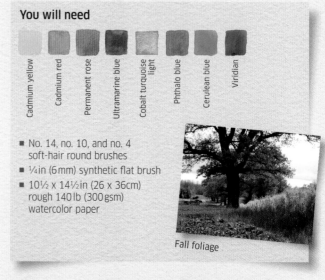

Cadmium yellow · Cadmium red · Permanent rose · Ultramarine blue · Cobalt turquoise light · Phthalo blue · Cerulean blue · Viridian

- No. 14, no. 10, and no. 4 soft-hair round brushes
- ¼in (6mm) synthetic flat brush
- 10½ x 14½in (26 x 36cm) rough 140lb (300gsm) watercolor paper

Fall foliage

1 Underpainting
After lightly drawing the scene, wet the entire surface of your paper so that you can work all of the underpainting entirely wet-in-wet. Apply washes of orange, green, and violet for the main areas, allowing the pigment to flow freely.

> "The key to dry brush is the angle of the brush; the flatter the better."

2 Broken edges for foliage
Working wet-on-dry, use an upright brush to apply a flat wash for masses of foliage. Break up the edges with dry brush marks from a flattened brush, without overworking.

3 Preserving edges
To paint the branches in between the foliage, apply a clear wash along the length of a branch and then add pigment between the foliage. This will preserve dry brush edges.

4 Directional strokes
For the long grass in the foreground, separate the bristles of a flat brush with your thumb and make quick, light, directional dry marks over the soft underpainting.

Layering paint

BUILDING WASHES

Watercolors are painted from light to dark and require the whites to be reserved from the outset. Painting transparent washes of individual colors allows you to build them up to create mixes on the paper instead of in a palette. This layering technique produces vibrant watercolors that are unified and harmonious.

■ Working from light to dark

Layering is one of the most important techniques in watercolor. In general, weaker washes and lighter hues are applied first, with successive stronger layers laid after each one has dried; test the strength of your washes on scrap paper before applying. Each transparent layer will influence the color of the wash laid beneath or on top of it.

First layer
The initial wash (here, yellow ocher) is applied over a large area to unite the light tones. Where needed, leave the paper unpainted to reserve white.

Second layer
Once the first layer is dry, apply a darker color on top. Here, crimson looks warm over the yellow but appears as a cool pink over the reserved white paper.

Third layer
Apply the darkest or strongest color last, after the second layer has completely dried. The darker layer will modify the colors beneath, as cerulean blue does here.

The first layer is important in quickly uniting all the light tones. There is no need to preserve edges, as the painting will derive its forms from additional colors and tonal values that are overlaid.

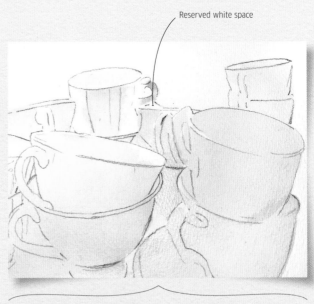

You will need

Cadmium yellow | Yellow ocher | Cadmium red | Alizarin crimson | Burnt sienna | Burnt umber | Cerulean blue | Ultramarine

- No. 14 and no. 8 soft-hair round brushes
- 11 x 15 in (28 x 38 cm) cold press 140 lb (300 gsm) watercolor paper

Stacked teacups

Reserved white space

1 Apply a unifying wash
First make a pencil drawing of the cups, taking care to describe the shapes accurately. Once you are satisfied that they are correct, paint them with a wash of yellow ocher to unify them, reserving small white areas of unpainted paper as highlights.

2 Add a second color
Painting the lightest colors first, lay down a wash of alizarin crimson. This will give warmth to the shadow areas and appear cool pink on the reserved white paper. Paint the pink stripes on the cups, using stronger color on those in the foreground.

3 Layer with blue
When the paper has dried, mix a wash of cerulean blue and layer it over the top of the yellow and pink mix, allowing the underlayer to show through here and there. This creates a turquoise color over the yellow ocher and neutralizes the warmer crimson areas.

>

Stronger color for rims

4 Use stronger color for details

Once the paint is completely dry, erase the pencil drawing. Using stronger mixes to cover the washes, put in cadmium red, cadmium yellow, and burnt sienna for the gold rims and details.

5 Add complementary colors

Layering a complementary hue keeps the colors lively. Mix a lilac from crimson and cerulean and use it in shadows to complement the ocher wash. Cover the turquoise mixes with cadmium red.

"Even in subtle layers, complementary colors give extra liveliness to a painting."

Layers of contrasting
color provide depth
and complexity

6 The final layer
With a mix of burnt umber,
alizarin crimson, and ultramarine,
paint the shadows as the last layer to
define and separate the shapes of the
teacups, creating detail and focus.

Alla prima

COMPLETING A PAINTING IN ONE SESSION

Sometimes you will want to capture an impression of a scene in one session, known as *alla prima*. It is a great discipline, encouraging you to be organized, to find the essence of your subject through simplification, and to mix and use colors economically. Aim to capture just enough light and color information about the subject quickly, using as few brushstrokes as possible.

PUTTING IT INTO PRACTICE

A strong first wash sets the tone to capture the warmth and light of this subject. A limited palette of dominant reds with cool blues creates simple contrasts, so that just a few shapes and tones are needed.

You will need

- Cadmium yellow deep
- Cadmium red
- Alizarin crimson
- Burnt umber
- Cobalt blue
- French ultramarine
- Viridian

- No. 14 and no. 8 soft-hair round brushes
- 6 x 10 in (15 x 25 cm) cold press 140 lb (300 gsm) watercolor paper

Shutters and blinds

1 Base sketch
Simplify the composition in a quick sketch, noting the main areas of shadow and outlining the whites that you want to retain, here the white blinds. The defined shapes of the cast shadows create the darkest tones: sketch these in so that they can be filled with a dark wash later to give instant depth.

2 First flat wash
Start with a vibrant first wash, mixing alizarin and cadmium yellow deep to establish the tone for the painting. Apply as a strong, flat wash around the window shapes, using burnt umber as an underlay for areas of darker shadow.

Complementary contrasts add an instant sense of depth

PLANNING AHEAD

Lightweight unstretched paper is ideal to use as it dries quickly. Plan your progress beforehand and follow a checklist (right) before putting paint to paper. You will need to wait for washes to dry so keep them to a minimum, breaking the timing down as follows: 5 minutes to apply the first wash, wait 10 minutes; 15 minutes for second and final washes; dry for 5 minutes then add fine details. Don't be tempted to overwork.

Checklist for working *alla prima*

- **Simplify the composition:** Speed up your observational skills and look for shapes rather than objects. Edit peripheral details.
- **Choose a limited palette:** Include a dominant color for the majority of the composition, with mid and dark tones sharing values; subdue other colors.
- **Plan whites:** Retain the white of the paper for lights and highlights.
- **Limit darks:** Keep dark areas to a minimum, they will have more impact and you only need to strengthen existing washes.
- **Plan blends:** Consider which washes can merge wet-in-wet and which ones need to be kept separate.

Wait to add the pale viridian wash for the shutters until the warm, second washes are almost dry, to avoid them merging together

3 Second washes
Decide which washes can merge without loss of control. Continue with warm colors that will harmonize with the first wash, adding red and neutral earth colors to the shadow areas.

4 Calligraphic marks
When the second washes are dry, add minimal marks to convey details. Focus on the white blinds, using thin, calligraphic lines for the shutters, with just a few shadows on the perimeter.

Use rich colors for simple, calligraphic marks

Some wet-in-wet merging adds to the sketchy theme

Artist **Rod Craig**
Title **Spirit of Eden**
Paper **13 x 21 in (33 x 54 cm) rough**
140 lb (300 gsm) watercolor paper

Wet-in-wet

≪ See pp.52–55

Watching new tones emerge where two washes meet—in this case, when yellow and blue combine to create green—is an exciting aspect of painting wet-in-wet.

Lifting out

≫ See pp.82–83

The ethereal merging of the trees into the background was created by adding water to the black paint in those areas, then using a cloth to remove the color entirely.

Balanced composition

≫ See pp.110–113

Simple compositions are often the most successful; the diagonal swathe of white running down the center of this painting anchors the markings either side.

Showcase painting

Using just three paint colors, this vibrant, abstract work demonstrates the creative possibilities of core watercolor techniques. The interplay between dynamic wet-in-wet washes and frenetic black markings takes the subject—a forest landscape—to the depths of the artist's imagination.

Using runbacks

>> See pp.68–69

Applying background washes on damp paper allows them to merge freely into one another, creating softly feathered edges where the colors meet.

Using salt

>> See pp.148–149

A little salt, sprinkled onto the paint while it was still wet, was used to create interesting textures on the trees, resulting in an abstract suggestion of bark.

Wet-on-dry

<< See pp.50–51

To create movement and expression, trees were suggested with just a few free brushstrokes, applied with quick gestures once the other colors had dried.

Tone

DESCRIBING FORM AND MOOD

Tone refers to the range of values from black to white—darks, mid tones, and highlights. All colors have a tonal range, but when you look at your work it's easy to become so engaged by the hues, or colors, that you forget about the tonal values. Half-closing your eyes will help you judge the lights and darks in your composition.

■ Choosing the mood

A knowledge of how to use tone is essential in order to paint convincing subjects, since we understand three-dimensional forms on two-dimensional paper by the light and shade on them, and the shadows they cast. It is also a way to establish an overall mood to a painting, using strong tones for drama or more subtle, close tones to convey a sense of calm and intimacy.

Dramatic tones
The stronger the light source, whether it is artificial or from the sun, the more dramatic the tones on surfaces appear. Dark cast shadows appear on the opposite side from the light source.

Close tones
When the light is more evenly distributed, such as on a cloudy day or from a shaded lamp, tones become softer and more diffuse. A calmer, more gentle mood is established.

Here, the use of tone describes the softly rounded shapes of the kitten's body. The colors have been mixed on the paper rather than in the palette, but you can choose whichever method you prefer.

You will need

Raw sienna | Quinacridone rose | Cerulean blue | Payne's gray | Davy's gray | Ivory black

- No. 8 and no. 6 soft-hair, and no. 0 synthetic round brushes
- Paper towel for blotting
- Craft knife
- 8 x 8 in (20 x 20 cm) cold press 140 lb (300 gsm) watercolor paper

Gray kitten

1 Lay the first washes
Make a pencil drawing of the kitten, then, with the no. 8 brush, lay a wash of rose and Payne's gray on the darker areas. With clear water, bleed out the transition to the light areas (see pp.94–97). Apply a mid-tone wash of cerulean blue, Payne's gray, and rose to bridge the darks to lights on the kitten's back.

"Cast shadows anchor a subject to a surface."

2 Paint in the eye
With the no. 0 brush and black, paint the pupil of the eye. Once it is dry, use very dilute raw sienna for the iris and drop in a little cerulean to create a slight shadow.

3 Add facial details
Use mixes of Payne's gray, black, and rose to refine the dark tones on the face with the no. 6 brush. With a craft knife, gently scratch out the eye highlight and the whiskers.

4 Paint the background
With washes of Davy's gray, rose, and cerulean, work all around the outline of the kitten, leaving the white highlight. Bleed out the edges of the background with clean water.

Using runbacks

INCORPORATING ACCIDENTAL EFFECTS

Runs and drips on wet paper create textured edges as they
dry, known as runbacks. As a beginner, you may have produced
runbacks by accident, but with a little understanding of how they
occur, you can use them to your advantage with stunning results.

PUTTING IT INTO PRACTICE

Drips and runbacks are used in
this painting to represent the
effect of foam breaking on the
crest of a wave without painting
every droplet of water. The effect
is achieved by controlling the
dampness of the paper surface.

You will need

Lemon yellow
Dioxazine violet
Ultramarine blue
Phthalo blue
Cerulean blue

- No. 20 and no. 10 soft-hair
 round brushes
- 1 in (25 mm) flat brush
- Fine mist spray
- 11½ x 16½ in (29 x 42 cm) rough
 140 lb (300 gsm) watercolor paper

Breaking wave

1 Define edge of wave
Using a no. 20 round brush, apply a
clear, solid wash with broad brushstrokes
from the top. Break up this wash where
you want to represent the curve of the
wave head, and leave dry any highlights
that you want to appear white on the
finished painting.

2 Add water to crest
Apply color to the body of the wave
in bold strokes. As soon as the sky area
dries to damp and has lost its sheen,
apply small amounts of clear water to
areas on the crest of the wave where
they meet the damp pigment.

A drop of water creates
small, separate blooms

Assisting runbacks

Runbacks need a damp surface. To encourage their formation you must ensure that the paper surface maintains the same level of wetness throughout the painting. As the painting dries to damp, continue to add water to the same wetness, using a brush or fine mist spray to apply the water. Judge when to add your wet wash to the damp paper so that it spreads to leave a bloom or feathery edge as it dries.

Judging surface water
The shine on wet paper indicates it is damper than the pigment area, so the water will mix with the drier paint edges. Check this surface reflection constantly.

Timing paint application
Let an area dry to damp before adding water next to it; done too soon, you will simply have a smooth wet-in-wet blend. Allow the runback time to develop.

Space the runbacks so they don't merge together

Soft edges appear where the water spreads into the drier sky

3 Tilt the paper
To encourage the runbacks, tilt the paper in the direction of the flow of the wave. Soft edges will emerge where the run meets with a slightly drier area. Harder edges form where the damp bleed meets the dry wash beneath.

4 Final solid marks
Add a little more definition to the body of the wave. Rewet it with an even mist of water and apply a few streaks with a small brush, keeping the detail understated in this area.

Flat wash

APPLYING SMOOTH COLOR

A fundamental technique to master in watercolor is applying smooth layers of color that dry to an even tone. Flat washes can represent large areas such as sky or water, and define architecture and features in a landscape. A smooth, flat layer is also a good base for adding details in darker mixes, or building layers to vary the tone.

▇ Laying a flat wash

Use a soft-hair brush or a large synthetic-fiber brush that will hold the most paint. Before you start, make sure that you mix sufficient colors–there is nothing worse than running out of a particular mixture before the wash is complete. Try not to stop in the middle of laying a wash, as any variation in application could lead to patches or stripes showing as the wash dries. When the wash is complete, leave the paper to dry.

Beads of wash form on the lower edge of each stroke

First stroke
Hold the paper at a shallow angle (around 30º), so that the paint retains a wet lower edge. Load the brush fully and start at the top, painting across the paper in one continuous stroke.

Continue to paint across the paper in the same direction

Blending brushstrokes
Reload the brush, pick up the wet edge, and blend it smoothly into the next stroke. Continue, keeping the brush well loaded so that you can cover an area quickly and evenly. Absorb any excess at the bottom with a dry brush or paper towel.

PUTTING IT INTO PRACTICE

In this view of Istanbul, flat washes were applied to give solidity to the building, contrasting with the lighter sky. Visual interest is created by varying the tone of the flat washes from light to dark.

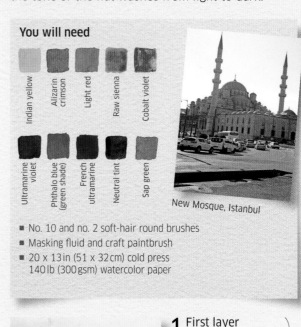

You will need

Indian yellow • Alizarin crimson • Light red • Raw sienna • Cobalt violet
Ultramarine violet • Phthalo blue (green shade) • French ultramarine • Neutral tint • Sap green

New Mosque, Istanbul

- No. 10 and no. 2 soft-hair round brushes
- Masking fluid and craft paintbrush
- 20 x 13 in (51 x 32 cm) cold press 140 lb (300 gsm) watercolor paper

1 First layer
Lightly sketch the outlines of the main composition and mask any areas that are to remain unpainted with masking fluid, and leave to dry. Apply a sky wash in loose patches from top to bottom, and on the road, leaving white for the clouds, buildings, and vehicles.

2 Add mid-ground color
When the sky wash is dry, lay a flat wash of solid color to the building. Start at the top of the minarets and lay the wash within the outline in one smooth area. Apply the first layers of wash for the vehicles and road.

White highlights are reserved
with masking fluid

"Watercolor
lightens as it dries,
so apply a **darker wash**
than you think."

3 Define features
Lay a third wash
over the building to
define the larger
features and separate
each facade. Use
darker values to
accentuate the
domes and roofline.
The contrast of
color with the
bright taxis adds
foreground interest.

4 Dark details
Working over
the flat wash, use a
darker neutral mix
to add details to
the buildings. The
windows and doors
create a sense of
scale with the darker
details of bushes and
cars, drawing the eye
into the composition.

5 Refine foreground features
In the final stage, add the darkest shadows and
features. The strong shadows of the vehicles have
several colors of the same tonal value (see pp.66–67)
to suggest reflected light and avoid them looking flat.

Graduated wash

DILUTING COLORS IN WASHES

Watercolor pigment can be manipulated with just water and gravity to run freely over the paper, creating beautiful effects that are unique to the medium. A graduated wash fades as the pigment becomes progressively diluted, making this an especially effective technique for painting skies and indicating distance.

▪ Two ways to lay a graduated wash

The most common way to lay a graduated wash is to brush clean water into the paint as you work down the paper, but stripes or bleeding may occur if the paper dries unevenly. Wetting the paint on the paper with a spray bottle avoids this.

Using the brush
Working from top to bottom and painting from left to right (if you are right-handed), lay a stroke of paint with a wet brush on dry paper. With each successive stroke, dilute the same mix with one dip of the brush into clean water.

Spraying
Using a spray bottle to wet the paint gives a smooth and even result. Using two colors in the mix sometimes results in them separating into a lovely haze.

Separating paint

PUTTING IT INTO PRACTICE

A graduated wash is ideal for a day when mist reduces a complicated landscape to just a few tonal passages. Use a large brush and tilt the paper at an angle of about 45 degrees.

You will need

Cadmium lemon
Indian red
Burnt umber
Cobalt blue
French ultramarine

- No. 10 soft-hair mop brush
- No. 5 soft-hair round brush
- Spray bottle
- 11 x 15 in (28 x 38 cm) cold press 140 lb (300 gsm) watercolor paper

Estuary scene

1 First loose washes
With a mix of French ultramarine and burnt umber, start from the top of the page and work downward, to create a graduated wash by dipping the mop brush in clean water before each horizontal stroke. Allow to dry.

2 Add the boats and banks
Starting at the horizon, with the same mix but adding a touch of cadmium lemon, paint in the distant and foreground banks and highlight the boat shapes. Use less lemon as you work down toward the mud banks.

3 Describe details
Once dry, use the round brush and a stronger mix of French ultramarine and burnt umber to add details such as the boats, masts, and posts and the shadows on the banks.

4 Graduated wash for wet mud
To create the feeling of wet mud, add a graduated wash of cobalt blue using the spray bottle and allow the mud to merge with the water. Guide the paint down with the mop.

5 Strengthen the foreground
When the painting is dry, add a foreground wash using the mop with a mix of French ultramarine, burnt umber, and a touch of Indian red.

Variegated wash

MINGLING COLORS IN A WASH

You can create fantastic backgrounds and stormy skies with initial washes that transition from one color to another. It takes some practice and confidence to conquer, so enjoy some experimentation until you're happy with the results for backgrounds before moving on to other details. Wetting the paper in places can add to the way in which the colors spread and also avoid any obvious stripes.

▨ Marbled and smooth effects

For a random marbled effect, background washes are applied to wet paper and then further paint is washed on, catching the moments when the paper is damp in some places and dry in others. Mixing while the paints are both wet allows softer blending which is key for natural-looking and picturesque effects.

Random color transitions
Applying small areas of wet paint to wet paper creates random transitions of color. You can tilt the paper to influence the direction of paint flow. Using a stronger wash enables you to add intensity.

Visible color edge

Smooth color transitions
For a gradual transition of color, tilt your board at an angle of at least 45 degrees. Lay your first wash from the top, with plenty of dilute paint on your brush. Apply a wash of another color, allowing the diffuse edges to blend together.

Gradual color variation

PUTTING IT INTO PRACTICE

There is no need for a pencil sketch here. After the background wash, build up the clouds with stronger mixes, using different brushes on damp and dry areas of the paper to create an impressionistic effect.

You will need

Hansa yellow · Scarlet · Ultramarine · Neutral black · Sepia

- No. 18 and no. 12 soft-hair mop brushes
- No. 5 and no. 2 synthetic, and no. 3 soft-hair round brushes
- 6 x 8¼in (15 x 21cm) hot press 140lb (300gsm) watercolor paper

Cloudy sky

1 Background wash
Wet the paper all over. Lay washes of blue and black in the upper third, then yellow with a band of scarlet below. Use more blue and black at the base.

2 Paint the clouds
While the paper is still wet, mix blue, sepia, and black. Use strokes of color for clouds, tilting the paper to create movement. When the paper dries a little, use a finer brush for a variety of small clouds.

3 Detail around the horizon
When the paper dries, paint the remaining clouds above the horizon. Then paint the sea and horizon in a watery wash, adding a little blue and black in places for some depth.

4 Foreground setting
When the paper is just damp, paint the beach with an expressive stroke of sepia with a little black and blue. When it is dry, add small strips of sand and some details.

5 Add depth
Apply water to the horizon area then use a little blue mixed with sepia to create a stronger impression of depth and firm up the horizon.

Line and wash

COMBINING WATERCOLOR WITH PERMANENT INK

Working in pen and ink opens another means of expression for the watercolorist, with the opportunity to use spontaneous drawing marks in waterproof ink that become an integral part of your painting. Employ the descriptive range of lines either as a foundation for your washes, or as a final signature to enhance your subject matter with an illustrative style.

◼ Using sketch lines

The portability of watercolor makes it an ideal sketching medium, and combining it with ink as a drawing tool will encourage you to approach your work with confidence, as you learn to accept the permanency of marking pen to paper. Start with a small, smooth-paper sketchbook to make a feature of ink sketches.

◼ Finalizing with lines

For a more illustrative approach, line is very effective over a dried wash to add the finishing touch to a painting. Simple outlines and defined edges will visually enhance shapes but it is also an opportunity to draw freely, using fluid, freehand marks that add an additional element to your painting.

Loose marks and impressions

Different pens and nibs give lines of varying thickness; check that the ink flows smoothly so you can work spontaneously and freely. If your ink line looks too dominant, use richer paint and allow the lines to be part of the finished piece for a bold yet effortless effect.

Outlines and details

The use of abstract washes and shapes mixed with organic, sketchy lines adds definition to your artwork and provides vibrant points of interest throughout. Choose bold, contrasting colors from the rest of the painting to define outlines and details for a sense of playful impact.

SKETCHING WITH INK

Here, a quick sketch in waterproof ink uses line to capture the figure and the detail of the fishing rod. Strong and simple washes are used to complement the pared-back nature of the image.

You will need

White gouache · Cadmium yellow · Cadmium red · Burnt sienna · Raw sienna · Cerulean blue · French ultramarine

- No. 14, no. 10, and no. 8 soft-hair round brushes
- 1 in (25 mm) and ½ in (13 mm) synthetic flat brushes
- 0.5 mm technical pen
- 9 x 12 in (23 x 30 cm) cold press 140 lb (300 gsm) watercolor paper

Fisherman on rocks

1 Simplify the image

Sketch the image confidently with waterproof ink, simplifying the scene to the main components. Apply a wash of ultramarine over almost the entire image, leaving hints of white for the face and hat.

2 Vary base colors

Keep it simple by using tones of blue; add more ultramarine around the figure to make the arm and leg appear lighter. Use the pen outlines to guide the shapes, making sure that they are still visible.

White gouache on the rod leads the eye to the drawn shape

3 Balance color and line

Reinforce darker tones using as few strokes as possible to retain the sketchy feel without losing the ink lines. Mix gouache in the lighter tones for final highlights.

DESCRIPTIVE OUTLINES

The dark background to the reference image has been reversed
to provide a light, neutral foundation for the intense flower colors.
Enclosing all the shapes in inked lines gives a sense of containment
to the painting, combining precise outlines with loose, fluid strokes.

You will need

Watercolor

| Lemon yellow | Light brown | Transparent orange | Crimson red | Opera rose | Perylene violet | Ultramarine | Cobalt turquoise light | Cobalt green | Viridian |

Liquid watercolor

Pastel green

- No. 2 mop brush
- No. 4, no. 1, and no. 0 soft-hair round brushes
- Watercolor pencil
- Fine permanent marker, ink pen, or calligraphy pen

- 12 x 8 in (30 x 20 cm) cold press cotton 140 lb (300 gsm) watercolor paper

Bouquet of flowers

1 Background wash

Use a watercolor pencil to
sketch the main elements and
any connections between them.
Mix a light, neutral wash for the
background and apply it around
the main shapes to provide a
foundation for the flower and
leaf colors. A pale wash will
ensure that pen lines stand out.

2 Fill shapes

Add light and mid tones
to the leaf and flower shapes,
keeping within the drawn lines
so the shapes have defined
edges that you can follow with
a pen later. Let each stage dry
before continuing to add darker
tones to the bouquet.

3 Saturated color
Build deeper, intense washes on top of your preliminary lighter tones. Work wet-on-dry (see pp.50–51) so the colors dry with defined edges, which can be used as guides for pen marks.

4 Loose lines
Use a fine pen to trace outlines and add details. Add stippling with a thicker pen for the flower centers. Describe the petals and buds with loose lines, using the varied tones of the underlying wash as a starting point.

5 Ink outlines
In this painting, final lines play an essential role. They not only define your elements' edges, but also give an overall sense of closure to your artwork. Try keeping your line loose and expressive, it will give an effortless finish to your painting.

"Abstract washes and shapes mixed with organic lines have an effortless feel."

Straight edges

PAINTING AN EVEN LINE

Almost all man-made elements in a subject will
have some straight lines. Surprisingly, these do not
necessarily need to be painted perfectly straight.
Variety in the line is always preferable, but there are
some subjects, such as telegraph poles, where bends
will look incongruous. There are a few ways to help
keep lines straight without a ruler, so that they look
like a natural part of the painting process.

▇ Aids for achieving natural lines

Painting a freehand straight line does not often come easy, but you
can employ various tools, either from your painting kit or made
from materials close at hand, to help you achieve a natural line.
To make the line appear painterly rather than graphic, vary the
pressure to adapt the line's width and solidity.

Swordliner
Gently lie the
curved "blade" of
the brush on the
paper, then lightly
draw it down.

Card
Paint the edge of a
credit card or mat
board with a slightly
stronger mix and
stamp or drag.

Maulstick
Use a straight edge
or maulstick as a
guide; draw down
with the ferrule
against the stick.

Flat brush
Chisel edges will
create a variety of
lines; stamp gently
for a fine line, drag
for a thicker line.

Here, different aids were used to convey
the variety of lines, from the corrugated
iron to the telegraph poles that are so
integral to the composition.

1 Background wash
Paint the background vegetation using
the flat brush and a French ultramarine and
cadmium yellow mix. Vary the mix as you
paint. Use the edge of the brush to create
the squared edges of negative roof shapes.

2 Brush lines
Continue with the flat brush to fill in the
buildings, using the edge for corrugations
and planks. Vary the line width and color,
using a variety of blues, browns, and grays.

You will need

Cadmium yellow

Burnt sienna

Cadmium red

French ultramarine

- 1 in (25 mm) soft-hair flat brush
- No. 10 soft-hair round brush
- ¼ in (6 mm) swordliner brush
- Ruling pen
- Mount card or maulstick, and credit card
- 10 x 14 in (25 x 35 cm) cold press 140 lb (300 gsm) watercolor paper

Street view, St. Lucia

3 Assisted lines

Use the maulstick or the edge of some mat board to create the poles, using a variety of darker mixes. Cut the mat board to different lengths and drag it sideways to broaden the line for the wider poles.

4 Fine lines

With a strong shadow mix, apply finer lines with a credit card for the corrugated sheets and straight cables. Use a ruling pen (see pp.20–21) for the slightly curved lines.

Lifting out

REMOVING PIGMENT

You can control the level of definition in a painting by taking pigment away, rather than adding more and more. Lifting out lets you decide on the amount of looseness you want in a more considered way, giving you control to define edges and shapes; it is ideal for portraying patterns of light.

◼ Ways to lift out pigment

There are several options available for removing a colored wash and manipulating it to leave shapes or edges in the paint. A sponge will leave a textured effect (see pp.84–85), or try a cotton swab for small details, or a paper towel to absorb larger areas. Apply a brush to absorb pigment; it is easy to control and can be used to soften wet edges, or leave a more defined dried edge. Use a medium such as gum arabic to assist lifting out; it binds pigment so you can lift off all the color.

Using a brush
To lift off an area of wash, use a clean, dry brush, pressing quite hard with every brushstroke to avoid replacing the pigment.

Stroke a dry brush to absorb the wash and soften edges. White paper is revealed where pigment is removed

Soft edges Hard edges

Soft and hard edges
For soft edges, use a dry brush to lift off when your wash is still wet, leaving a diffused mark. For a hard edge, apply a clean, damp brush when the wash is drying, or completely dry.

(see pp.84–85)

PUTTING IT INTO PRACTICE

Gum arabic has been used in this painting to slowly allow definition to appear out of a mist, by lifting out the highlights that create a dappled pattern of light on the horse's body.

You will need

Lemon yellow · Cadmium yellow · Permanent rose · Burnt sienna · Phthalo blue · Ultramarine blue · Indigo · Viridian

- No. 20 and no. 10 synthetic round brushes
- Gum arabic
- Paper towel
- Fine mist spray
- 10½ x 14 in (26 x 36 cm) rough 140 lb (300 gsm) watercolor paper

Horse in dappled light

1 Underpainting
Lay the background color around the horse's body, using colors that will form highlights when lifted out later. Mop up any runs with a clean, dry brush.

2 Add a wash of gum arabic
When dry, apply a 50:50 mix of gum arabic and water over the entire painting. Add pigment to the background wet-in-wet to soften shadow edges.

3 Apply light markings
Start applying the rough areas of dappled light and shade on the horse's body with a smaller, drier brush. Detail is not necessary at this stage; let the wash flow and run naturally to define the form. Lift off soft edges.

4 Lift off edges
Continue to add pigment to the wet surface so the wash maintains a soft edge. When dry, lift out hard edges of the pools of light, so the lines of pigment that are left read correctly as shadows, not random marks.

5 Mottled texture
Create texture by pressing a paper towel onto damp paper, either by spraying a dried area, or before a wash has completely dried. Try spraying then tilting your painting and allowing the droplets to run in rivulets.

Using a sponge

CREATING TEXTURES IN PAINT

Sponging is an easy-to-control technique that adds texture and vibrancy to your painting. The natural dimples in a sponge are ideally suited to creating loose effects in watercolor, either by making marks or lifting out color. Use sponging for many subjects from foliage, dappled light, sea spray, clouds, and smoke, to fur or fabric.

Making textured marks

For best results use a natural sponge. Prepare it by submerging in clean water and squeezing out the excess with a paper towel. Dip into your prepared wash and test before applying. Lightly dab or drag the sponge to add textured marks, or lift out for softened edges.

Dragging
Working dark over light, drag the sponge in short strokes, taking care not to overwork an area and muddy the washes. This method will cover large areas quickly and is suited to grasses, trees, and branches.

Stippling
Build texture or add natural highlights by lightly dabbing the sponge. Test the amount of paint and water; too much water will cause the texture to be lost.

Alter wetness
The wash doesn't always have to be dry. Alter the wetness of your paint to achieve different effects, using wet-in-wet where you want the colors to blend.

PUTTING IT INTO PRACTICE

Working from light to dark, the textured background of flowers and grasses was created by stippling and dragging layers of color. A trail of smoke was added by sponging out color when the painting was dry.

You will need

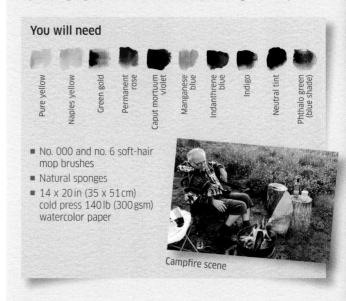

Pure yellow • Naples yellow • Green gold • Permanent rose • Caput mortuum violet • Manganese blue • Indanthrene blue • Indigo • Neutral tint • Phthalo green (blue shade)

- No. 000 and no. 6 soft-hair mop brushes
- Natural sponges
- 14 x 20 in (35 x 51 cm) cold press 140 lb (300 gsm) watercolor paper

Campfire scene

Tear pieces off a larger sponge for ease of use when stippling

1 Light first layers
Add the foreground grasses by dragging the sponge in short strokes, building layers of color. Stipple color for the background flowers and seed heads, building oranges, pinks, and copper browns.

2 Begin painting figure
Use different-sized brushes to paint the more detailed figure and the fire in the foreground, using wet-in-wet and wet-on-dry techniques to build up the layers.

3 Lift off dry color
Leave the painting to dry completely, then use a clean, damp sponge to gently rub the path of the smoke trail to diffuse and lift the color away. Be careful not to rub a hole!

4 Build texture
Drag and stipple with the sponge to build up the darker tones and shadows in the foliage and grass, creating more layers of texture and interest. Add any final details.

Correcting mistakes

REMOVING UNWANTED MARKS

Unwanted spills, bleeds, and runs can be hard to control and will dry to leave a stain. But making mistakes in watercolor needn't be the end of the world; by being prepared and ready to act quickly, you can rescue your work and repaint the area when dry. There are also methods for revising or removing more permanent marks, allowing you to correct your painting at a later stage.

REMOVING SPILLS

To avoid a spill or run bleeding or drying over other washes, act quickly to blot and remove the wet paint. Do not scrub, to avoid scuffing the paper surface.

You will need
- Paper towel
- Clean, damp brush

Paint run
Excess red wash has run across the dried light-green wash. You must respond instantly to prevent the run from drying with a hard edge. Always have paper towels on hand so that you can act swiftly.

Blot excess
Lightly dab on the spill with a small piece of paper towel to gently soak up the excess. Let the paper dry and continue painting. If a mark remains, rewet the area and remove it with either a damp brush or paper towel.

REMOVING BLEEDS

Watercolor can be difficult to control, and often colors will run into one another just where you don't want them. One solution is to remove the paint with a brush.

You will need
- Clean, damp brush

Definition of each apple is lost where the paint merges

Areas where paint has been removed can be repainted when dry

Merging colors
If you apply areas of wet watercolors too closely together, it is likely they'll bleed into one another, creating unwanted blends and color mixes. Here, the red and green washes have merged to create a brown.

Brush away bleed
Soften the area of the bleed by brushing it with a clean, damp brush to remove the excess paint. Leave to dry, then repaint, letting each area dry completely so that the colors don't bleed together again.

REMOVING DRY PAINT

Watercolor is water-soluble, which means most unwanted marks can be rewetted and lifted off the painting. You can also scrape off marks on thick paper.

You will need
- Natural or synthetic stiff-bristle brush
- Paper towel
- Sponge or Magic Watercolor Eraser
- Craft blade

Damp brush
Gently scrub the area with a damp bristle brush. Blot with a paper towel, rinse the brush, and repeat.

Sponge eraser
Lift or erase dry paint with a sponge or white "magic" eraser. Tear off a piece, wet, rinse, then "rub" off an error.

Craft blade
To remove a light stain left after blotting, let it dry then scrape away layers of paint with the edge of a blade.

PREVENTING RUNBACKS

A runback is an area that has dried with a feathery edge where washes have mingled. Working quickly will reduce the likelihood of runbacks happening.

You will need
- Paper towel
- Clean, damp soft brush

Causes of runbacks
Excess paint will seep back toward an area of drier paint, causing the washes to feather together.

Runback marks
Unintentional water marks known as runbacks, blooms, or cauliflowers, are left as the area dries.

Taking action
As soon as a runback appears, dab it with a soft brush or paper towel to lift off the excess paint.

SOLUTIONS FOR PERMANENT MISTAKES

Some pigments stain and won't allow you to lift out using the quick fixes above. Repainting is one option, either dark over light or using white gouache, or wash away to start again.

You will need
- White gouache
- Soft brush
- Tap or shower

Restoring highlights
Opaque white gouache can be applied over a dried wash to bring back lost highlights.

Color mixing
Mixing white gouache with transparent watercolor on the paper will cover mistakes.

Overworked piece
If painted on thick, heavy paper, an overworked piece can be washed away and repainted.

Washing off
Gently wash the color away with a brush under running water to leave a "ghost."

Artist **Julia Trickey**
Title **Fading Hydrangea Study**
Paper **11 x 17½in (28 x 45 cm) hot press**
300 lb (640 gsm) watercolor paper

Wet-on-dry
<< See pp.50–51
Pale green was painted over the whole of each petal, then left to dry completely, creating a background onto which subsequent colors were built.

Using masking fluid
>> See pp.100–101
Masking fluid was used for small flower stems and petal blemishes in order to lay down initial washes without having to work around these areas of precise detail.

Lifting out
<< See pp.82–83
To create the veins on the petals, a slightly damp brush was gently agitated along the path of each vein, then blotted using paper towel or a cloth.

Showcase painting

This stunning botanical illustration demonstrates how, with just a few core techniques, accomplished watercolorists can create incredibly detailed artworks. The subtlety and softness afforded by watercolor are ideal for capturing the imperfect beauty of nature.

Dry brush

« See pp.56–57

Using the tip of the brush to apply small amounts of concentrated paint is the easiest way to create fine detail, such as the veins on a leaf.

Wet-in-wet

« See pp.52–55

To add vibrant pink to the hydrangea petals, water was applied, then shades of pink and purple were dabbed into the wet areas and coaxed into place.

Tone

« See pp.66–67

Making use of the whole tonal range, from the palest areas to the darkest, such as those under the turns of the leaves, brings a painting to life.

Granulated wash

EFFECTS WITH GRAINY PIGMENT

When the pigments in your paint separate and clump together to create a speckled effect, this is called granulation. Choosing granulating colors for part or all of a painting can bring delicate textures, variety to washes, and overall interest.

▦ Experimenting with granulation

There are many ways to encourage granulation. Use a rough paper that will hold the pigments in the surface, working flat on wet paper where you want the granulation to occur. Use granulation medium for a more intense effect or mimic it with salt crystals (see pp.148-149). Mix pigments in a separated wash (see pp.92-93) to extend the effects.

PUTTING IT INTO PRACTICE

With a palette that comprises nearly all granulation pigments, mixes of grays and strong darks are used to convey the drama in this stormy view of Venice. Granulation medium is used for added texture in wet washes.

You will need

White gouache · Cinabrese · Raw sienna · Burnt sienna · Burnt umber

Caput mortuum violet · Cerulean blue · French ultramarine · Viridian

- No. 10, no. 3, and no. 2 soft-hair round brushes
- Granulation medium
- 19½ x 24 in (50 x 61 cm) cold press 200 lb (425 gsm) watercolor paper

Venetian sky

1 Foundation wash
Apply a pale wash of cerulean blue and raw sienna to tint the paper and provide a transparent foundation with subtle texture. Cover the whole paper.

Cerulean blue + Burnt sienna = Granulated sky mix

2 Granulated sky
Apply blue and brown granulating pigments to the wet paper, mixing some washes with granulation medium instead of water, and allowing them to blend.

Light red

Cerulean blue

French ultramarine

Violet with granulation medium

Natural and enhanced granulation

Wet paper helps naturally granulating pigments separate and settle, leaving a grainy effect when dry. Add granulation medium for similar effects in smooth washes, or to enhance naturally granulating pigments.

Suitable granulating pigments

Not all colors granulate, but the following pigments all produce natural granulation effects, either used alone or mixed together.

- Burnt sienna
- Burnt umber
- Cadmium red
- Cerulean blue
- Cinabrese
- Cobalt blue
- Cobalt violet
- French ultramarine

- Light red
- Pozzuoli earth
- Raw umber
- Rose madder genuine
- Terre verte
- Ultramarine violet
- Viridian

3 Architectural details

The buildings add a sense of scale and solid drama to contrast with the transient sky. Use dark mixes and granulated textures to make the facades stand out.

4 Final highlights

When the previous layers are dry, add finer details, such as the boats and stanchions, with a no. 2 brush and dark tints. Apply touches of thick white gouache at the end to give glittering highlights.

Separated wash

ENCOURAGING REACTIONS BETWEEN PIGMENTS

Properties of certain pigments react when mixed with others to create an effect known as a separated wash. The reactions vary, from a granulated texture to patterns caused by restricted bleeds. You can use these natural reactions to your advantage; they can be employed over large areas to create mottled effects for skies and water, or to suggest more detailed patterns such as animal markings or fabric designs.

Special effects

Knowing how certain colors behave (see Granulating, Repelling, and Separating Pigments p.247) can enhance your painting, creating natural effects that you may otherwise struggle to achieve. Some pigments react by blocking and pushing other colors away; others leave grains of intense pigment that add random texture.

Restricting spread
This mix of opaque Naples yellow and cadmium orange has completely restricted the spread of the Van Dyke brown. The stripes are perfect for animal markings.

Feathered bleeds
On a wet Indian yellow wash the cadmium red struggles to fully merge. Indian yellow likes to run away and bleed. The resulting effect is useful for flowers and sunsets.

Rough texture
Cerulean and raw umber are both very granulating and don't like to spread evenly. When mixed they naturally separate, resulting in a textural effect that is useful for painting rock.

PUTTING IT INTO PRACTICE

Here, the granulating effects of the burnt sienna and French ultramarine produce an interesting sky with depth. The blocking properties of Naples yellow allow the wing markings to blend naturally.

1 Granulated wash
Lay loose mixes of ultramarine and burnt sienna diagonally across the wetted paper to create a wet-in-wet background. Tilt the board at differing angles, so the colors merge naturally.

The opaque nature of Naples yellow stops the brown markings from flowing uncontrollably

2 Wet-in-wet glazes
When the background is dry, paint the owl with a wet-in-wet glaze of Naples yellow and raw sienna, taking the yellow out to the wing tips. Add the wing bars with a swift stroke in Van Dyke brown.

You will need

Naples yellow | Raw sienna | Burnt sienna | Van Dyke brown | French ultramarine

- No. 16 and no. 8 soft-hair round brushes
- 2 in (5 cm) hake brush
- 14¹/₂ x 20¹/₄ in (36 x 52 cm) cold press 140 lb (300 gsm) watercolor paper

Owl in flight

3 Face detail
Paint the eye, leaving a chink of paper unpainted for the highlight. Use the granulating properties of French ultramarine and burnt sienna with dry brushwork to add the feathered edge to the face.

4 Final shadows
Paint the shadow under the wings in a clear wash of ultramarine. Add Van Dyke brown to the blue wash to strengthen the shadow under the body and tail. Add splatter to the background for a sense of immediacy.

Softening edges

MAKING DECISIONS ABOUT EDGES

Any mark that is made by a brush has an edge, and it is the artist's choice what sort of edge that will be. Soft edges can be employed to suggest surfaces, indicate depth, and evoke atmosphere. Combining them with hard edges can help create focal areas and give a three-dimensional feel. Many subjects, including portraits (see right) and landscapes (see pp.96–97) benefit from the use of soft edges.

Manipulating the paint

The easiest way to soften edges in a watercolor is to brush clean water on the outer edge of the paint while it is still wet. This gives a fading-out effect, for example where a shadow meets a highlight. Alternatively, you can blend the paint before it dries, moving it gently with a brush, or lay wet areas of paint adjacent to each other so that the edges merge.

Wetting the edge
To achieve a gently fading soft edge, dip the brush in clean water and brush it over the edge before the paint has dried.

Blending when damp
With the first wash still damp, add a stronger mix so that the paint blends into the wash without losing its intensity.

Wet-in-wet edges
Tilt the paper enough to allow the paint to run downward. As it collects at the bottom of the paper, use a damp brush to soak up the paint so it avoids runbacks.

For this portrait of a sleeping child, the soft edges that are used not only convey the texture of hair, silk, and youthful skin, but they also suggest repose in peaceful surroundings.

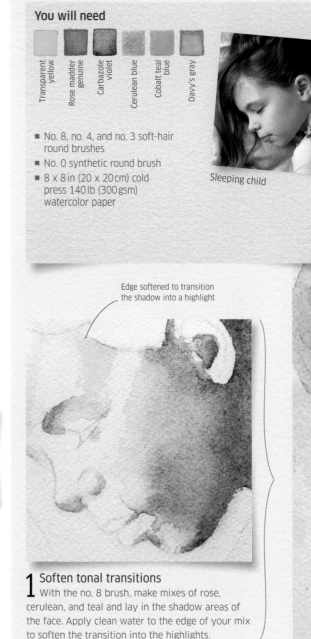

You will need

- Transparent yellow
- Rose madder genuine
- Carbazole violet
- Cerulean blue
- Cobalt teal blue
- Davy's gray

- No. 8, no. 4, and no. 3 soft-hair round brushes
- No. 0 synthetic round brush
- 8 x 8 in (20 x 20 cm) cold press 140 lb (300 gsm) watercolor paper

Sleeping child

Edge softened to transition the shadow into a highlight

1 Soften tonal transitions
With the no. 8 brush, make mixes of rose, cerulean, and teal and lay in the shadow areas of the face. Apply clean water to the edge of your mix to soften the transition into the highlights.

2 Soft edges for hair
With the same brush, mix violet and yellow for the eyelashes and hair. Apply it freely and confidently in pools on the paper. Use the no. 0 brush for the small areas such as the eyelashes. Paint the rose motif.

"Using mainly soft edges draws attention to the more defined features in a face."

3 Refine the ear
With the no. 0 brush, add small amounts of the violet mixed with rose and cerulean to create more strength in the shadows of the ear.

4 Strengthen the features
Use a violet and yellow mix for the shadows of nose and eyes. Mix rose and violet for the lips. Apply gray behind the shoulder.

5 The final touches
Apply a violet and yellow mix to darken sections of the hair. With the no. 0 brush, refine the features. To finish, mix rose and cerulean to emphasize the cheekbone.

ILLUSION AND MYSTERY

Softening edges creates an illusion of a scene rather than describing it, adding to the mystery of a painting. The most common occurrence in nature where edges are softened is reflections in water. Not surprisingly, watercolor is the best paint medium for capturing this quality. Keep your paper tilted at 45 degrees to allow the paint to flow.

You will need

Cadmium lemon Vermilion Prussian blue

Reflections in water

- No. 10 soft-hair mop brush
- No. 5 soft-hair round brush
- No. 10 synthetic flat brush
- Masking fluid and an old brush
- 11 x 15 in (28 x 38 cm) cold press 140 lb (300 gsm) watercolor paper

1 Mask out white areas

Roughly draw the outline of the floating weeds then, with an old brush, use masking fluid to highlight these areas. Remember to make the weeds larger toward the foreground to add a sense of perspective (see pp.26–27).

2 Soften sky reflections

After wetting the paper, wash in mixes of Prussian blue and vermilion with the mop brush, leaving patches of white and blue to reflect the sky above. This wet-in-wet wash technique softens the sky and gives the painting a sense of drama.

"Softened edges are perfect for evoking reflections in water, contrasted with crisp details."

3 Allow the paint to run
To add distant trees and other reflections, wet the paper, holding it almost vertical, and mix in the same colors to run downward. Touch up with a little of the lemon on the tree.

4 Soften the edges of ripples
While the paper is still a little wet, using a damp brush, slide across the reflections from left to right and over the untouched paper to give a soft edge to distant ripples.

5 Add crisp details for contrast
Remove the masking fluid when the paper is dry. Add the reeds and weed reflections with the no. 5 brush. Keep them crisp so they contrast with the softened background.

Splattering and spattering

USING SPOTS AND SPRAYS OF PAINT

Splattering and spattering techniques create interesting background textures, and can also represent gravel, sand, stonework, falling snow, and splashes of water or rain.

Splatter and spatter techniques

Loading a round brush and tapping the handle creates splatters, or large spots of paint. A toothbrush will create spatter, or small speckles. Spraying onto wet or dry paper produces different effects.

Spattering on dry paper
Pull the bristles of a toothbrush backward with your thumb to create a fine mist of paint.

Splattering on wet paper
Splatter or spatter on wet paper for a softer effect, using either a toothbrush or a paint brush.

Spatter with white gouache
Using a toothbrush, spatter white gouache onto a background wash to represent falling snow.

Splatter and spritz
Spritz areas of splattering with water from a spray bottle to give random diffuse effects.

PUTTING IT INTO PRACTICE

In this painting of Chinese lanterns, the background is tied in with the main subject by using sprays of paint in similar colors. They are more defined where the paper is dry and softer where it is still wet.

You will need

- Transparent pyrrol orange
- Aureolin
- Raw sienna
- Moonglow
- Burnt umber

- No. 8 soft-hair liner brush
- No. 1 soft-hair rigger brush
- Old toothbrush
- Paper towel or tissue
- 15 x 11 in (38 x 28 cm) rough 140 lb (300 gsm) watercolor paper

Chinese lanterns

1 First washes
Sketch the main lanterns. Mix four separate washes of orange, aureolin, moonglow, and sienna. Paint the central lanterns with dilute orange, varying with aureolin. Paint sienna in the background and allow the orange to run in. Add moonglow to the background top right, leaving the edges quite rough and ragged.

2 Add texture
Flick paint from your round brush into the wet background, or use a toothbrush if you prefer finer paint spots. Have some paper towel or tissue ready to blot if necessary. Keep adding more lanterns and background, progressing around the painting.

"Use **splatters and spatters** to suggest background textures."

3 Build up layers
Continue to build up the layers, ensuring that you maintain a balance of light and darker tones, and a mix of diffuse and defined edges. Allow the paper to dry before adding the final details.

4 Finalize details
Using the rigger and a stronger mixture of orange, paint some ribs on the lanterns. Spatter a bit more orange on dry paint for fine textures. Mix a small amount of umber with moonglow and paint some fine stems.

Using masking fluid

PRESERVING WHITE AND LIGHT AREAS

Also known as liquid frisket, masking fluid is a water-based medium used to repel paint and preserve white or light areas on the paper. This technique is useful for creating small or complex details that would be too difficult to paint around. Masking off can produce unusual effects that would be impossible to do by hand with just a brush.

▮ Working with masking fluid

You can paint freely with masking fluid, using it at the start to reserve the white paper beneath or to create highlights; or at later stages to preserve lighter colors when darker washes are laid on top. Always apply and remove the fluid when the paper is completely dry, to avoid damaging the surface.

Using a brush
A brush gives you control when applying the fluid, but because masking fluid can damage brushes, protect them by soaking first in a mix of one teaspoon liquid soap in a glass of water. Wash the brush immediately after use.

Removing masking fluid
When the paint is dry, blot any excess pigment on the masked areas to avoid transferring it to the white areas. Remove masking by rubbing with fingertips or an eraser for small areas, or with a stiff piece of cloth for large areas.

Here, masking fluid is used to create complex layers and lots of texture. The masking fluid was painted on not only to preserve the white but also to maintain the colors of several layered washes.

You will need

Carmine red · Indian red · Alizarin crimson · Burnt sienna · Phthalo turquoise · Prussian blue · Olive green

- ¾in (20mm) synthetic oval wash brush
- No. 12 and no. 6 synthetic round brushes
- Masking fluid (blue-colored), eraser, and paper towel
- 14 x 20in (35 x 51cm) cold press 140 lb (300 gsm) watercolor paper

Circular botanical arrangement

Masking fluid only

Blue-tinted masking fluid applied over watercolor

1 Paint masked shapes
Draw a circle in pencil and paint the shapes of loose flowers and leaves inside, varying wash strength from concentrated to transparent. When the layer is dry, paint over the shapes with masking fluid. Then, paint more flowers, shapes, and spatters using only masking fluid; these will be white in the finished painting.

The dark background builds from the combination of all the blue and green washes

Areas of light that were masked off in step 1 by painting with masking fluid

Masking the pink flowers protected them from the green and blue washes

Darker green leaves were masked off later in the process

2 Lightly wash with color
Once the fluid is dry, paint a light wash of blues and greens. When that layer is dry, paint another layer of masking fluid shapes.

3 Build up layers
Repeat step 2 for more layers of color and masking fluid to preserve the lighter colors. The washes can be more saturated each time.

4 Remove the masking fluid
When the paper is totally dry, blot off the masked areas then peel off the masking fluid; it is easiest to start with a corner.

Using wax resist

ALTERNATIVE HIGHLIGHTS

Wax crayons, candles, and oil pastels can all add elements of color and texture to your painting. Their water-resistant properties are useful for creating highlights over which you can paint uninterrupted washes.

■ Exploring wax effects

Watercolor and wax don't mix, so watercolor will only settle into the paper around your waxed marks. Unlike removable masking fluid, these marks are permanent and will become part of the painting. Experiment with different wax materials, from clear candle wax to crayons that give colored and textured marks.

Applying candle wax
Candle wax is clear and preserves the layers beneath. Apply it before your first wash to retain any whites. When dry, add more candle marks to preserve the color of your first wash under any subsequent washes applied freely on top.

Applying oil pastel
Use colored oil pastels or wax crayons to build textured and descriptive marks that will be visible through a transparent wash applied over the top.

Relief rubbing
Place lightweight paper over a textured surface, such as a plank of wood, and rub with the flat side of a candle. The texture will be visible through your wash.

To create an effect of animation, a loose drawing with wax crayons and oil pastels captures the vibrant pose. Melted wax combined with disjointed small washes completes the vitality of the image.

You will need

Cadmium yellow | Permanent rose | Cadmium red | Alizarin crimson | Cobalt blue | Phthalo blue | Indigo

- No. 10 soft-hair round brush
- Wax crayons or oil pastels
- Wax candle
- Parchment paper and an iron
- 15 x 10¼in (38 x 26cm) rough 140lb (300gsm) watercolor paper

Flamenco pose

1 Wax marks
Draw over a light supporting pencil sketch with oil pastels and crayons. Make loose, expressive marks with both the sharp tip and the flat edge of the pastel or crayon to vary the thickness of your colored strokes.

2 Fill color
Apply small areas of disjointed washes wet-on-dry, using the tip of your brush to add more description and movement. Keep marks loosely described, with some gaps to retain vitality.

Colored melted wax reflects the warm tones used on the figure

Melted white wax repels the final wash

> "Drawing with wax under a wash gives you freedom to be expressive and creative."

3 Wax shavings

When shaving oil pastels or wax crayons, keep the shavings to one side because they can be used to add texture and color. Scatter these wax or oil shavings around the edge of the figure.

4 Melt wax

Place a sheet of greaseproof paper over the top of the painting. Apply a warm iron over the parchment paper until the shavings melt beneath and spread a little, depending on how thickly you cluster the shavings.

5 Overpaint wax

Peel back the parchment paper and remove; your splattered wax will now be firmly fixed. Apply a final darker background wash to expose any white or colored wax you have melted. Paint loosely to keep the sense of animation.

Highlights

CREATING DRAMATIC LIGHT EFFECTS

When painting with watercolor, natural and dramatic light effects are usually best achieved by leaving areas of white paper untouched rather than adding white pigment. Working this way, light will reflect off the surface of the paper with greater luminosity. However, you can also use other techniques to create added light, texture, and movement.

■ Using white effectively

Painting around white space is the classic way of reserving the lightest areas you want in your painting, but you can also add highlights to areas where you have laid color in order to bring more life and interesting texture to your work. Additional flicks of white can suggest the sparkle of light and reflections.

Reserving white paper
Leaving some areas of paper unpainted is a classic technique. It works best where edges are fractured or faded to give a natural effect rather than a harsh, even line. Here, the background trees appear bleached by strong light.

Textural highlights
Scattering salt into wet paint gives small, diffuse highlights that are ideal for suggesting the play of light on the surface of water. A white watercolor pencil dipped in liquid white watercolor ground provides a brighter, defined highlight.

Watercolor pencil markings

PUTTING IT INTO PRACTICE

This painting has strong contrasts of tone between the dark land and the sea and sky, which are illuminated by the use of reserved white paper, added salt, and some touches of liquid white ground.

You will need

Titanium white watercolor ground Cadmium red Verditer blue Ivory black

- No. 20 soft-hair mop brush
- Medium swordliner brush
- White watercolor pencil
- Spray bottle
- Table salt
- 14 x 20 in (35 x 50 cm) rough 300 lb (640 gsm) watercolor paper

Porth Nanven beach, England

1 Apply the first color
Spray the paper all over with water, just enough to dampen it. Apply the blue loosely with a broad brush, leaving a larger area of white than you need, as the paint will spread.

2 Add dark and light
While the paint is wet, add some black. Dab with a damp paper towel to create softer effects, then make some quick strokes with fresh paper towel for bursts of light. Allow to dry.

3 Add the land shapes
Paint a strong mix of blue and red on the cliffs. Dilute the mix and paint the far coast. As the dark areas begin to dry, spray lightly with water to add texture and soften edges.

4 Light on the water
Paint a wash of mixed blue and black, lifting off the brush to leave white paper where the light hits. Sprinkles of salt added to the wet paint will add a textured light effect.

5 Add highlight details
Once the paint has dried, dip a watercolor pencil into undiluted titanium white ground to add a suggestion of spray and birds in flight. These touches will add depth and movement.

Artist **Chris Robinson**
Title **By the Thames at Old Isleworth**
Paper **15 x 22 in (38 x 56 cm) cold press
140 lb (300 gsm) watercolor paper**

Warm and cool colors

>> See pp.120–121

Cool blues and brown-grays
are the predominant colors,
offset only slightly by the
warm red tiled roof and
yellow morning light.

Negative spaces

>> See pp.114–115

The gap between the banks
of the river is an area of
visual interest and the
focal point of the painting,
allowing the viewer's gaze
to drift into the distance.

Graduated wash

<< See pp.72–73

The reflections in the water
are painted in a wash that
starts at the hard edge of
the quay; a spray bottle
can be used to help the
paint run down the paper.

Showcase painting

This moody, watery landscape combines a structured composition with loose, expressive techniques, capturing the dramatic interaction of nature and a semi-urban setting. Watercolor is the ideal medium to depict weightless clouds and glassy reflections in the river.

Softening edges

<< See pp.94–97

A damp flat brush was used to create the horizontal water lines here, creating a soft glow of light catching the surface of the water and adding life to the reflection.

Balanced composition

>> See pp.110–113

The buildings and quayside together create a strong L-shaped composition; the quayside is a third of the way up and a third of the way along the painting.

Spattering

<< See pp.98–99

Spattered paint provides a lively spontaneity; here, it adds texture to the quayside walls, and elsewhere creates the suggestion of trees and branches.

Repetition

COMPOSING WITH SHAPE AND COLOR

Repetition simply means to feature an element, shape, or color more than once. This simple yet powerful technique allows you to create visually interesting paintings, whether they're landscape, still life, or abstract. Repeatedly painting motifs also helps improve your brushwork.

▉ Adding subtle variations

Repeating a shape, for example fence poles in a landscape or a snowflake in a snow-themed pattern, is a good way to create harmony in a painting. Working with a limited palette also maintains cohesion. However, repeating exactly the same shape can look boring, so incorporate variations in size, color, orientation, and position. Making such small tweaks will bring a sense of visual rhythm to your piece.

Vary shape, size, and color
Paint just two or three different but connected shapes from the same theme, changing the size, shape, and orientation when repeating them around the page, and using a limited palette to create a cohesive whole. If you need more shades, mix the colors or adjust their strength.

For this repetition exercise, three main leaf shapes were painted in a limited palette of three colors. The leaves vary in size and position around the page, but the overall effect is one of unity and cohesion.

You will need

Phthalo turquoise | Olive green | Payne's gray

- No. 16 and no. 10 synthetic round brushes
- No. 6 synthetic rigger brush
- 21 x 14 in (54 x 35 cm) cold press 90 lb (190 gsm) watercolor paper

Pattern of leaves

1 First shape
Paint your first leaf shapes. Repeat and distribute this same shape around the paper two or three times with the same color, but lessen the opacity by adding more water to your pigment. You can also vary the size of your leaves.

Painted dots or lines can resemble leaves or flowers in the empty spaces between the leaves

"Varying the **shape, position,** or **color** of a motif can bring a sense of **movement** and **rhythm.**"

2 Second shape and color
Repeat step 1 but with a second leaf shape and a second color. Do change the orientation of the leaves each time.

3 Third shape and color
Repeat for a third leaf shape and a third color. To vary the scale, be sure to paint a big leaf here and there.

4 Fill the gaps
Continue filling your paper. Mix new shades as you go within the same palette; if more contrast is needed, add a drop of black.

Balanced composition

CREATING STRUCTURE AND SHAPE

Whether you are painting a landscape, figures (see p.112–113), or other subject, a good structural composition will engage the viewer. The "rule of thirds" (see right) is one classic technique. Another is to use alphabet letters, such as L, V, Z, C, T, and S, as compositional shapes. You do not need to paint objects to lead the eye—colors, tones, and individual shapes provide just as much interest.

USING V AND Z SHAPES

Your painting must have a background, a middle distance, and a foreground to succeed. To balance the composition, this painting relies on the strategy of using "V" and "Z" shapes.

You will need

Cadmium lemon · Raw sienna · Vermilion · Burnt umber · Prussian blue · French ultramarine

- No. 15 and no. 10 soft-hair mop brushes
- No. 10 stiff-bristle round brush
- No. 5 soft-hair round brush
- 22¹/₂ x 15 in (56 x 38 cm) cold press 140 lb (300 gsm) watercolor paper

Cumbrian hills, England

1 Initial sketch
For a valley amid steep mountains, a "V" structure is ideal. Also, a strong "Z" composition connects the foreground stream, the middle-distance rocks, and the background mountain.

2 Background wash
Dampen the paper with the no. 15 mop brush, leaving areas untouched. Mix Prussian blue, vermilion, and a little raw sienna to paint the sky and carry the wash over the ground. Add a touch of lemon for the valley in the wet wash.

Selecting your scene

Even a scenic landscape can struggle
to interest the viewer without a good
composition, whereas an apparently
mundane view can make an exciting
painting if the composition is strong. The
rule of thirds involves dividing a picture
into thirds and placing a focal point where
the thirds intersect. Finding other shapes
to lead the eye will help you arrive at a
scene that will engage the viewer's eye.

The rule of thirds
Make sure the scene has a focal point
for the eye to travel to, placing it at
the intersection of thirds rather than
in the center.

Connecting the shapes
Find a connection between the main
shapes. The simplest way here is to use
the stream, the distant road and the
mountains for a hidden "Z" shape.

3 Define the shapes
While the paint is still wet, lift out
the road and stream with a dry brush
to connect the white areas and form a
"Z" composition.

4 Strengthen shapes and tones
Paint the rocks wet-on-dry. Give the
middle and foreground a wet-in-wet
wash of ultramarine, lemon, and umber.

5 Balance the color
Add cloud shadows, wet-in-wet,
with umber, ultramarine, and lemon to
the upper part of the mountain on the
right to balance the composition.

USING AN S-SHAPED COMPOSITION

The compositional technique of following an "S" shape has been used in this painting to add intrigue and keep the viewer looking at the piece longer. This is a more interesting and dynamic way to arrange multiple figures than placing them all standing together. Here the figures, faces, and limbs create the shape.

You will need

Indian yellow · Yellow ocher · Quinacridone red · Venetian red · French vermilion · Ultramarine deep · Payne's gray

- No. 1 soft-hair mop brush
- No. 1 soft-hair round brush
- Sketchpad
- Masking fluid
- 11 x 15 in (28 x 38 cm) rough 300 lb (425 gsm) watercolor paper

Figures in harmony

Main "S" shape (pink) leads the eye round

Gaze of figures (yellow) reinforces "S" shape

Dark areas (blue) balance the composition

Filling the frame (green) grounds the composition

Limbs and dress folds (purple) point to "S" shape

1 Planning out the composition

Achieving the correct angles is crucial to the success of this flowing composition, so begin by making a drawing. Start with the "S" shape shown here, which will become the line around which you place your elements. Use the limbs of the figures to follow the sketched line as closely as possible while still being believable in their angle. Vary the heights of the figures so you can follow the shape. Next, map out the areas of darker tone.

Apply masking fluid in a thick layer to ensure that it can be removed easily

Vary the weight and size of the lines to flow down the fabric

2 Sketch and mask the highlights

Once you are confident about the composition, draw it on your watercolor paper. Using the wooden end of a paintbrush, apply masking fluid to the highlights of folds on the fabric and high points on the lighter figures.

> "A dynamic composition can be both simple and powerful if the forms and angles work well."

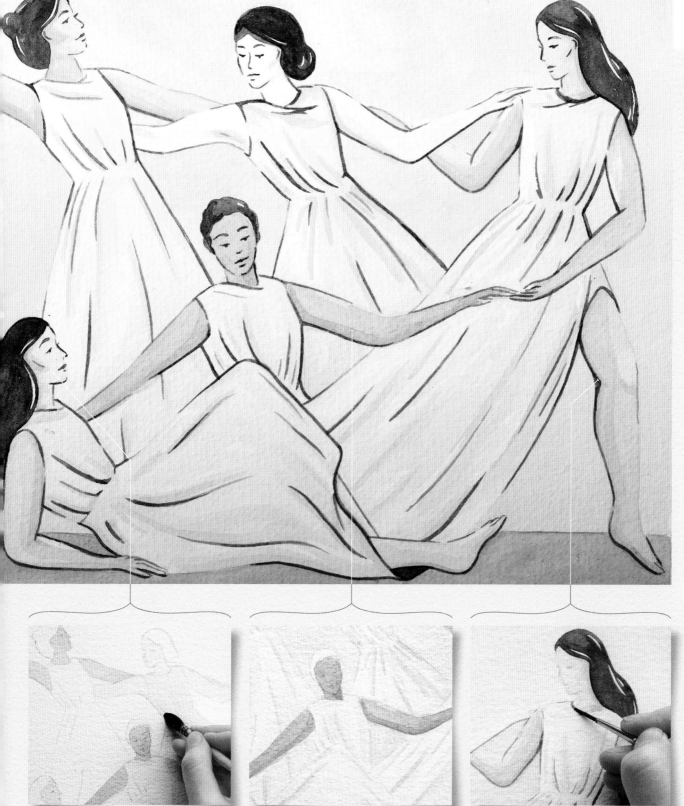

3 **The first skin tones**
Using the mop brush, mix very dilute skin tones and apply in flat layers. Allow the washes to dry completely before painting adjoining areas.

4 **Deeper tones and shadows**
Work from the lightest remaining tone, in this case the background, to the darkest. For shadows on the figures, overlay the same light skin tone used in the previous step.

5 **Darker details**
Make a thicker mix of the darkest tone using blue and gray and apply with the round brush, using as few strokes as possible. Finally, remove the masking fluid.

Negative spaces

DEFINING THE SHAPES IN BETWEEN

The areas that create voids inside a subject, or around the outside of a shape or "positive" form, are called negative spaces. In a landscape this could be the sky behind a wood, or the gaps between the trees. By following the shape of the negative, sometimes seen as a silhouette, you will define the shape of the positive form.

■ Looking for the negative

Negative spaces can be dark or light. To find a negative, concentrate on observing the space around or in between solid objects. Observe differences in tone to define either a light solid against a dark space, or dark solids in a light space. For some subjects, try viewing your subject as a silhouette to help find the solid form.

Tonal differences
It can be useful to see the negative spaces in and around an object as an aid to drawing a complicated shape. Here, the dark spaces in between the fence posts recede, which brings the light fence forward and clarifies the solid structure.

Silhouetted shapes
Look at the shapes around an object or in the voids between shapes. These can be found in skies in landscapes or the backdrops to a still life or figure study, where the empty space creates a silhouette that defines the solid form.

The light sky behind the buildings creates a silhouetted skyline

In this painting, the negative spaces help define the character of the classical architecture and its features. The spaces around and between the solid objects are all negatives that bring a sense of depth to the composition.

1 Preliminary drawing
The strong shadows in this location sketch help articulate the architecture and can be used as a guide for defining the negative shapes. Plot outlines of the building to organize the proportions.

2 Paint silhouettes
First, apply the pale color of the building and foreground, with a few touches of cerulean blue wet-in-wet. Next, paint the sky around the silhouette of the buildings.

You will need

- Cadmium orange
- Yellow ocher
- Light red
- Burnt sienna
- Raw umber
- Opera rose
- Cobalt violet
- Ultramarine violet
- French ultramarine
- Cobalt blue
- Cerulean blue
- Phthalo blue
- Indigo
- Neutral tint

- No. 10 and no. 3 soft-hair round brushes
- 20 x 22½ in (50 x 56 cm) cold press 300 lb (425 gsm) watercolor paper

Town Hall, Liverpool

3 Define shadowed spaces

Use a cool blue to add the main shadows between the columns, the spaces between the balustrades, and the ones inside the arches. These negative spaces will clarify the structure of the building.

4 Structural details

There can be more than one layer of negative space; the windows between the columns are also negatives. Add the darker details within the architecture with a no. 3 brush to ensure the shapes are not flooded.

Analogous colors

USING COLORS THAT HARMONIZE

Analogous colors are those that sit next to each other on the color wheel (see below). When used together, they create a calm and harmonious feeling. They can also be used to bring life into a solid color by varying the color as you paint.

◼ Harmony and interest

While complementary colors placed adjacent to each other appear brighter (see pp.118–119), analogous colors are more subtle and harmonious. They are ideal when you want to add interest to an area of color without introducing bold, clashing effects.

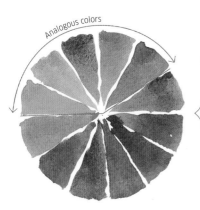

Analogous colors

Adjacent colors
The color wheel is arranged in terms of analogous colors— for example, green is analogous with blue and yellow. Choose a sequence of up to five colors to create a harmonious scheme.

Single color
If you mix just one green and use it to paint a leaf the effect can be rather flat and dull.

Analogous colors
A leaf painted with some added yellow and blue has more variety and therefore looks more lively.

This painting of pansies uses a set of colors analogous with purple, so they range from crimson through purple to blue. The bright yellow centers of the flowers provide small splashes of contrast.

1 Establish a focal point
Draw two or three pansy flowers. Mix several pink, purple, and blue colors. Start with the central flower, painting the center and two top petals but leaving the others as mainly white paper to act as a focal point.

2 Build up the colors
Keep adding more flowers, allowing the colors to overlap and run into each other, but leaving the paper dry for the yellow centers. Paint these in with crisper edges.

You will need

Aureolin | Permanent rose | Dioxazine violet | French ultramarine | Neutral tint

- No. 8 soft-hair reservoir liner brush
- 15 x 11 in (38 x 28 cm) rough 140 lb (300 gsm) watercolor paper

Sketch of pansies

"Analogous colors are harmonious and provide subtle effects."

3 Darker centers

Put in the dark markings as the paint dries, painting with a strong mix of neutral tint. Use water to blur the edges of the petals into the background to keep a loose, painterly style.

4 Work into the background

Keep adding more flowers, leaving some unfinished. Use the analogous colors in the background, fading out with water to soften edges (see pp.94–97).

Complementary colors

USING CONTRASTING COLOR FOR VISUAL EFFECT

Complementary colors lie opposite each other on the color wheel. They are naturally contrasting colors that enhance each other. By choosing a limited palette of complementaries, you can exploit this visual relationship as a key part of your composition, especially in subjects that include light and shade. They can bring balance to a painting, especially when used as transparent washes.

■ Complementary options

Artists can use complementary colors in various ways to visually change the perception of an image. Placing them side by side enhances their vibrancy. You can exploit this effect either in details, or as the basis of your composition in a palette built on one or two pairs. Mixing complementary colors to create a range of neutrals is an advanced way to unify a painting. Consider color bias (see p.34), too, to extend your options and keep your painting lively.

PUTTING IT INTO PRACTICE

To recreate the glowing golden light and cool shadows of an Italian evening, a limited palette of yellow and orange was used with complementary purples and blues, mixed to make spectral grays.

Matera, Italy

You will need

Indian yellow | Cadmium orange | Light red | Burnt sienna | Cobalt violet | Ultramarine violet | French ultramarine | Cobalt blue

- No. 10 and no. 2 soft-hair round brushes
- 19 x 20 in (48 x 51 cm) cold press 140 lb (300 gsm) watercolor paper

"Create a range of neutrals from complementary pairs to unify your painting."

1 Complementary washes
Paint a blue sky wash next to orange, to make the orange stronger and create the impression of light and warmth.

Aerial perspective (see pp.122–123) is enhanced by using cooler colors in the background shadows

Complementary pairs

The colors that lie opposite each other on the color wheel (see p.32) are complementary: red with green, orange with blue, and yellow with purple. Consider using pairs to give your painting visual excitement.

Visual effect

Using complementary colors together, either juxtaposed or in an optical mix, will enhance their effect, throwing the colors forward. Using complementary pairs in your composition, adding one color against the other, will draw attention. Take care to balance their use as the visual effect can be jarring.

Mixing neutrals

Create warm, cool, and colored grays by mixing complementaries in different ratios, ensuring the neutrals vary in temperature and give a strong enough dark.

Alizarin + Viridian = Dark neutrals

Color bias pairs

Paint pigments often have an undertone with a warm or cool bias. To ensure a broad range of mixes, include both warm and cool complementary pairs in your palette.

COOL — Carmine Red, Phthalo Green
WARM — Cadmium red, Sap green

A bright green was used for the window shutters as a contrast to the complementary palette

2 Warm shadows

When the first layer is dry, block in the architecture with pale tones of mixed grays using complementary colors. Yellow and purple give neutrals with a warm color temperature (see p.34) that reflect sunlit shadows.

Indian yellow + Ultramarine violet = Warm neutrals

3 Cooler tones

For the areas furthest away from the light or in deep shadow, use a mix with a cooler feel, creating blue-toned neutrals from orange and blue.

Cadmium orange + French ultramarine = Cool neutrals

Warm and cool colors

USING COLOR FOR HARMONY OR CONTRAST

The colors in your paint palette can be divided in many ways, and color temperature is one that you can use to influence a composition. Warm and cool colors have properties that work individually, or influence each other when combined, and how you use them can create harmony or discord. Understanding these properties, and how to balance or combine them, will help you create compositions that are visually stimulating and engaging.

PUTTING IT INTO PRACTICE

These examples are a valuable exercise to help you understand the visual effects of color, using fluid watercolor mixes to explain how our perception of the same image changes according to color temperature.

Contrasts add energy

Analogous colors
(see pp.116–117) work together

Cobalt violet

Ultramarine

Aqua green

Turquoise blue
(liquid watercolor)

Cobalt turquoise
light

Cobalt green

Pastel green
(liquid watercolor)

Lemon yellow

Gold ocher
(liquid watercolor)

Transparent
orange

Crimson red

Opera rose

Perylene violet

Cool color scheme
A composition using only cool colors is gentle on the eye and will convey a sense of tranquility, serenity, and coldness. Although these colors work well together, the image is flat and subdued, and lacks focus. A painting using only cool colors will struggle to hold your attention.

Warm color scheme
Choose a predominantly warm palette to stimulate sensations of warmth, tension, and energy. These colors can be intense and overly saturated, creating vibrations at a visual level, which may suit particular subjects, but these same effects may create disharmony in a color scheme.

■ Perceiving temperature

We associate certain colors with perceived temperature, and it is relatively simple to use these qualities to influence the feel of a painting. The predominant colors in your palette will give your work either a warm or cool atmosphere, for example using blues for a snowy scene.

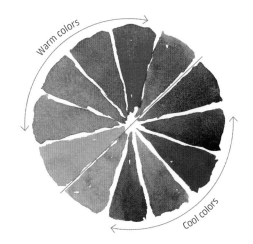

Warm colors

Cool colors

Warm and cool color wheel

We associate warmth with the yellow-orange-red half of the color wheel, and the green-blue-purple half is seen to be cool. Bear in mind that paint colors also have a temperature bias (see p.34), with cool reds and warm blues, to extend your mixes.

You will need

| Watercolor | Lemon yellow | Transparent orange | Crimson red | Opera rose | Perylene violet | Cobalt violet | Ultramarine | Aqua green | Cobalt turquoise light | Cobalt green | Viridian | Liquid watercolor | Gold ocher | Turquoise blue | Pastel green |

- Liquid watercolors
- No. 5, no. 1, and no. 0 synthetic round brushes
- 12 x 8in (30 x 20cm) cold press 140lb (300gsm) watercolor paper

Floral design

Transparent orange

Opera rose

Ultramarine

Aqua green

Turquoise blue (liquid watercolor)

Cobalt turquoise light

Cobalt green

Pastel green (liquid watercolor)

Gold ocher (liquid watercolor)

Transparent orange

Opera rose

Ultramarine

Aqua green

Turquoise blue (liquid watercolor)

Cobalt turquoise light

Viridian

Contrasting color scheme

To highlight one or more elements in a composition, exploit the visual effect that cool colors recede and warm colors advance. Using a warm or complementary color against a cool color scheme, immediately creates a focal point, adding depth to the flower.

Balanced color scheme

Using tones from both the warm and cool sides of the color wheel will create a balanced composition in which each element will stand out and complement each other. Choose three or four colors from each side to achieve harmony, using them equally across the image.

Aerial perspective

THE ILLUSION OF DISTANCE

To create depth on the flat paper surface, artists can simulate the natural effects of the atmosphere—known as aerial perspective—on objects as they recede into the distance. For realistic landscapes, observe how objects lose color, tone, definition, and detail in the distance.

▦ Contrasts of color and tone

Divide the landscape into back, mid, and foreground. As objects recede in the background, note that their color leans toward cooler blue or gray, with mid tones in the middle ground, and warm, strong tones in the foreground. When painting, you may need to exaggerate this natural effect with glazes or deeper mixes.

PUTTING IT INTO PRACTICE

Here, the atmospheric effect of the distant mountain has been exaggerated by adjusting the warmth and coolness of the landscape colors, changing what you see to reflect the mood.

You will need

White gouache | Azo yellow | Cadmium yellow | Burnt sienna | Quinacridone magenta

Cadmium red | Phthalo blue (green shade) | French ultramarine

- No. 10 soft-hair mop brush
- No. 14 and no. 6 soft-hair round brushes
- ¼ in (6 mm) swordliner brush
- 10 x 14 in (25 x 35 cm) cold press 140 lb (300 gsm) watercolor paper

Distant mountain

1 Cool and warm washes
Paint a background wash from top to bottom, starting with a cool blue mix of phthalo blue with a touch of quinacridone magenta at the top, and a warm ocher color mixed from quinacridone magenta and yellow at the bottom.

2 Enhance distant contrasts
Exaggerate and push the mountain further back using richer, cool tones from French ultramarine with a little quinacridone magenta and yellow. Add more yellow to the distant trees to bring them forward.

Minimal contrast
If the background, middle, and foreground are painted in the same tonal value, the landscape appears flat, with no illusion of depth.

Strong contrast
A more natural approach uses warm colors and stronger tones in the foreground with cooler, weaker tones in the background.

Emphasizing the contrast
If your painting still lacks depth, enhance the contrasts with glazes: a cool blue over the background and warm yellow coming forward.

Tonal variation increases toward the foreground

3 Warm mixes
Add warmer Indian yellow to mixes with plenty of pigment to make a warmer, strong green that brings the middle ground forward. A touch of red for the barn will enhance the effect.

4 Foreground detail
For the foreground, use a variety of color and tone and add almost all the detail, which brings this area forward; resist putting detail in the background. Mix a little white gouache with red and yellow to add a few light highlights.

Glazing

APPLYING TRANSPARENT LAYERS

This useful technique simply involves laying one thin wash, or glaze, of color over another dry layer of paint, either to build colors from light to dark, or to interact with the underlying color to create a color mix or alter color temperature. Use transparent glazes to adjust large areas of tone across a landscape, or over small pockets of local color.

▉ Altering layers

Before applying a glaze, consider its effect on the dried wash underneath, and how that will modify the feel of your painting. A glaze can be used to enhance aerial perspective; a cool glaze helps a background recede, whereas a warm glaze makes it advance. Use glazes to modify shadows or add color to a monochrome sketch.

Modifying color
Change the underlying color with a transparent glaze in a different hue to create optical mixes, such as purple where red and blue meet, or orange where yellow and red cross. You can also use warm or cool glazes to alter color temperature.

Blue is warmed by red glaze

Modifying tone
Build tones from light to dark by layering thin glazes on top of each other. The subtle effect can be used over a large area, such as a sea or sky, and will give a light, transparent feel with modulations of tone.

Glaze layers build darker tone

PUTTING IT INTO PRACTICE

The calm, peaceful mood of this scene is conveyed in a few stages, taking note of the three main areas of light, mid, and dark tone. Glazing is used to add depth to the water and to warm the foreground.

You will need

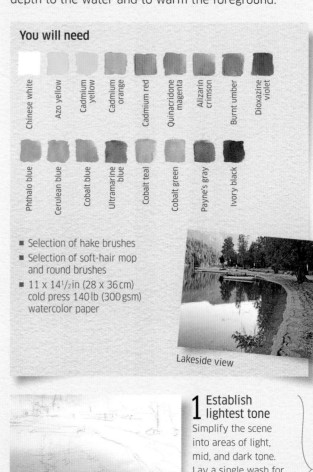

Chinese white · Azo yellow · Cadmium yellow · Cadmium orange · Cadmium red · Quinacridone magenta · Alizarin crimson · Burnt umber · Dioxazine violet

Phthalo blue · Cerulean blue · Cobalt blue · Ultramarine blue · Cobalt teal · Cobalt green · Payne's gray · Ivory black

- Selection of hake brushes
- Selection of soft-hair mop and round brushes
- 11 x 14½ in (28 x 36 cm) cold press 140 lb (300 gsm) watercolor paper

Lakeside view

1 Establish lightest tone
Simplify the scene into areas of light, mid, and dark tone. Lay a single wash for the lightest areas of the distant mountains, becoming slightly darker toward the foreground water.

2 Medium tones
The lit green mountain and the shoreline are part of the medium value, so work on these at the same time to make sure that the tonal relationship with the water and distant mountains is correct.

3 Assess the tones

After blocking in the dark trees and the water reflections, assess your painting. Here, the foreground shoreline needs to be warmer and the near water needs to be darker.

4 Darker glaze

Glazing is the simplest way to modify these areas. Apply a deeper blue glaze to darken the foreground water, taking the glaze over the shadow areas to unite each element.

5 Warm glaze

To help the foreground advance, apply a warm orange glaze over the base blue and add a light magenta glaze over the trees to warm the middle ground against the cool sky.

Artist **Eleanor Hardiman**
Title **In the Grass**
Paper **22 x 30 in (56 x 76 cm) cold press**
200 lb (425 gsm) watercolor paper

Layering paint

≪ See pp.58–61

Oval shapes in paint of a light consistency have been layered over one another to create a scalelike texture. Using golden hues gives the impression of warm light.

Using masking fluid

≪ See pp.100–101

The handle of a paintbrush was used to apply masking fluid in a thick enough layer to ensure a uniform, crisp-edged shape was left at each white highlight.

Repetition

≪ See pp.108–109

Repeating shapes and colors gives the painting a graphic look, while quieter areas of block tone in the background contrast with the detailed pattern on the snake.

Intermediate | **Techniques**

Showcase painting

A limited but satisfyingly complementary color palette, enticing composition, and use of bold repeated shapes allow this illustration to uncoil from the page with a pleasing sense of harmony. Clean lines and interesting color combinations add to the graphic, characterful style.

Flat wash

« See pp.70–71

Making sure there is plenty of the chosen color in the palette, and applying it in one fluid movement using a mop brush, helps create a smooth, flat wash.

Balanced composition

« See pp.110–113

The curving body of the snake creates an interesting variation on an S-shaped composition, which keeps the viewer's eye moving around the page.

Complementary colors

« See pp.118–119

Yellow and purple are from opposite sides of the color wheel. When paired on paper so they touch and interact, they enhance each other.

Working in monochrome

FOCUSING ON TONAL VALUES

The structure of a painting is based on tone, or value, not color. It is important to understand the difference between the two. Color refers only to the hue, but tone is the lightness or darkness of that hue (see also pp.32–33). By painting in one color and concentrating on tone, you will be able to produce simple interpretations of even the most difficult subjects.

PUTTING IT INTO PRACTICE

If working in monochrome, a colorful subject forces you to think tonally. Here, the scene is reduced to three base values: lights are left as white paper, mid tones are reduced to one wash and darks are built up on top.

1 Mid-tone base
Merge light tones together and render the whole subject with a light, mid-tone wash, except for the lightest lights left as white paper. Forget color—look for light and dark only, to define the structure.

You will need

Neutral tint

- No. 14 and no. 6 soft-hair round brushes
- 10 x 14 in (25 x 35 cm) cold press 140 lb (300 gsm) watercolor paper

Beach on the Amalfi coast, Italy

2 Selective second wash
With a second, darker mid-tone wash, cover everything except for the lightest lights and the mid tones from the first wash. Converting color to monochrome makes you see the importance of strong tonal shapes rather than detail.

■ Converting color to tone

To assess tones, convert color into value, or gray scale; light, mid, and dark. Paint your subject in one color, using a paint that is naturally dark, such as neutral tint, black, sepia, or indigo. Start with a mid-tone wash, leaving the white of the paper for the lights. Don't differentiate between the lightest tones, even if they are different colors; allow them to merge together. Mix a darker wash for the stronger colors and details.

Little tonal contrast
If you think only in color you could end up with a flat and uninteresting image. Convert the subject to gray scale (right), and everything merges into one.

Stronger tonal contrast
By also thinking of the tone of colors, you will produce something where the structure can still be clearly seen when converted to gray scale (right).

Don't differentiate between the lightest tones of different colors; allow all of them to merge together

3 Reinforce darker areas
With the third wash, cover only those darker-toned areas. You will find areas where you are itching to use color, but resist and enjoy the process.

4 Intense darks
Dilute the paint with very little water to create the darkest darks for the final details that pull the painting together.

Monochrome emphasizes the need to reserve the light areas from the earlier stages

Simplifying figures

USING SIMPLE SHAPES

Tackling the drawing of figures can seem intimidating, but in fact they can be broken down into simple shapes to create convincing human beings in a contemporary graphic style. By using flowing lines, a stylized figure can be drawn that still remains believable.

■ Drawing the essentials

This technique can be used when drawing from life, from a reference, or even from the imagination. It uses lines running through the center of the body to make the figure flow convincingly. The figure is drawn in sections, starting with the torso. Reducing the complex human form to simple graphic shapes makes figures easier to draw in any position. Once the shapes are determined, the form is drawn over with darker lines.

The initial lines
Sketch a line, imagining it going through the center of the body from the neck to the hips. Draw the torso as a simple oblong shape.

Adding the limbs
Next, add curved hips and render the legs and arms as simple shapes, splitting the legs into two parts, above and below the knee.

The head and neck
Add the neck and an egg shape for the head. Draw a central line between the eyes and down the nose. Base the features on this central point.

This stylized watercolor is painted from the palest tone to the darkest detail color, using light and medium washes that are layered to create blocks of shadows and a graphic style.

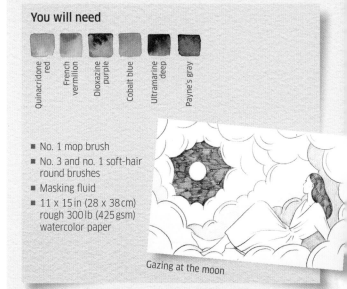

You will need

Quinacridone red
French vermilion
Dioxazine purple
Cobalt blue
Ultramarine deep
Payne's gray

- No. 1 mop brush
- No. 3 and no. 1 soft-hair round brushes
- Masking fluid
- 11 x 15 in (28 x 38 cm) rough 300 lb (425 gsm) watercolor paper

Gazing at the moon

1 Sketching and masking
Using the reference sketch, lightly draw the composition. With the end of a paintbrush, apply masking fluid in the areas that are to remain white. When it is dry, mix plenty of very dilute color and paint in the lightest tone using a mop brush. Try to paint these areas at one time to keep the color as flat as possible. Mix the reds together for the skin tones.

2 Building up tones
Once the first layer is dry, paint shadows on it in the same color. The moon is the light source, so follow the direction of the light. You should now have two tones.

3 Painting the negative shape
Mix a darker blue wash and paint around the figure in a flat layer. Repeat the areas of the first wash with the darker wash and paint flowing cloud shapes.

4 Add detail with the darkest tone
Mix the darkest tone and, using a round brush and small strokes, paint details such as the face, hair, sky, and edges of some of the clouds. Finally, remove the masking fluid.

Simplifying a scene

ELIMINATING DETAILS

Townscapes can tempt the watercolor artist to overcomplicate a scene and lose the freshness of the medium. Instead, look for a few main shapes and lines that direct the eye. Use tonal contrasts that emphasize the shapes and make them three-dimensional without the need to add explanatory detail.

◼ Using washes for effect

Limiting the number of washes you apply can simplify shapes by creating impressions rather than more realistic representations. Blending colors helps link shapes and also allows you to create the illusion of depth by using color temperature.

Using fewer washes
On the left, the window has been given seven washes, each pane carefully painted. On the right it is loosely painted with just two washes, the glazing bars painted over the first one.

Blending colors
Keep a limited palette and control the tone by strengthening the colors toward the foreground. Blending colors from cool to warm creates depth without requiring detail. Ideally use one wash, painting from background to foreground.

Background (light wash) cool colors

Middle distance (medium wash) mid-temperature colors

Foreground (heavy wash) warm colors

PUTTING IT INTO PRACTICE

This is a subject that has strong tonal shapes, few colors, and a sense of depth, with shadows masking a host of complicated details. Avoid using small brushes as they create a temptation to fiddle.

You will need

Raw sienna | Light red | Burnt umber | Cobalt blue | French ultramarine

- No. 10 soft-hair mop brush
- No. 10 synthetic and no. 5 soft-hair round brushes
- 15 x 11 in (38 x 28 cm) cold press 140 lb (300 gsm) watercolor paper

Dinan, France

Broken rooflines add unnecessary detail

No path to lead the eye in

Strong shapes make a focal point

Overly complex drawing

The background is simplified

Deep shadows give depth

Simplified drawing

1 Identifying key shapes and tones
It helps to draw the scene from different angles first. In the top drawing there are too many fussy details and no deep shadows to give distance. The view above is simpler, with depth and strong shadows, and captures the essence of the timber-framed houses.

2 Putting in the palest tones
Draw a rough outline of the positions of the buildings and add a general wash of cobalt blue. Add light red and raw sienna over the lower part of the paper.

3 Emphasizing the main shapes
As the paint starts to dry, tilt the paper to 45 degrees and, with the mop brush, add a second wash of burnt umber and French ultramarine over the two main buildings.

4 Picking out details
With the synthetic brush, paint over the pencil marks. Strengthen deep shadows with a stiffer mix of the same colors. Add figures and the timber frames with the no. 5 brush.

Linear perspective

DEPICTING DISTANCE AND THREE-DIMENSIONAL SPACE

A sense of perspective is one of the tools that an artist can use to give a drawing or painting depth and substance. These examples explain linear perspective, a concept most often found in landscapes where it is used to show how objects diminish in size into the distance. These principles can also be applied to other subject matter, from still lifes to life studies.

▨ One-point perspective

The simplest form is one-point perspective. Here all lines of perspective vanish to one focal point positioned on the horizon line. Parallel lines above the horizon will slope down to meet it, and those below will slope up, getting closer together toward the vanishing point.

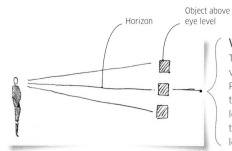

Horizon

Object above eye level

Viewpoint
The horizon is the viewer's eye level. Place objects above the horizon to imply looking up, or below the horizon to imply looking down.

Single vanishing point

Elements of perspective
When planning a painting with one-point perspective, note how objects seen face on remain flat, but the parallel lines of buildings and the road follow the slant of linear perspective, getting closer as they approach the horizon until they meet at a single vanishing point. Objects placed following these lines become smaller toward the vanishing point.

Horizon line

Applying perspective
The horizon represents the eye level of the artist or viewer and helps position the different elements that convey perspective. The parallel lines, such as the sides of the road, converge at the vanishing point on the horizon. Placing a focal point here, such as the church, adds to a sense of depth.

Horizon line

Focal point

Shadow in perspective

Vanishing point · Objects decrease in size · Horizon line

Elevated viewpoint
This scene is viewed from a high viewpoint with most objects placed below the horizon. An off-center vanishing point is reflected in different perspective lines, with shorter lines on the left. The high viewpoint means most lines slope up, with only the rooflines above the horizon sloping down.

Vanishing point · Distant telegraph pole · Horizon line

High horizon
In the finished painting, the high horizon is placed about one-third down from the top of the painting, following the composition principle known as the "rule of thirds" (see p.27). The extended foreground uses perspective to draw the viewer's eye into the distance. The telegraph poles enhance the sense of depth as they decrease in size, following the sloping parallel lines to accurately portray distance.

■ Two-point perspective
A less confined composition often includes objects seen from an angle to all surfaces, where both sides are distorted by perspective. The surfaces (usually perpendicular to each other) will diverge to two different vanishing points.

Two vanishing points
When painting objects with surfaces perpendicular to each other, ensure the lines of perspective vanish to two distant points, both on the same horizon line.

Horizon line

Vanishing point

Vanishing point

Relative size
Vertical lines defining the height of objects, such as the telegraph poles and fence posts, should reflect their relative size correctly as they diminish. Including figures with their eye level on the horizon will help judge scale correctly.

Smaller, distant figure is placed on the same eye level on the horizon line

As this group of buildings are viewed from an angle, two-point perspective is used to render them accurately in the setting. The receding river, riverbank, and fence posts all converge in the distance toward a vanishing point just behind the tree, leading your eye through the scene. The sides of the buildings in shadow follow perspective lines to a second vanishing point on the left.

You will need

Yellow ocher	Burnt sienna	Burnt umber	Ultramarine blue	Sap green

- No. 18, no. 12, and no. 8 soft-hair round brushes
- No. 4 and no. 2 stiff-bristle fan brushes
- 12½ x 21½ in (32 x 55 cm) hot-pressed watercolor paper 140 lb (300 gsm)

Riverside scene

> "Linear perspective aids a composition by drawing the eye toward a focal point."

1 Sketch perspective lines
Draw perspective lines over a light pencil sketch. Follow the lines from two focal points, adding in the roof, window, and wall surface lines along with vertical lines, such as poles and posts.

2 Establish base washes
When the underdrawing is complete, erase the perspective lines. Apply basic washes to the sky and water first then add initial colors to the main surfaces, using a warm palette.

3 Suggest movement
Work on the river, using a fan brush to add surface movement to the water. Washes on the distant buildings give them depth and emphasize the flat face of the church.

4 Layer tones
Add stronger tones to all surfaces with a round brush. Using darker tones on the shadowed sides of the buildings will enhance the perspective and three-dimensional effect.

5 Foreground detail
Build the foreground details where the converging lines of the path and diminishing fence posts lead to the vanishing point hidden behind the trees.

Shadows and sunlight

CREATING A SENSE OF LIGHT

Sunshine in a painting is only obvious when there are shadows. Avoid subjects that are either totally in shade or with the sun behind you. Instead, look for a balance of light and cast shadow that translates into highlights and soft tones on paper.

■ Suggesting realistic shadows

Shadows are not random shapes and colors. For a convincing cast shadow, note how its length and direction is determined by the position of the sun. Realistic shadows needn't always be based on local color; unify multiple shadows with a single wash.

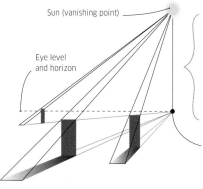

Sun (vanishing point)

Eye level and horizon

Shadow direction
Shadows have a vanishing point on the horizon and in the sun. To calculate shadow length, draw a line from the sun across the top of the object until it intersects the shadow.

Vanishing point of shadow directly below sun

Without shadow wash

Shadows added in gray wash

Shadow wash
The transparency of watercolor means you can create the look of shadows with a single, gray shadow wash. This darkens the underlying wash and avoids the need to mix dark versions of each color.

Here, sunlight from the right creates rims of light on the backlit figures, with subdued and softened edges in the muted background, unified with a shadow wash. Cast shadows bring sunshine to the foreground.

You will need

White gouache | Indian yellow | Burnt sienna | Quinacridone magenta | Cadmium red | Phthalo blue (green shade) | French ultramarine

- No. 14 and no. 6 soft-hair round brushes
- 10 x 14 in (25 x 35 cm) cold press 140 lb (300 gsm) watercolor paper

Crowds in a piazza

Soft hues establish shaded buildings

Drop color into the wet wash to suggest figures merging in the crowd

1 Subdued tones
Cover the paper with a warm wash and paint the main shapes. Backlighting has the effect of blending everything in subdued color, so paint the background in a gray wash of French ultramarine and burnt sienna.

2 Add shadow wash
Add a shadow wash of ultramarine and cadmium red over the buildings and figures. Keep the wash as transparent as possible so that underlying colors are visible.

3 Cast shadows
Use the shadow wash for cast shadows, checking their length and direction, but don't worry too much about precise shapes. Keep edges soft; don't let them dry as you paint.

4 Final contrasts
With the no. 6 brush, add the deep darks with a strong shadow mix, using white gouache to add some highlights to the right edges of the figures, where the sun hits.

Focal points

DIRECTING THE VIEWER'S EYE

The focal point is the center of interest in a painting. Your chosen focal point should not be too difficult to paint, and its position should clearly tell the story of the scene. Once you have chosen your focal point, don't be tempted to change paths or the painting will become muddled.

Emphasizing key areas

We usually focus on recognizable objects or shapes, but sometimes it is the gaps between them that draw our attention. Try to connect your focal point to other shapes, then look for complementary colors so your focal point contrasts with the other colors in the painting. Contrasts of light and dark can also create a focal point.

PUTTING IT INTO PRACTICE

Here, the cows are the focal points. Using recognizable shapes and adding warm color attracts the viewer's eye. Adding details of the bridge, softening the trees, and showing ripples in the river puts the cows into context.

You will need

Cadmium lemon | Raw sienna | Light red | Burnt umber | Prussian blue | French ultramarine

- No. 10 soft-hair mop brush
- No. 10 and no. 5 soft-hair round brushes
- No. 10 synthetic flat brush
- 11 x 15 in (28 x 38 cm) cold press 300 lb (640 gsm) watercolor paper

Cows by a river

1 Planning and painting
First sketch the positions of the key shapes, such as the bridge, the cows, the tree, and the reflections. Then tilt the paper to 60 degrees. Mix French ultramarine and burnt umber. Wet the paper and paint in the clouds with the mop brush, adding some French ultramarine to the sky.

2 Establish depth with color
While the paint is still wet, run the wash over the bridge but add raw sienna to give it a warm color, working around the cows so they remain white. Add Prussian blue and cadmium lemon to the fields, leaving the river untouched.

Tonal contrast
Recognizable shapes catch the eye. The contrast of the dark cow's head against a light background achieves this here.

Detail
Add some surrounding detail so the focal point sits convincingly in context and looks natural rather than over-emphasized.

Color
Use complementary colors. Here, the red-brown of the cow is highlighted against the gray-greens of the trees and grass.

3 Paint in the details
Using Prussian blue, lemon, and light red, dry-brush the tree. Then paint the cows, using burnt sienna and ultramarine.

4 The foreground river
Mix ultramarine, umber, and a little raw sienna. Wet the paper and paint the reflections, starting from the bank. Add green for the tree.

5 Enhance the focal points
With the same mix, add shadows under the tree and bridge. Add more reflections and detail to the cows so they come into sharp focus.

Artist **Ian Ramsay**
Title **Mountain Farm, Western Wyoming**
Paper **18 x 24 in (46 x 61 cm) cold press
140 lb (300 gsm) watercolor paper**

Simplifying a scene

≪ See pp.132–133

Moving from the center
toward the edges of the
painting there is less and less
detail; this has the effect of
enhancing the focal points
of the painting.

Linear perspective

≪ See pp.134–137

A one-point, low-level
perspective directs the eye
toward the buildings. The
fences, structures, wall, and
trees all reinforce the sense
of perspective.

Focal points

≪ See pp.140–141

The viewer's attention
is drawn to the buildings,
framed by surrounding trees.
It is usually easier to make
a group of buildings more
interesting than just one.

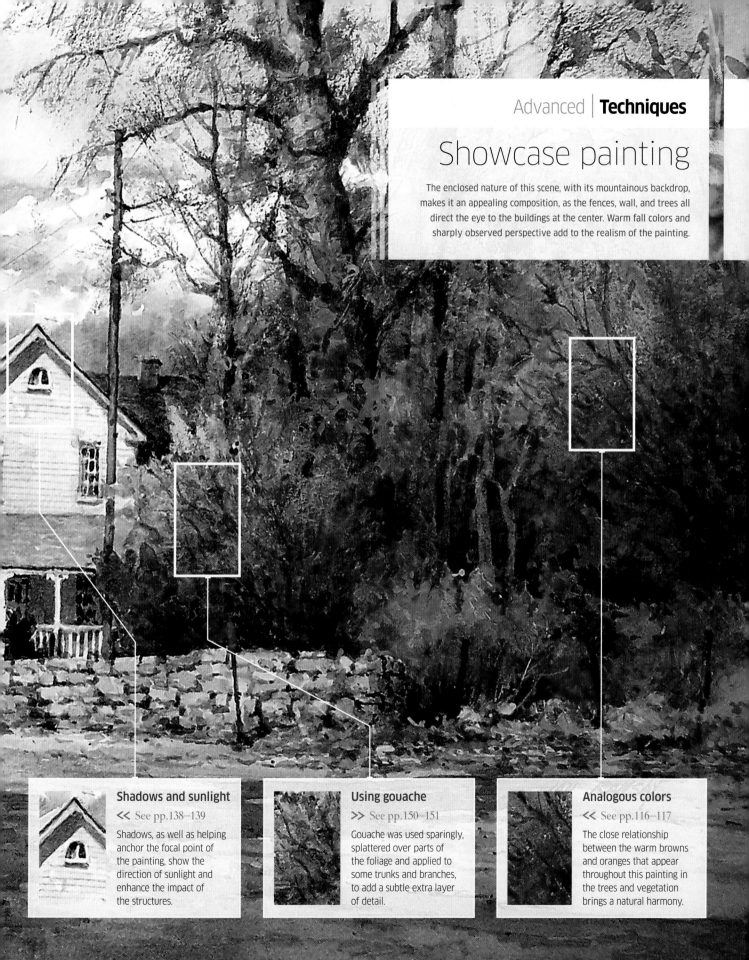

Advanced | **Techniques**

Showcase painting

The enclosed nature of this scene, with its mountainous backdrop, makes it an appealing composition, as the fences, wall, and trees all direct the eye to the buildings at the center. Warm fall colors and sharply observed perspective add to the realism of the painting.

Shadows and sunlight
« See pp.138–139

Shadows, as well as helping anchor the focal point of the painting, show the direction of sunlight and enhance the impact of the structures.

Using gouache

» See pp.150–151

Gouache was used sparingly, splattered over parts of the foliage and applied to some trunks and branches, to add a subtle extra layer of detail.

Analogous colors

« See pp.116–117

The close relationship between the warm browns and oranges that appear throughout this painting in the trees and vegetation brings a natural harmony.

Scraping

SCRATCHING AT THE PAPER'S SURFACE

Scraping is a useful technique to remove layers of color, create light shapes, and add texture to a painting when a brush can't do the job. The best scraping tools—from old credit cards and penknives to palette knives and plastic spoons—have relatively flat edges. Judicious scraping is always called for; don't get carried away.

■ Judging when to scrape

When the wash is still damp, you can scrape out details with your chosen tool. Paint removed from the paper's fibers reveals the lighter area beneath. Paper types that absorb more paint make it harder to lift out colors, and some colors, such as phthalo blue, are more staining.

Scraped paint

Staining pigment

Too wet

Too dry

Wet or dry?
Move damp color with your chosen tool, scraping and rotating the tool at the same time. If you try to move the paint when it is too wet, pigment will creep back into the shape instead being lifted out; if the paper is too dry, you won't be able to scrape the paint away.

PUTTING IT INTO PRACTICE

Scraping back creates points of interest through varied marks and is an effective way to suggest texture, as shown in this painting of a stone Buddha monument in Sri Lanka.

You will need

Pure yellow | Yellow ocher | Cadmium red | Quinacridone magenta | Manganese blue | Ultramarine blue | Indanthrene blue | Caput mortuum violet | Neutral tint

- No. 10 and no. 000 soft-hair mop brushes
- Scraping tools, such as a cut-up credit card as used here
- Rubber scraper
- 16 x 12 in (40 x 30 cm) cold press 300 lb (640 gsm) watercolor paper

Buduruwagala, Sri Lanka

The paper is evenly damp and ready for the paint

1 Prepare the paper
Draw out your composition on heavy watercolor paper, then dampen evenly with a large mop brush, keeping the figures and rest of the foreground dry.

2 The first wash of color
Lay in a variegated wash of yellows, oranges, and purples mixed from indanthrene and quinacridone magenta, letting the colors mix gently on the paper. Leave the wash for a minute before scraping—the paper must have just the right amount of wetness.

"You can scrape out subtle details, lines, and irregular shapes with your tool of choice."

3 Scrape shapes
Press hard into the wash with the edge of your tool and pull or drag the paint away—you want to scrape and rotate the tool at the same time. If the paper feels too wet, the paint will fill back in, so leave it a few minutes to dry before you start.

4 Scrape details
When the first shapes are dry, repeat the process in smaller areas using finer tools. Let the paint soak in a little before lifting out the color, and wipe the tool clean between scrapes to prevent color transfer.

5 Finishing touches
Stand back to assess the overall effect and, if required, finish any last details with a small brush, adding more local color in the desired areas, without overworking them.

Using plastic wrap

CREATING RIPPLED AND WRINKLED TEXTURES

By applying plastic wrap to a wet wash and creasing it on the wet paint you can create interesting textures. This is great for adding character to stones, patterns in foliage, and ripples in water. The paint becomes lighter in areas where the plastic touches the paper and the wrinkles create sharp outlined shapes.

PUTTING IT INTO PRACTICE

For this painting of a turtle in the sea, plastic wrap is used to create lines and shapes to suggest waves and ripples in the water. It is an easy way to achieve random, unforced changes of tone and line.

You will need

- Raw sienna
- Quinacridone gold
- Burnt umber
- French ultramarine
- Cobalt turquoise light

- No. 8 liner brush
- No. 8 soft-hair round brush
- Plastic wrap
- 11 x 15 in (28 x 38 cm) rough 140 lb (300 gsm) watercolor paper

Swimming turtle

1 Initial drawing and first wash
Sketch in the turtle. Mix up washes of two or three different blues. These need to be strong in color but liquid. Paint the area around the turtle in diagonal strokes, using your different blues. Allow the colors to run together and invade the outline of the turtle.

2 Apply plastic wrap
Before the blue has had time to dry, place the plastic wrap on the whole painting. Use your fingers to create wrinkles and folds in a broadly diagonal direction to make rippling shapes. Leave to dry, overnight if possible.

Imprinting wet paint

Using plastic wrap to make shapes in a wash helps suggest forms and textures that are hard to achieve with a paintbrush—for example, rocks, heavily textured vegetation, or the movement of water. The plastic wrap must be applied while the wash is still wet and allowed to stay in place until it is completely dry; if you remove it too soon you run the risk of your textures fading or even disappearing altogether.

Applying plastic wrap

For a texture such as the crinkled leaves of primroses, plastic wrap is ideal. Lay it flat on the paper then crease it with your fingers to make appropriate shapes.

Texture and pattern

Carefully remove the plastic wrap when the paint is absolutely dry. The flat paint wash will be transformed with interesting textures and patterning.

Random textured marks made by the plastic wrap

3 Paint the turtle

Remove the plastic wrap. Mix washes of umber, sienna, and gold. Start with a thin wash of sienna over all the turtle. Let that dry, then add the pattern of his scaly skin and shell with darker colors.

4 Finishing touches

When the paint is dry, add further diagonal strokes of a thinner mixture of blue to make darker waves of water. These can go over the turtle a little and can also be used to fill in white areas.

Using salt and bleach

EXPERIMENTAL EFFECTS

The creative use of salt and bleach will add a different dimension to your work. Consider how best to employ their abilities to lift out areas of color, whether for texture or to play with hues and add back whites. These special effects suit many subjects, from flowers to fabric patterns.

▇ Adding light and texture

Bleach offers some interesting effects for creating white and lights. It is best applied to strong pigments, such as liquid watercolors, and bear in mind that the effects are permanent and you won't be able to paint on top. Rinse your brushes well after use. Table salt also lifts out color but leaves grainy, textural marks.

Bleach on dry wash
Apply bleach to a dry wash and let it dry to achieve a complete white with a hard edge. If you want to lighten tones, interrupt the process by lifting off the bleach with a paper towel.

Bleach on wet wash
While the surface is still wet, apply bleach to create random lights as it spreads and blends. You can also lift it out before it turns completely white.

Table salt
Sprinkle over fine grains of salt while the watercolors are still wet. Let it dry completely before removing with a paper towel to reveal mottled marks. Coarse sea salt can also be used.

PUTTING IT INTO PRACTICE

Salt has been used here to give a special effect of textured elements to the abstract florals. Bleach is used to lighten the petals and add pale spots on the leaves, enhancing the variety of shapes and colors.

1 Apply salt grains
Draw the outlines of the main elements with watercolor pencil. Fill some flower centers with color and add salt. Before continuing to paint, wait until these areas are completely dry and remove the salt.

2 Mix tones
Rather than using flat washes for the leaves and petals, experiment by mixing two or three tones on one element, or using cool and warm colors together (see p.120).

You will need

Watercolor	Transparent orange	Opera rose	Perylene violet	Cobalt turquoise light	Aqua green	Liquid watercolor	Gold ocher	Violet	Turquoise blue	Pastel green

- Liquid watercolors
- Watercolor pencil in carmine
- No. 4, no. 1, and no. 0 synthetic round brushes
- Table salt
- Bleach
- Paper towel
- 12 x 8 in (30 x 20 cm) cold press 140 lb (300 gsm) watercolor paper

Flower sketch

3 Lift out bleach
Apply bleach with a brush into the wet washes, lifting out the bleach with a paper towel to achieve a lighter tone before the paint turns white.

4 Pale spots
Let the painting dry completely, then add spots with bleach to achieve whites and lighter tones. Use it with care in limited quantities, as it will work differently on each color.

5 Fine details
Work over the painting, adding details to give richness to your watercolor. Use lines, outlines, small stains, and general details to make the image more complex.

Using gouache
ADDING OPACITY TO COLORS AND HIGHLIGHTS

Including gouache paints in your palette will extend your range of techniques. Opaque effects add contrast to transparent washes, with the opportunity to add light over dark in any color. Any subject with white or light components is suitable, from snowy scenes to falling water or breaking waves.

■ Enhancing light-colored shapes

Remembering to leave clean, white shapes in the paper for highlights and lights can be slow and clumsy, interrupting the flow of a wash and perhaps losing edges. Instead, use gouache to paint light-colored areas on top of a watercolor wash, giving you more control of your marks and to add defined lights.

Adding highlights
It can be difficult to leave shapes in white paper for small highlights. Use gouache, either as a pure white or mixed with a wash to create an opaque light that gives added dimension to the shape.

Using white gouache can be easier than painting around small spaces

Uneven edges in watercolor

Defined edges in gouache

Defining edges
Painting around intricate light shapes in watercolor makes it difficult to create crisp edges. Apply gouache over a wash to paint in detailed shapes and retain a defined edge.

The tracks across the snowy field are represented here in a few blue washes. Rather than trying to paint around the highlighted snow furrows, opaque shapes are added on top of the watercolor wash.

You will need

White gouache | Cadmium red | Alizarin crimson | Burnt sienna | Raw sienna | Cerulean blue | Cobalt blue | French ultramarine

- 1 in (25 mm) synthetic flat brush
- No. 12 and no. 8 soft-hair round brushes
- 11 x 15 in (28 x 38 cm) cold press 140 lb (300 gsm) watercolor paper

Tire tracks in snow

1 Base washes
Establish the main composition with a light pencil sketch. Start with a sky wash of cerulean blue and while still wet, paint simple shapes for the background trees with bold, transparent mixes of French ultramarine and alizarin crimson, adding burnt sienna to the left.

2 Foreground snow
It is important to apply all the snow as one continuous wash, only leaving a few highlights and breaks to show the white paper, to enable a comparison with the gouache at a later stage. Allow sky and background to merge wet-in-wet.

3 Blue shadows
Mix a range of blues for the dark shadows. Apply simple strokes in different brush sizes, using cobalt for the mid ground and transition to a warmer tone darkened with red.

4 Warm contrasts
Darken blue washes with red, burnt sienna, and some alizarin crimson, letting the warmer tones blend in the trees. Add dashes of the shadow colors for the tire treads.

5 Opaque texture
Use dry brush marks in pure gouache with little water added to highlight the edges of the furrows against the blue shadows. Contrasts with the white paper add textural interest.

Using charcoal

CONTRASTING TONAL QUALITIES WITH COLOR

Combining an expressive drawing tool such as charcoal with watercolor adds different qualities to your paintings. Its fluid nature lends itself to fast sketches, and its tonal qualities are ideal for adding shadows and textures. Filling a charcoal outline with watercolor suggests a graphic, illustrative style, adding color effects that aren't possible in charcoal alone.

▓ Tonal effects

Charcoal lends itself to tonal studies, from rich blacks to light smudges. Use it to establish shadows, outlines, and tones: either dry or wet the marks to smooth and intensify them. Blend with water to create a light wash, or lay color on top.

▓ Textural effects

Broken charcoal marks will add texture to a painting, and this effect can be enhanced by working on paper with a rough surface. Apply a wash over the top so that both the grain of the paper and the charcoal marks become integrated with the painting.

Combining media
Vine charcoal smudged into the paper results in a granulated effect when light washes are applied on top. White gouache adds accents of light.

Creating tone
Charcoal is easy to apply and marks vary in intensity according to how hard you press. Use the different tones for shadows and form.

Wet charcoal
Apply a little water to the charcoal mark to smooth and intensify the effect, creating a velvety black with a unique, matte texture.

Add color
Lay a relatively dry wash over charcoal to create layers of tone and texture. Use more water to blend the tones, if preferred.

Charcoal wash
For more varied marks, add water to dissolve the charcoal and move the wash with a brush or let it bleed and spread naturally.

PUTTING IT INTO PRACTICE

This still life uses the contrasting textures of the charcoal outline and the watercolor wash to imbue the simple subject matter with color and immediacy. Intense mixes of the liquid watercolors are used for dark tones, blending the contrasting colors for mid tones and highlights.

You will need

Watercolor					
Lemon yellow	Peach	Tyrian rose	Magenta	Blue violet	

Charcoal	
Charcoal pencil	Willow charcoal

Shoes still life

- Liquid watercolors (colors above)
- No. 8, no. 6, and no. 4 soft-hair round brushes
- Mechanical drawing pencil
- Charcoal pencils and willow sticks
- 8¼ x 12 in (21 x 30 cm) cold press 140 lb (300 gsm) watercolor paper

Charcoal wash for inner shadows

1 Charcoal outlines

Draw light, simple outlines with a mechanical pencil. Using charcoal with different thicknesses, draw over the underdrawing in a sketchy style, avoiding smudges. Hold the charcoal with a loose grip and don't apply too much pressure.

Different tones are achieved with dry and wet charcoal

When applying the color, you don't need to fill the shape perfectly

2 Smooth charcoal

Moisten and smooth the outlines with a small amount of water on your brush, moving the charcoal wash to areas of darker tone.

3 Fill with liquid color

Add liquid color in a mix of tones inside the lines, with undiluted wash for darker tones over the charcoal marks.

4 Blend shadows

Add shadows beneath the shoes with smudged charcoal. Use a little water to create a lighter tone wash around the outside of the shape.

Using inks

WORKING WITH INTENSE COLOR

Inks are super-concentrated and more vibrant than standard watercolor paints. There are a few types, but all can be used undiluted for bold color or diluted with water for less impact. The brilliant colors offered by inks make them popular with illustrators.

■ Types of inks

Liquid watercolors (also called watercolor inks), water-soluble drawing inks, and India inks are great when you're looking for vibrant and colorful results. Those made from dyes rather than pigments are usually not lightfast, and therefore better suited to illustration for print rather than paintings for display.

Liquid watercolors
These are very concentrated watercolors. Just a drop will give intense color, and they blend beautifully wet-in-wet. You can also use them undiluted to pick out details.

Blending color

Intense detail

Water-soluble inks
Some drawing inks are water-based. They blend well with watercolor washes without losing intensity and impact. They are usually made with dyes, and are not lightfast.

India inks
Made with lamp black pigment and binder, India ink is waterproof when dry, making it great for the "line" in "line and wash" paintings. It mixes with wet watercolor, but can repel the paint to create interesting effects.

This floral abstract is created by introducing liquid watercolors in strategic places in every layer of the painting, from base washes to accents of saturated color that highlight the simplified botanical shapes.

1 A watery mix
Dilute your colors to create a watery mix in your palette. Paint the first shapes of flowers loosely, alternating between your colored water and the watercolor inks. Make sure this layer is very wet— you should be able to see mini-pools of colorful water.

2 Drops of color
To gain immediate vibrancy, use a brush or dropper to add the contrasting liquid watercolor to the bright flower centers. Ensure that the first layer is damp enough for the colors to blend naturally. Add fine stems with the darker color.

"Use liquid watercolor to add intensity or saturated color."

You will need

Watercolor	Azo yellow	Rose Doré	Green gold	Neutral tint	Liquid watercolor	Scarlet	Burnt sienna	Mahogany

- ¾in (20mm) synthetic oval wash brush
- No. 16 and no. 6 synthetic round brushes
- 54 x 35 in (21 x 14 cm) cold press 90 lb (190 gsm) watercolor paper

Spray of flowers

Accents of bright color add vibrancy

Beautifully blended colors

Touches of green between the flowers gives cohesion and direction to the work

3 Controlling the blending

Add flowers using liquid watercolors, very saturated pigments, or a mix of the two. Encourage blending by allowing this layer to slightly touch the others. Let some areas dry more to control the edges and retain shapes.

4 Intense darks

Paint the first leaves with a highly saturated color scheme. Allow this layer to gently touch some areas of the flowers. Feel free to add touches of green to the white gaps between items.

5 Vibrant extras

Add more flowers, leaves, and stems directly on dry paper, to give defined shapes. When fully dry, use liquid watercolors to pick out smaller details, such as adding saturated scarlet for small petals and flower centers.

Watercolor pencils and pens

USING PIGMENTED DRAWING TOOLS

With a high concentration of water-soluble pigment, watercolor pencils and pens are a versatile and quick way to draw and paint. They give you much more control over finer details and marks than a brush and wash, and create a smooth surface with subtle variations. Use alone or combine with traditional washes for detailed studies.

▣ Surface marks

The effects from water-soluble drawing tools depend on whether you work on wet or dry paper. Laying tone on dry paper and wetting with a brush creates an even wash, whereas drawing on damp paper translates your drawn marks into intense pigment in one stroke.

Adding water to pencil
Lay your pencil marks on dry paper, drawing or shading where required. Load a clean brush with water and work over the pencil mark to dissolve the pigment and create a wash.

Adding water to pen
Treat water-soluble pen marks in the same way as pencil, using a clean brush to apply water. Move the brush to blend and spread the wash.

Drawing on wet paper
Dampen your paper with clean water applied with a brush or spray. Draw with a watercolor pencil to create rich and intense marks where the pigment blends into the paper.

This colorful rendering of a beetle combines liquid washes, watercolor pencils, and markers to create a varied and detailed surface. Controlled application maintains the precision of the initial drawing.

1 Fill outline with liquid color
Draw precise outlines that will be used as guides for washes or pencil shading. Using a no. 10 brush, fill the largest sections of the beetle's shell with bold washes. Use plenty of water for a more transparent effect.

2 Pencil shading
When the liquid watercolor washes are completely dry, use watercolor pencils to continue to fill in the smaller parts of the design, laying different colors and staying within the outlines.

"Create different shades or tints by varying the pressure of your pencil marks."

You will need

- Liquid watercolor
 - Aqua green
 - Black
 - Apple green
 - Chartreuse green
- watercolor pencils
 - Lime
 - Yellow
 - Forest green
 - Aqua green
- Marker pens
 - Apple green
 - Olive
 - Aqua green

- No. 10, no. 6, and no. 2 soft-hair round brushes
- 12 x 8 in (30 x 20 cm) cold press 140 lb (300 gsm) watercolor paper

Beetle

3 Apply water
With a small round brush, apply water to the pencil areas, following the drawn shapes within the lines and taking care not to over-wet each area. Move the wash gently to build a soft but solid tone.

4 Add solid color
To add a third layer of texture, use thin marker pens to draw in lines of solid color, accentuating the divisions along the body and contrasting with the lighter transparency of the watercolor washes.

Effects with gouache

ADDING OPAQUE COLOR AND SURFACE TEXTURE

Combining gouache with watercolor can be very liberating, allowing you to paint light passages over your darks and adding another surface layer of opacity. Pure gouache contains much more pigment than pure watercolor–used on its own it has a powerful impact, but by mixing it in watercolor washes you can merge seamlessly between the two media.

PUTTING IT INTO PRACTICE

This painting combines both media, with watercolor providing a light, translucent setting of sea and sky, against which the strong opaque mixes solidify the boat with texture and bold color.

You will need

Watercolor: Yellow ocher, Cadmium red, Burnt sienna, Cobalt blue, Cerulean blue, French ultramarine

Viridian

Gouache: Yellow ocher, Cadmium red, Cerulean blue, French ultramarine, Indigo

- 1 in (25 mm) synthetic flat brush
- No. 12 and no. 8 soft-hair round brushes
- 11 x 14 in (28 x 35 cm) cold press 140 lb (300 gsm) watercolor paper

Lifeboat

1 Bold washes
Loosely sketch the scene. Next, fill the paper with a continuous wash of cerulean sky merging with an ocher harbor wall. Apply a cobalt and French ultramarine blend in the foreground. Paint around the top of the boat where you will apply an orange wash later.

2 Ignore highlights
When using gouache, you don't need to plan ahead for highlights; lay a flat wash at once across all the elements. The small boat and figure here will be worked on later.

■ Benefits of opaque paint

Employ gouache to bring body and texture to your paintings. Its opacity and high pigment content add strength to lighter colors, creating better coverage with a chalkiness that can be used in contrast to transparent washes. Working light over dark means you don't have to plan for highlights, adding lights and whites with control at the end. Gouache is naturally thick and works well as an impasto texture, too.

Chinese white

White gouache

Adding body
Chinese white leaves a semi-opaque, mixed tone compared to the matte effect of gouache.

Adding color
The rich pigment in pure gouache leaves fresh, bold marks that retain their shape.

Adding texture
Use undiluted gouache to create texture through impasto effects or with dry-brush techniques.

3 Contrasting washes
Paint the deck with mixes of red and orange, laying in the main shapes and avoiding detail. Orange instantly appears bolder against the blue.

4 Watercolor darks
Use a dark orange for the shadowed shapes, letting it blend slightly. Apply the darkest darks with a mix of indigo and ultramarine on the boats and water.

5 Assess your painting
After building watercolor darks, stop to assess if you can continue to inject color without muddying the mixes. At this point, introduce gouache to strengthen your colors.

6 Mix lights and brights

Enhance the bright colors using pure red and orange gouache to bring light back to the boat's upper levels. The opaque orange mix stands out clearly over the darker undertones. Applied thickly, it adds surface texture, too.

7 Shadow highlights

Use a pale blue gouache mix to bring light and life back to the ripples of water behind both boats, adding strokes over the dark shadow wash beneath. Use pale opaque blue as a gray for the off-white shadow areas on the main boat.

8 Detail highlights

Use dabs of pure white gouache for the bright highlights on the boat and fisherman, and the lightest reflections in the water. Mix a range of blue tones in gouache to add light over dark.

Pure cadmium red watercolor

"The opaque qualities of gouache will enhance your watercolors with added body and light."

Pure orange gouache

Orange gouache mixed
with white

9 White over dark

Use pure white gouache to draw in the fine lines of the boat rails and steps, over the dark underlayers. A broken stroke is all that is needed to suggest the tethering rope to the buoy.

Toward abstraction

PAINTING INTUITIVELY

In the absence of clearly identifiable objects, abstract painting relies on interesting shapes and successful color combinations to please the viewer's eye, giving the artist endless opportunity for expression. The "controlled accidents" you can achieve in watercolor add real excitement and freedom to a painting.

■ Abstract principles

Making the first marks is an exciting experience in an abstract painting, since they will often determine the direction of the piece. In the absence of a scene or subject that the viewer can relate to, concentrate on interesting shapes, edges, colors, and textures. Rough papers are great for this type of work. Use a lot of water, strong colors, and large brushes.

Color palette
In an abstract painting, colors do not have to resemble real life. Choose any colors that work well together (see pp.116–121), and experiment with hues you don't see in nature.

Shapes and composition
Assemble shapes in a form that makes a strong composition. Some shapes may hint at recognizable objects while others may come from your imagination.

Hard and soft edges
Incorporating a range of hard and soft edges adds visual stimulation. In the absence of representational forms for the viewer to identify, they can be of any shape.

PUTTING IT INTO PRACTICE

Watercolor is a wonderful medium for achieving abstract and semi-abstract images, since the colors blend to create tones and shapes you might not have visualized. This painting, done from the imagination, has bright, warm colors that suggest a heightened version of fall. The background shapes can be read as trees, though there is no attempt at realism.

You will need

Cadmium yellow deep · Cadmium red · Azure blue

- White watercolor stick
- Indigo powdered pigment
- 4 in (10 cm) soft-hair wash brush
- No. 20 soft-hair mop brush
- Medium swordliner brush
- Spray bottle
- 28½ x 39½ in (70 x 100 cm) rough 300 lb (640 gsm) watercolor paper

1 The first marks
Having decided on a color palette, work from light to dark. A deep yellow is a good base for subsequent colors to blend with. Just make some vigorous marks with a large brush.

> "Encourage the paint to move and blend by angling the board."

2 Introduce a second color
While the paint is still wet, mix plenty of strong red and work it quickly onto the paper. Begin to establish a horizon line.

3 Add deeper tones
Work in deep blue which will mix to create warm browns and purples and produce blue where the paper was still white.

4 Develop a composition
Let the paint dry, then, using the same blue, outline a suggestion of trees. Add water to the outer edges to blend them in.

>

5 Add white highlights

Loosely add white highlights and a suggestion of branches with a watercolor stick. This gives the painting a real lift, but keep the marks moderate so that the eye is not too distracted. This technique works best on more textured papers.

6 The final brushstrokes

Add some fine blue brushstrokes to the foreground and woodland areas to create an increased sense of movement and landscape. The more you add, the less abstract the painting will become; it is your choice how far to take this.

Marks from a white watercolor stick suggest rough, natural textures

> "Abstract paintings give you total freedom of shape, texture, and color as long as you arrive at a pleasing result."

Soft edges create depths
that invite the viewer
to explore them

Hard edges give
definition, offering
contrast for the eye

7 Use dry pigment for texture
Before the painting has dried, sprinkle powdered pigment
randomly over the blue area and spray with water. This creates
beautiful textures and makes the trees less defined.

Artist **Maria Montiel**
Title **Surreal Botanicals**
Support **12 x 16½ in (30 x 42 cm)**
hot press 140 lb (300 gsm)
watercolor paper

Wet-on-dry

≪ See pp.50–51

Painting wet-on-dry was key to creating the defined shapes that are layered in this painting; it also allowed the artist to play with transparencies.

Toward abstraction

≪ See pp.162–165

Depicting natural forms in a nonrepresentational way enables creative expression. These floral elements are simple, stylish abstractions of real flowers.

Using salt and bleach

≪ See pp.148–149

Salt, applied to areas of still-wet paint, creates unique, random textures. Elsewhere, bleach was applied to dry surfaces to create glowing lighter tones.

Showcase painting

This energetic floral artwork demonstrates just how bold and spirited watercolors can be. The considered layering of elements and clean edges delineating forms temper a more-is-more approach to color, while watercolor markers, salt, and bleach add graphic detail.

Layering paint

« See pp.58–61

Complex forms can be created with layered washes, building up colors from light to dark—the interactions between colors add interest and vibrancy.

Watercolor pens

« See pp.156–157

The defined outlines of these elements were created using pens around the edges of the shapes, then a wet brush was applied to gently blend the colors in places.

Wet-in-wet

« See pp.52–55

A range of bright colors were mixed dynamically on the paper, allowing new shades to emerge. Choosing analogous colors helps maintain a cohesive balance.

Subjects

Choosing a **subject**

Traditionally used for landscape paintings, watercolor is now employed by artists to convey anything from portraits to fashion illustrations. Each subject presents its own challenges, whether portraying reflections in water, shadows in snow, or capturing a fleeting impression of an animal. Mastering these challenges will help convey the essence of your subject.

On the following pages, subjects have been divided into three groups, with approaches for landscapes and townscapes discussed in detail, followed by a guide to still life and flower subjects, thinking about pattern and texture. In the final section, the challenges of figures and portraits are addressed, along with the skills needed to paint animals. Showcase paintings by different artists illustrate the range of styles that can be used.

Landscapes and townscapes

■ See pp.172–203

This section gives you examples of different approaches to the perennially favorite subject of the landscape, breaking it down into not only classic views but also how to convey snow, water, skies, and urban settings in varied styles.

Harbor scene (see pp.188–189)

Patterns, still lifes, and flowers

■ See pp.204–217

The second section focuses on those subjects that require close-up attention, from flower studies and patterns, to still lifes and textures. Find inspiration for illustrative designs and impressionistic interpretations.

Botanical painting (see pp.212–215)

Watercolor adapts to any subject. When planning your painting, take into consideration the myriad ways to approach a subject, illustrated in this chapter with examples from different artists who demonstrate how they plan and execute a painting, with insights into their methods, from how to handle the composition of a busy street scene to painting a crashing wave.

Some work in a representational way, capturing scenes such as sunlit water by exploiting the luminosity of watercolor. Others work in a more abstract style, breaking subjects down by color or tone, rendering trees as abstract shapes, or reducing a moving animal to soft, minimal brushstrokes.

For a more graphic approach, take inspiration from artists who use intensely saturated liquid watercolors to create patterns or illustrations, particularly suited to flower studies.

Extending your options

Certain subjects lend themselves to particular techniques or media to convey key elements, such as texture, details, and movement. Consider how your painting could be enhanced by introducing other media; use gouache, for example, to add contrasting opaque effects.

Extending your repertoire of skills to include techniques that help with details or texture, such as using bleach or salt, will enable you to plan and work at greater speed and with greater confidence. Continue to experiment, drawing inspiration from the artists and subjects shown here, and translating it into your own individual style.

Portraits, figures, and animals

■ See pp.218–245

The final section explains how best to approach figures, whether as a portrait or incorporating figures in a setting or as an illustration. Find out how to paint animals, capturing the essence of a wild animal or the character of a family pet.

Skin tones (see pp.220–223)

Woodlands

SHAPING MASSES OF TREES AND FOLIAGE

Trees are an almost universal component of a landscape. To create a feeling of depth, trees must be painted in different ways to capture both the essential simplicity of a distant mass of woodland, along with the infinite variety of color, tone, and shape seen in the foreground. To maintain a sense of a group of trees, ensure that each element blends naturally with the next.

PUTTING IT INTO PRACTICE

A feeling of dense woodland is captured here through the effects of aerial perspective; soft washes map out the distant trees, with warmer mixes and varied strokes used to define the trees that advance in the foreground.

You will need

Cadmium yellow
Burnt sienna
Cadmium red
Phthalo blue (green shade)
French ultramarine

- No. 14 and no. 6 soft-hair round brushes
- ¼ in (6 mm) swordliner brush
- 10 x 14 in (25 x 35 cm) cold press 140 lb (300 gsm) watercolor paper

Woodland walk

1 Distant mass
Apply a simple first wash of blue sky followed by warm mixes for the local color in the foreground. Add a flat wash of French ultramarine and burnt sienna to give the impression of the distant trees, using the side of the brush to suggest the broken edge of the leaf canopies. Leave to dry.

2 Tree groups
Use the point of a no. 14 brush to paint the middle distance trees. Add detail to the branches and trunks using varied mixes of the same wash to connect them. Aim for a group, not separate trees, and allow to dry.

▪ Three-dimensional shapes

Foreground detail gives depth to any painting and is especially important in landscapes, helping differentiate the woods from the trees. While distant tree trunks can be rendered with tonal lines, those in the foreground should be more complex, with the suggestion of solidity and a rounded form. Simplify the shape into light and dark tones, adding texture for bark with dry brushstrokes.

Light and shade

The main trunk of a tree is essentially a cylinder. Use a soft blend between the light and dark side of the trunk to give a three-dimensional effect.

Bark texture

When the wash is dry, apply linear marks using dry brush (see pp.56–57) and a rigger or swordliner, to create a convincing suggestion of bark texture.

Connect the shapes of the masses of leaves together with softly blending twigs

3 Foliage shapes

In the foreground, use stronger mixes and varied shapes to suggest the leaf cover and twigs, working wet-in-wet; complete sections of a tree before moving on. Blend the base of the trees with the ground.

4 Foreground detail

Use a strong mix of burnt sienna and French ultramarine for the dark shadows that connect the trees. Hint at leaves on the forest floor with dots and dashes of splatter.

Tree blossom

CREATING THE EFFECT OF MASS PETALS

It is impossible to paint individual cherry blossom flowers with a brush. Instead, you can use a sponge on top of a wash in order to create the texture and varied shades of the blossom. Some white gouache mixed with the pink in one layer gives better coverage and a more realistic expression of blossom petals on a tree.

■ Key techniques

When painting blossom or any other flowers en masse, it is important to avoid heavy, solid blocks of color and concentrate on suggesting a surface of varied depth and color in a lively manner. To prevent background colors affecting the flowers, lay a light wash of your flower mix first.

Stippling and splattering
Suggest blossom through a mixture of sponging and splattering or spattering the paint expressively, without having to paint every flower. Layering analogous colors (see pp.116–117) creates extra depth and dimension.

Background color
To prevent the sky color affecting the color of the blossom, paint a "blush" of pink in the underpainting where you will place the blossom. This will keep the blossom color bright and vibrant.

PUTTING IT INTO PRACTICE

Painting the blossom first may seem counterintuitive, but this way the branches can be threaded in and out to look natural. Using a rigger for the finer branches helps show their gradually diminishing size.

You will need

White gouache · Aureolin · Opera rose · Permanent rose · Burnt umber · Cerulean blue · French ultramarine

- No. 10 soft-hair round brush
- No. 8 soft-hair liner brush
- No. 1 or no. 0 soft-hair rigger brush
- Old toothbrush (optional)
- Natural sponge
- 11 x 15 in (28 x 38 cm) rough 140 lb (300 gsm) watercolor paper

Cherry blossom trees

1 First washes
Mix three washes of rose, cerulean, and aureolin. Wet the paper with your round brush and quickly lay the pink areas of blossom. Add cerulean to the sky then aureolin for the grass.

2 Add texture
When dry, mix a strong rose wash and one of rose with white gouache. Dip a barely-damp sponge in the rose and lightly dab over the tree. Repeat with the gouache mix.

"For blossom, use texture and variation of color for a lively effect."

3 Add dark trunk and branches
Paint an ultramarine and umber mix on the trunk. Using a clean, damp brush, fade the branches and trunk into the blossom and grass. Switch to the rigger for the finer twigs.

4 Finishing touches
With the sponge and pink mix, add more blossom, but this time let it go over the trunk and branches a little. Repaint the grassy area with aureolin mixed with a little cerulean.

Splatter or spatter some pink with a brush or toothbrush at the branch tips and on the ground

Open landscapes

EVOKING A SENSE OF SPACE

Aerial perspective techniques (see pp.122–123), using paler tones and colors in the distance, are well-suited to an open landscape. Conveying depth and drama, and creating the illusion of walking through the landscape, will draw your viewer in. Avoid unnecessary details, which will lose the spontaneity of the work, and keep the foreground loose to help maintain a painterly rather than linear feel.

PUTTING IT INTO PRACTICE

Broad brushstrokes with minimal fuss are needed for this type of landscape. Use wet-in-wet washes and suggest atmospheric haze to convey the sense of the landscape receding from the viewer.

You will need

- Cadmium lemon
- Raw sienna
- Light red
- Indian red
- Burnt umber
- Cobalt blue
- Prussian blue
- French ultramarine

- No. 15 and no. 10 soft-hair mop brushes
- No. 5 soft-hair round brush
- Small penknife
- 15 x 22½in (38 x 56cm) cold press 140lb (300gsm) watercolor paper

Sussex Downs, England

1 The first washes
Dampen the paper and paint the sky using ultramarine and umber. Leave white paper for clouds, fields, and blue sky. As the paint dries, add darker cloud color and cobalt blue in the sky, and green for hills and foreground.

2 Paint the distant view
With the no. 10 mop, paint the distant hill and trees with cobalt blue and Indian red. Use the same technique for the middle-distance hills and trees with a mix of Prussian blue, lemon, and red.

▨ Impressionistic techniques

To make the background recede, use loose, impressionistic techniques. Hills and trees can be kept loose with a single wash of color, usually blue to give the effect of atmospheric haze. Pick up the "bead" of paint that collects at the base of a wash (see p.70) to paint loose, continuous washes down the paper, avoiding details in the distance. Add texture and details in the foreground to bring it closer to the viewer.

Using a bead of paint
Add to your first wash with the same paint to create a bead at its base. Use this to continue down with horizontal strokes.

Splattering
Wet paint thrown from the brush into existing wet washes creates the impression of foreground vegetation and stones.

Lifting out
Lifting the existing wet washes with a penknife or a dry brush also produces the effect of foreground elements.

Light clouds in the sky are echoed in the lighter ground beneath

3 Build up the foreground
With the no. 5 brush, emphasize the perspective by making the trees larger toward the foreground. Add a light wash of raw sienna over the fields.

4 Add warmth and detail
Use ultramarine and red for cloud shadow over the foreground. Scratch a tree out of the wet paint with the knife. Lift out other areas with a dry brush.

5 Strengthen the sky
Wet the sky and lay a wash of ultramarine and umber over the dark clouds to strengthen the top. Keep the clouds toward the horizon much lighter.

Abstracting a landscape

SIMPLIFYING AND INTERPRETING

The key to abstraction is to simplify the composition and eliminate detail while retaining elements of the landscape—sky, a hillside, or a suggestion of foliage can be enough to establish a sense of place. Use bold, energetic marks and strong colors that can suggest a rugged scene or gentler washes for more of a serene feel.

▓ Using identifiable shapes

While a representational painting describes a scene or subject, a semi-abstract relies on the power of suggestion. In a landscape subject, large shapes imply landmasses or dense vegetation, while smaller blotches of color and vertical strokes of paint can be read as individual trees.

Washes and large shapes
Broad washes of color are familiar in landscape scenes, but in a semi-abstract painting they do not necessarily aim to describe a recognizable place; colors are chosen to work as part of the composition rather than to be realistic.

Lines and breaks
Vertical and horizontal linear shapes and crisp-edged colors provide some structure and lead the viewer's eye around the painting. Reserved white paper suggests a circular passage which is broken by the implied tree trunks.

Reserved white paper

PUTTING IT INTO PRACTICE

Part of the process of abstraction can be to opt for less obvious colors. The deep yellow and blue hint at a tropical scene, but using yellow for sky and blue for land gives the painting a more surreal quality.

You will need

Cadmium yellow deep
Cadmium red
Phthalo blue

- No. 20 soft-hair mop brush
- Medium swordliner brush
- Spray bottle
- 12 x 16½ in (30 x 42cm) rough 300 lb (640 gsm) watercolor paper

1 Make the first marks
Having decided on your main color, make your first marks. You may have a composition in mind—maybe something as simple as a horizon line. This is purely a starting point.

2 Merge washes
Quickly block in the second color, allowing the two washes to merge and random shapes to form. This stage will determine the direction and personality of the painting. Allow to dry.

3 Add perspective
You now need to achieve a sense of perspective. Drawing treelike shapes with a strong mix will contrast with the softer wash and give the illusion of foreground.

4 Paint the foliage
Quickly add loose blobs of the same strong color rather than trying to engage with the detail of branches or leaf shapes; a swordliner brush is perfect for this.

5 Achieve random effects
While they are still wet, spray the foliage areas with water to soften the edges and give random effects as the colors bleed. Add a few red highlights to contrast with the blue.

Artist **Yong Hong Zhong**
Title **Waterlily Reflections**
Paper **12 x 18 in (30 x 46 cm) hot press**
140 lb (300 gsm) watercolor paper

Simplifying a scene

« See pp.132–133

Simplification is key to
this painting; starting out
by limiting the use of values
to just dark, medium, and
light helps to reinforce the
structure of the scene.

Complementary colors

« See pp.118–119

The pleasing contrast
between the red flowers
and surrounding green lily
pads jumps from the page,
enhancing the focal points.

Focal points

« See pp.140–141

The group of waterlilies here
forms the main focal point,
with other lily pads in the
foreground and background
taking supporting roles as
minor focal points.

Showcase painting

This peaceful, light-filled scene appears lifelike when viewed in its entirety, but a closer look reveals loose brushstrokes and simple shapes, layered in perspective to build up a realistic landscape. A wide tonal range and use of contrasting colors create overall balance.

Lifting out

≪ See pp.82–83

When the piece was nearly finished, the artist fine-tuned the work by lifting out areas of paint, in order to soften edges and bring out details in darker areas.

Linear perspective

≪ See pp.134–137

The lily pads appear larger in the foreground of the painting, then gradually become smaller as they go further back, creating a realistic sense of depth.

Dry brush

≪ See pp.56–57

These broken, textured lines, painted with the dry brush technique, are both naturalistic and stylish, calling to mind traditional Chinese calligraphy.

Still water

REFLECTIONS, RIPPLES, AND SHADOWS

It is important to consider how water moves and the way reflections appear when tackling still water in a landscape. Exploit the natural transparency of watercolor paint to capture the delicate sense of light on water, where colorful reflections, ripples of light, and shifting shadows are integral to the composition.

■ Capturing subtle movement

Use a mixture of techniques to convey the sense that water is gently animated: combine larger flat washes, wet-in-wet modulations of color, and dry brush for texture to provide variety and interest. Use with care so as not to overpower the whole composition.

Wet-in-wet reflections
Where reflected colors merge and shift, apply pigments quickly and allow them to blend on the paper. Paint colors either side by side or into each other while they remain wet.

Glazing
Use thin, transparent glazes (see pp.124–125) for shifting colors and tonality or changing the temperature from warm to cool. Avoid opaque colors as they can obscure the layers.

Wet-on-dry shapes
Work wet-on-dry, manipulating the brush to make marks and dashes for ripples and gentle waves. Build dark washes over a flat layer, with a mix of tones to add a sense of movement.

PUTTING IT INTO PRACTICE

The glittering reflections in a gently rippling canal are captured here using soft glazes and wet-in-wet blends that create atmospheric effects to envelop the scene with subtle cool and warm coloring.

You will need

- Indian yellow
- Raw sienna
- Burnt sienna
- Cadmium red
- Alizarin crimson
- Light red
- Opera rose
- Cobalt violet
- Phthalo blue (green shade)
- French ultramarine
- Ultramarine violet
- Neutral tint

- No. 12, no. 8, and no. 2 soft-hair round brushes
- 20 x 14in (51 x 35cm) cold press 140lb (300gsm) watercolor paper

Venetian canal

1 Tonal study
A pencil study helps organize the relationships between the buildings and the water. Note the shadows beneath the bridge and the darker tones along the canal edges, which can be referred to when painting.

Add darker tones beside the reflection to enhance the effect of light

"Use soft, **wet-in-wet edges** to convey the shifting colors of reflections in water."

Apply warm washes to the buildings and their roofs, with bright mixtures where the light hits

2 Establish light
Add a first wash to establish the general light in the view. The violet-blue color of the sky is complemented by the light yellow wash falling over the buildings. At this stage, leave the area for the water unpainted.

3 First wet-in-wet layer
Quickly add the first base layer of water wet-in-wet within the shape of the canal and around the boats and gondola. Leave clean paper where the sunlit tower is reflected. Add bright yellow into this space and let it spread.

4 Add ripples
Use the tip of a no. 2 brush to add a layer of ripples under the bridge, painting small points and lines of the darker ripples. Apply ripples in the foreground, then dampen the paper with clean water and leave so that the ripples soften out.

5 Strengthen shadows

The strong lighting in the scene casts dramatic shadows on the buildings. Use a variety of colors in the basic shadow mixture to keep the painting interesting. Add a second, slightly darker sky layer to allow the light effects to shine out.

6 Foreground detail

Add the dramatic darks of the boats and striped mooring posts. Here, the cool, neutral coloring is a good foil to the rich variety of color in the background. Keep the boats, pole, and reflections as simple as possible, working wet-on-dry for the dark tones of the reflected solid shapes.

"The golden hour in Venice is the ideal moment to paint reflections on rippling water."

7 Transparent glazes

Apply thin, transparent glazes over the dry layers to shift the tonality and coloring in the painting, using warm glazes to connect the reflections to the buildings. Add successive glazes to give depth. Apply a gentle glaze of viridian to the lower section of the water, adding more ripples while the glaze is still wet.

Viridian glaze brightens the foreground

8 Fine details and final glazes

Use different colors for the windows, carefully observing shapes to bring character and scale to the buildings, adding the finer edges to the roof cornices and tiles. Balance the composition with a few additional glazes on the buildings to create a richer sense of space, and finally paint the gondolier to give a sense of movement.

Adjust thin glazes to modulate and unite the composition throughout the painting process

Waves

CAPTURING MOVEMENT AND DRAMA

A crashing wave is so exciting and dynamic to watch, but so difficult to paint as it only lasts for a few seconds. Use field sketches and photographs as a reference to help "freeze" the action and manipulate your composition to focus on the wave, keeping it in context but subduing the rest of the scene.

▉ Making waves

Work from reference photographs to edit the composition, focusing on the wave. Decide in advance which tones to lighten or darken; which edges to soften or harden; which colors to mute or saturate. Leaving whites and planning dark contrasts throws action into the picture plane. Use opaque lights to give body to the spray.

Leave whites
Use initial washes to describe the shape of the wave as a negative space (see pp.114–115), painting around it to leave the white paper. Consider the height of the crashing foam, extending the white into the top of the picture plane.

Soften edges
Where washes have dried with a hard edge around the white wave, use a clean brush and water to gently blend and soften the edges (see pp.94–97).

Opaque color and detail
To contrast against transparent washes, use gouache to add opaque lights (see pp.150–151), splattering white blobs to add movement (see pp.98–99).

PUTTING IT INTO PRACTICE

Here, the wave in the reference photograph has been made taller, to fall into the center of the picture. Contrasts of tone and color help focus the action.

You will need

Cadmium red · Burnt sienna · Burnt umber · Viridian · Cerulean blue · French ultramarine

White gouache · Cadmium yellow · Indigo

- No. 16 and no. 8 soft-hair round brushes
- 10 x 14 in (25 x 35 cm) cold press 140 lb (300 gsm) watercolor paper

Breaking wave

1 Define main areas
With the composition divided into thirds, establish a cool sky with cerulean and a warm sea with ultramarine, using hard edges to define the horizon. Leave white paper for the rocks and breaking wave.

2 Emphasize dark contrasts
A white wave needs a dark backdrop; use a stronger mix for the sea to define the wave's shadow side. The rocks ensure a dark area adjacent to the lightest light of the wave.

3 Blend edges
To merge the white paper into the sea color, use clean water to soften the hard edge of the adjacent blue, moving the wash to blend light tones where the wave breaks.

4 Opaque effects
When the watercolor is completely dry, splatter white gouache to achieve the dash of wave droplets and mix opaque wave shadows in cobalt to complement transparent washes.

Harbor scene

CAPTURING A NAUTICAL LANDSCAPE

There is so much material to work with in a harbor scene. The colors and shapes of the boats, the rigging, reflective water, the mood created by the weather, and all of the structure that makes up a harbor are of endless fascination for the artist. Employ different techniques to capture the shifting layers of color in the water against the solid forms of the dock and boats, using dark and light values to create visual contrasts.

PUTTING IT INTO PRACTICE

The boats and harbor setting draw your eye through the scene, following the path of light on the water where the reflections connect to the sea. Be alert to the contrast between light and dark values.

You will need

- White gouache
- Yellow ocher
- Permanent yellow deep
- Deep scarlet
- Burnt sienna
- Burnt umber
- Ultramarine blue
- Cobalt blue
- Phthalo green (blue shade)
- Sap green

- Selection of soft-hair flat and round brushes, rigger brush, stiff-bristle fan brush
- 16 x 20 in (41 x 51 cm) cold press 140 lb (300 gsm) watercolor paper

Newport Harbor, Oregon

1 Foundation washes
Lightly draw your sketch in pencil, making sure all the elements are resolved before you begin to paint. Smoothly apply a flat wash of ultramarine mixed with a little burnt sienna with a flat brush and overlay it with cobalt blue. Use a slightly richer mix to begin the areas of major reflection.

2 Add background
Work rapidly with a large mop brush with a good point to render the background hills. Use plenty of water to apply layers of ultramarine with yellow ocher. Soften the tree shapes as you work, blending with a stiff fan brush.

Bringing it together

In order to make your painting a composition containing boats, and not a portrait of a boat or boats, look for ways to keep the scene connected. Make sure that the boats, dock, and structures connect and flow into each other where possible. Think about the setting, using a backdrop to contain the different elements, and blending each area into another to maintain a flow through the composition.

Background silhouette
By eliminating some of the buildings from the background the area is simplified and becomes a silhouette, adding atmosphere and depth.

Realistic forms
Painting the harbor structures and boats in detail attracts the eye through the painting. Carry colors and merge edges to keep the elements connected.

Layers of blue and green added with a fan brush introduce texture to the wooded hills

3 Introduce color
Start to fill in the boats and harbor scene with color, using large round brushes in order to avoid becoming too involved with detail. Lift out (see p.82–83) and soften some areas to suggest mist.

4 Define forms
Solidify the three-dimensional objects and create areas of contrast. Add line detail, accented color, and some white gouache for sparkle.

Layer movement in the water with a light touch and a large round brush with a sharp point

Colors in snow

PAINTING WHITE USING COLOR

Like other white subjects, snow reflects the colors around it. The key is to identify the light and shadow patterns, breaking the scene down into light, medium, and dark tonal values, and looking for colors to convey the snowy atmosphere.

■ Using color and tone

The appearance of snow is influenced by the colors of the surrounding objects and light sources. Look for tonal color changes in shadows to describe snowy shapes, and observe the effects of perceived temperature where cool shadows are contrasted against a patch of warm sunlight.

Shadow colors
In general, shadows on snow will reflect the sky. A clear sky will produce blue snow shadows, compared to dull tones of an overcast scene.

Use tonal variations of blue for shadows on sunlit snow

Temperature contrasts
Use contrasts in color temperature (see pp.34–35) to convey the literal chill of the shadows, where large areas of cool blue are juxtaposed against patches of warm orange or yellow.

PUTTING IT INTO PRACTICE

The feeling of light in the snowy scene is created through the dramatic contrast between the dark creek and the white snow. The warm, late afternoon sunlight and cool shadows enhance the drama.

You will need

Chinese white	Azo yellow	Cadmium yellow	Cadmium orange	Cadmium red	Quinacridone magenta	Alizarin crimson	Burnt umber	Dioxazine violet

Phthalo blue	Cerulean blue	Cobalt blue	Ultramarine blue	Cobalt teal	Cobalt green	Payne's gray	Ivory black

- Selection of hake brushes
- ½in (13 mm) and ¼in (6 mm) synthetic flat brushes
- Selection of soft-hair mop and round brushes
- Vine charcoal
- 11 x 14 in (28 x 36 cm) hot press 140 lb (300 gsm) watercolor paper

Snowy creek

1 Tonal study
Simplify your scene into a tonal study using charcoal. Note the shapes created by the areas of light, mid, and dark tone. Transfer these areas to your paper in a pencil sketch to guide your washes.

2 Light and mid tones
Start with the light tones, adding the warm yellow of the sunlit snow to wet paper to give soft edges. Block in the mid values of the shadows and background, with varied tones.

3 Dark tones
Next, fill the areas of darkest tone in the creek and the distant tree trunks. The stark contrast between dark and light edges helps throw the snowy bank forward.

4 Warm and cool contrasts
Add warm yellows and orange where the sun breaks through and hits the snow. Outline the blue shadow edges with yellow; the stark contrast makes the shadows appear colder.

Bright snow

WAYS WITH WHITE

Using pure white to depict snow can give a graphic, illustrative feel to a painting. The purest white you have in watercolor is the white of the unpainted paper, but using opaque gouache is another option. Painting white with a combination of techniques creates layers and textures that make the single color more interesting.

■ Creating effects in a snowy landscape

A very minimal color palette suited to a wintry scene can produce an image that has considerable depth as well as textural interest. Combining techniques and tools offers the artist plenty of choice.

Snow texture
Using a toothbrush and white gouache, spatter falling snow to create natural-looking flakes of random size and shape. You need to use a strong dilution for them to show up well.

White details
A rigger is a very slender and expressive brush and is ideal for suggesting smaller branches that narrow to elegant tips.

Negative reflections
Unless water is very still, edges of objects will not exactly match the reality. Paint ripples to enhance the impression of water.

Negative spaces between the trees give a sense of depth which is enhanced by the overlapping slender white branches. A spattering of snow over the scene gives a more natural effect.

You will need

White gouache Dioxazine violet French ultramarine Neutral tint

- No. 1 soft-hair rigger brush
- No. 10 and no. 6 soft-hair round brushes
- 15 x 11 in (38 x 28 cm) rough 140 lb (300 gsm) watercolor paper

Woods in winter

1 The background
After making a sketch, mix blue and violet and lay a wash, reserving white paper for four trees and the ground. When this wash is dry, lay a second wash, this time leaving the first wash visible in the shapes of more tree trunks. Repeat this wash to darken it further.

2 Tree bark effect

Make a creamy mix of some neutral tint. Squeeze most of the water out of a no. 6 round brush and splay the hairs. Pick up a little neutral tint with the brush and drag across the trunks in a slightly curved stroke.

"Combining several ways with white makes a lively snow scene."

3 Fine branches

Check that all the paint is dry, then, using white gouache and a rigger brush, paint the fine white branches. Pull the brush rather than push it, and hold it with a light touch away from the ferrule. Let the branches overlap.

4 Falling snow

With an old toothbrush dipped in more white gouache, spatter fine snow falling. Point the bristles downward and then pull your thumb backward across the brush.

5 Water

Use the method in step 1 to paint the water and reflections of the trees. With the point of your brush, paint horizontal ripples in blue across the water and reflected trees.

Urban cityscapes

CAPTURING STREET SCENES

With so much variety of shape, activity, movement, and color on offer in a vibrant city scene, you must plan your painting carefully to include a focus of attention. Capture the city atmosphere by rendering buildings in a recognizable way, and use the street-level bustle of people and cars to draw the viewer into the scene.

■ Balancing cityscape components

A street scene comprises many elements: people, vehicles, street furniture, windows, buildings. These can all be used to create interest and shape your composition, with people adding focus and buildings and signs used to direct the eye to the street-level activity. When choosing what to include, make the scene look as natural as possible.

People
Including figures will give life to your painting. Ensure that there is variety in clothing and poses, with men and women moving in different directions. If you are combining references, overlap rather than isolate figures, to connect the scene.

Street furniture
The visual variety of street furniture can be used to aid the composition by directing the eye along the street and down to street level. Edit out detailed signage from the top of an image that might detract from the foreground focus.

Buildings
Including buildings provides a quiet setting for the real stars of the show—the people, signs, and shop fronts. Paint buildings as generalized shapes, with correct proportions and perspective, and placed logically along the street plan.

Multiple references were used to compose this engaging painting. Dark values draw you in, signage and moving figures add foreground interest, and the wet road surface connects both sides of the street.

You will need

White gouache	Yellow ocher	Permanent yellow deep	Quinacridone gold	Cadmium red	Deep scarlet

Burnt sienna	Burnt umber	Ultramarine violet	Ultramarine blue

- Selection of soft-hair flat and round brushes, no. 8 and no. 4 mop brush, stiff-bristle fan brush
- 13 x 21 in (32 x 55 cm) hot press 140 lb (300 gsm) watercolor paper

Osaka alleyway, Japan

"In an urban scene **few surfaces are parallel,** but the horizon remains **constant.**"

Reference photo 1

Rough placement and perspective

Reference photo 2

Buildings add scale

Additional details, figures, and corrected perspective

1 Choose which elements to include

Using more than one reference image means that you can select and combine different components. Both of these scenes are dark and interesting but the yellow awning in Photo 2 was too dominant. The signs and street furniture in both images add interest and the foreground of Photo 1 shows the contrast of light and dark.

2 Develop a composition

Taking the photographs as a starting point, work up your composition in sketches, combining different elements to create a scene that is convincing in perspective and proportion. Pay close attention to the interaction of people and check that all of the objects are the right size in relation to the height of the people in the street.

3 First washes
Apply a watery yellow ocher wash to the sky with a flat brush, working quickly and adding ultramarine for the shadows to establish the light and dark areas of the painting. Paint the road in two layers, using no. 4 and no. 8 mop brushes with washes of quinacridone gold and burnt sienna.

4 Initial reflections
Working wet-in-wet with a mop brush, quickly paint a loose rendition of a rainy street surface, leaving bright light on the street that contrasts with the beginnings of reflections in the wet pavement.

Yellow ocher added to the initial wash suggests reflections

Cool values in the foreground

5 Add dark values
Start to add color to some of the forms. Develop an overall warm color scheme with cadmium red and deep scarlet for the background buildings, in contrast to cooler tones mixed with ultramarine used in the foreground. Introduce darker values to give depth and perspective, defining the buildings and some street furniture and foreground figures.

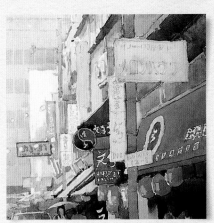

6 Define different elements
Signs, awnings, people, telephone poles, and cars are the elements that make a city scene interesting. Begin to define them, taking care to make sure they work together as a whole instead of being individual elements; carry similar colors, such as the warm tones used in the lanterns, through the painting, using round soft-hair brushes to blend the colors and bring the painting together.

7 Final details
Add color to all surfaces, blending the edges together with a loaded mop brush to avoid any hardness between the various features. Finish with line detail to define elements such as signage, using dark values for depth and a rigger brush for fine lines such as the electric wires. Add a little white gouache mixed with transparent watercolor to add accent and sparkle.

"Contrasts of shape and value draw the viewer into a scene. Exploit shadows cast from buildings on a sunny day or reflections on a wet street."

Buildings

RECORDING LANDMARKS AND VIEWS

Using a pared-back style to record an urban scene encourages you to simplify the view and make a feature of a particular building that may have caught your eye. Record surrounding details that provide a setting, using a simplified style filled with strong color and outlining features for impact.

Sketching guidelines

Approach the scene by simplifying the elements to a shorthand, using loosely drawn and colored local elements to provide a setting, suggesting perspective with simple lines, and sketching in details and features with a pen to add focus at the end.

Local elements
Simply drawn figures, cars, trees, and street furniture give quick reference points for proportion and scale when setting the scene.

Perspective lines
Observe linear perspective on buildings with simple lines without being too accurate; enough to give a sense of depth.

Drawn detail
To focus on your main areas of interest, render architectural features in a little more detail on top of flat washes by outlining or drawing them with a fine brush or ink pen.

PUTTING IT INTO PRACTICE

Here, simple washes provide a neutral background for adding more intense tones that draw attention to the central building, where ink lines focus on details. Loosely sketched local detail sets the scene.

Lift clouds with bleach

1 Neutral backdrop
Make a quick sketch of the main elements to note solid shapes, with the foreground tree framing the edge. Paint graduated washes for the sky to create a neutral backdrop.

2 Initial tones
Continue to add lighter tones, keeping the same colors but adjusting the tone on each one while the painting is still wet. A warm foreground helps lead the eye down the road to the cooler blue.

3 Urban textures
Apply grains of salt to the wet, flat wash on the side wall and road, to create the effect of urban textures of concrete and stone. Leave to dry completely before removing.

You will need

Watercolor

Transparent orange
Perylene violet
Light brown
Ultramarine blue
Aqua green

Liquid watercolor

Turquoise blue
Pastel green

- No. 2 soft-hair mop brush
- No. 1 and no. 0 soft-hair round brushes
- Fineliner pen
- Bleach

- Table salt
- 12 x 8 in (30 x 20 cm) cold press 140 lb (300 gsm) watercolor paper

Porto, Portugal

4 Flat facades
Fill in the flat faces of the buildings, using different tones for shadowed sides and overlapping some colorful washes of turquoise and ultramarine to bring interest to the main features.

5 Features
Mix darker tones and add details over the flat washes. Use a neutral gray for stonework and rich mixes for shadows of doors and windows. Loosely suggest the ornamental surround on the church.

6 Final detail
Use a pen to outline architectural details and street furniture. Include local details, such as passing cars and figures, adding a sketchy, loose line to bring the tree into focus.

Urban abstract

EVOKING A LOCATION AND ATMOSPHERE

A complicated urban scene can be daunting for an inexperienced artist, but simplifying it to the point of abstraction can be an accessible and exciting approach. Working quickly and not getting drawn into too much detail will keep your painting looking dramatic. The aim is to create a sense of place that will engage the viewer without making a very representational painting.

PUTTING IT INTO PRACTICE

The essence of a moody urban landscape drawn from the imagination can be captured quickly with the use of hard-edged shapes; strong, darker colors; bold gestures; and emphatic contrasts.

You will need

- Cadmium yellow
- Cadmium red
- Azure blue
- Phthalo blue
- Black

- No. 20 soft-hair mop brush
- Medium swordliner brush
- Spray bottle
- 12 x 16½in (30 x 42cm) rough 300lb (640gsm) watercolor paper

1 Block in the basics
Dampen the paper with a water spray. Decide where your horizon line will be and block in strong compositional marks with the mop brush. Trust your instincts and make some exciting marks. Use a concentrated mix of blue as it will become lighter when it dries.

2 Let colors bleed together
Add a hint of diluted red to the blue areas, applying it loosely and keeping your brush marks simple. Let the colors bleed together, but be sure to leave some areas of white paper.

"Dark colors and angular shapes suggest industrial areas."

■ Minimizing details

To make an abstract painting of an urban setting, reduce the amount of detail that gives definite information to the viewer. Instead, aim for ambiguity, allowing for the interpretation of the scene as the viewer wishes. Combine the basics of strong composition with diffuse edges, angular shapes that indicate buildings, and a play of lights and darks, emphasizing the latter as a way to evoke an industrial area.

Ambiguous shapes

These shapes could be read as wooden posts, clumps of reeds, rocks, or distorted reflections of buildings; the spattering might be birds, pebbles, or water spray.

Leading the eye

Strong diagonals in the sky and buildings and the linear shapes in the foreground lead the eye to the patch of light on the water that is the focal point.

3 Add the sky

Angle your board and give the paper a spray of water from the top. Let the colors merge. Blend black into the blue, suggesting a stormy or polluted sky.

4 Indicate the buildings

When the paint has dried, suggest the buildings with strong black marks to indicate warehouses and dockland.

5 Add foreground interest

Once the paint is dry, paint a few strong blue brushstrokes over the foreground black shapes to form a more solid area. Finally, add a couple of small orange highlights.

Artist **Grahame Booth**
Title **St. Mark's Square, Venice**
Paper **14 x 19 in (35 x 48 cm) cold press**
200 lb (425 gsm) watercolor paper

A group of figures

>> See pp.230–231

Almost all of the figures here are linked together, and most are only hinted at. A simple approach is always best, but the proportions must be correct for the effect to work.

Using gouache

<< See pp.150–151

Little touches of gouache successfully suggest a highlight. Masking fluid would also work, but it must be applied at the very beginning, before painting.

Straight edges

<< See pp.80–81

Applying paint using the edge of a piece of mount card gives a slightly broken straight edge, ideal for the flagpoles in this scene.

Showcase painting

This depiction of a famous, bustling scene relies mostly on suggestion. The individual marks hint at the complex structure and crowds of people (and pigeons), but each mark on its own is quite abstract. As a result, we are aware of everything in the scene without seeing any real detail.

Softening edges

<< See pp.94–97

A softly blended dark-to-light wash, disappearing as it reaches the sky, suggests a dome–a hard edge would have created the impression of a square shape.

Focal points

<< See pp.140–141

The focal point of this painting is the area of the strongest tone and color; the Z-shape of the pigeons and figures also lead the eye to this area.

Linear perspective

<< See pp.134–137

The vague lines of paving on the ground, if continued, will meet at head height of the crowd. This ensures that the ground appears level.

Creating patterns

BUILDING A FLORAL DESIGN

A successful pattern design is one that has a continuous, seamless repetition that will flow and extend endlessly without obvious variations. Use similar shapes and colors to create fluid connections on your base tile pattern, which will become the foundation for extended repeats.

▨ Repeating designs

To extend your watercolor tile pattern, scan or copy your artwork as many times as required, cropping the edges as close as you can so there are no borders or empty spaces. How you position the copies will affect the repeat. Orientate each copy the same way for a simple repeat, use a half-drop position, or try a mirrored effect.

PUTTING IT INTO PRACTICE

This base tile builds in successive layers, using organic elements that are linked together with repeated shapes and colors, to create a balanced pattern that can be used in repeated designs.

You will need

- Watercolor: Light brown, Crimson red, Opera rose, Perylene violet, Ultramarine
- Liquid watercolor: Gold ocher, Turquoise blue, Pastel green

- Liquid watercolors (colors above)
- No. 4 and no. 2 soft-hair round brushes
- No. 1 soft-hair rigger brush
- 12 x 12 in (30 x 30 cm) cold press cotton 140 lb (300 gsm) watercolor paper

Start at the outer edges

Fill all spaces, connecting elements

1 Plan design

When drawing the design, ensure all the elements are balanced and in scale, with no single element as the focus of attention. Work from the outside in, without bleeding off the edges to help when cropping for repeat designs.

2 First layer: foundation shapes

Start painting groups of elements by color. Here, three tones of green are used for the first color layer of leaves, mixing on the surface wet-in-wet. Ensure that the colors and shapes are evenly distributed across the whole tile.

Simple repeat
Place your copies in pairs in the same orientation without any spaces in between. Work in rows, ensuring corners meet neatly.

Half-drop repeat
Position two copies together vertically, align the mid-point of the third copy at the horizontal join. Add copies above and below.

Mirrored repeat
This is similar to a simple repeat but turn each copy so that the same corner meets in the center, creating a symmetrical design.

Repeat similar-sized circles of intense gold ocher

3 Second layer: connections
Mix two tones of brown from light brown and perylene violet for the tendrils that connect the flowers and help create harmony between the elements. Don't vary shapes too much; repetition is key to pattern making.

4 Third layer: balance color
Use intense mixes of pink and red for the petals and carry the color across the pattern to maintain the balance. Add details with lines and dots and overlap some new elements.

Still life shadows

USING LIGHT AND TRANSPARENCY

When composing a still life, think about the effect of lighting; the strength, direction, and brightness of a light source will create shadows that help give a sense of space and realism. The transparent nature of watercolor lends itself to delicate shadows, blending fleeting edges of light with colors and tones from the solid objects.

■ Working with shadow effects

In most still life setups you will need to consider not only the balance of solid objects but also the effects of shadows in the overall composition. Shadows add depth and help anchor objects to the surface. Look at shadows carefully, thinking about their placement, shape, and color.

Plan ahead
Establish areas of darker tone or shade to give shape to solid objects, ensuring that you leave highlights. Sketch in the outlines of cast shadows, mirroring the shape of the object and checking that the angle of the shadow is consistent.

Shadow color and shape
Observe shadow colors, as they often contain muted tones of the main object. Use a diluted wash to reflect the shape of the object in its cast shadow, noting the direction and source of light. If lit from the side, shadows will fall at oblique angles; overhead light creates short shadows. The vertical shadows seen here suggest a flat backdrop.

By keeping the shadows consistent you can create a convincing still life from a fabricated set up. In this still life, colored glass creates shadows in muted shades that are reflected onto a white backdrop, mirroring the varied shapes of the vases.

1 Plan the composition
You can create a still-life composition using found images. Here, the two pink vases inspired a still life that was set up as a photo montage of glass objects. Transfer the outlines of the composition to your watercolor paper.

Different glass objects are combined in one set up

Leave white highlights of paper where the light hits the surface

2 Establish background shapes
Establish the solid shapes that are the background for the glass objects. Wet the areas of the plinths and fill them with a light, medium gray tone with a no. 6 brush.

You will need

Nude	Harvest yellow	Camel	Light orange	Orange	Peach	Coral red	Light pink	Saddle brown	Turquoise	Aqua green	Light gray	Medium gray	Black

- Selection of soft-hair round brushes
- 11½ x 16½ in (29 x 42 cm) cold press 140 lb (300 gsm) watercolor paper

Vase shapes

Splattered color adds visual interest to the solid forms of the vases

Transparent wash bleeds at the edges into wet paper for muted tones

3 Transparent color

Fill the shapes of the vases in different colors, using transparent washes to vary the tones and represent the translucent surface. Where objects overlap, ensure one wash is dry to maintain crisp edges.

4 Add shadows

Using a lighter, transparent tone of the colored glass, apply the shapes of the shadows, keeping the wash darker close to the object and letting it soften and lighten toward the outside.

Aged surfaces

FOCUSING ON TEXTURE

The appeal of painting still lifes is that you can select your subject matter, bringing together objects that have a common theme. When focusing on texture, draw on different techniques to produce a painting that is visually exciting, with sedimentary pigments, granulation medium, and salt to convey your subject without painstakingly painting every detail. Use these methods for many subjects, from metal to fur.

PUTTING IT INTO PRACTICE

For this still life of rusty and mossy objects, grainy pigment represents the aged surface, with saturated salt applied to add real surface texture. Dry brush marks contrast with smooth blends.

You will need

- Lemon yellow
- Cadmium red
- Burnt sienna
- Cerulean blue
- Cobalt turquoise light
- Ultramarine blue

Granulating:
- Piemontite genuine
- Shadow violet
- Cobalt blue
- Lunar blue
- Green apatite genuine

- No. 18, no. 10, and no. 6 soft-hair round brushes
- Granulation medium
- Salt wash of 50:50 salt to water
- 10½ x 15 in (26 x 38 cm) rough 140 lb (300 gsm) watercolor paper

Patinated textures

1 Highlight underpainting
Paint the highlights that you want to retain, using large, transparent, overlapping washes for the brightest surfaces. For the rusted edges, use dry brush marks (see pp.56–57) and granulating pigments such as cobalt to introduce texture. Mix green and violet granulating pigments for the algae effect.

2 Encourage granulation
When the underpainting is dry, apply a wash of clear granulation medium over the areas of algae. While still wet, add granulating pigments with more medium, painting with a loaded brush at a vertical angle. Encourage rivulets to run freely.

■ Controlling textures

By combining granulating pigments (see pp.90–91) with granulation medium or salt, you can intensify or manipulate the effects to create some unique patterns, such as free flowing rivulets. Plan your palette to include pigments that separate, and match them to your subject and the textures that you wish to convey. A salt wash attracts pigment to look grainy, which differs to the light, mottled effects of using dry salt (see p.148).

Rivulets and runs

Apply granulation medium to the underpainting. Then slowly dribble granulation medium and granulating pigments down the surface for rivulets.

Salt wash

Mix 50:50 salt and water and apply as a clear wash. Drop strong pigment into the wash before it dries. The pigment and salt combine for a textured effect.

The texture of the rough paper holds pigment that adds to the overall effect

3 Apply salt wash

Once your rivulets have dried, scoop up a thick quantity of saturated salt onto your brush and apply it with the salt water to the rusty areas. Quickly add plenty of burnt sienna in blobs to this area; it will appear lighter as the pigment is drawn to the salt grains.

4 Smooth contrasts

While working on the rusty texture, keep other parts smooth for contrast, working wet-on-dry for the lamp base. Add the background, keeping the textures simple in order not to detract from the main focal points.

Artist **Michele Illing**

Title **Garlic, Lemons, and a Lime**

Paper **16½ x 27 in (42 x 69 cm)**

cold press 140 lb (300 gsm)

watercolor paper

Shadows and sunlight

≪ See pp.138–139

Strong shadows—which are colored, not just gray—with defined edges, give depth and a sense of three-dimensional form, and show the direction of light.

Using masking fluid

≪ See pp.100–101

Masking fluid is very effective at keeping small areas and thin lines white, which would otherwise be impossible when painting in watercolor.

Wet-on-dry

≪ See pp.50–51

Using the wet-on-dry method liberally gave the artist the freedom to enhance areas of the painting with interesting visual textures and brush marks.

Showcase painting

Light, shade, and color are key to this painting, as is the balance between free and controlled brushstrokes. By capturing the infinite variety with which light falls on objects, both natural and human-made, watercolor can elevate the humblest of subjects to the status of art.

Highlights

≪ See pp.104–105

Leaving some of the white of the paper rather than applying opaque white is a much fresher approach to adding highlights, and will make your painting glow.

Splattering

≪ See pp.98–99

A simple splatter technique adds energy to a still life. The thicker the bristles, the coarser the splatter. For these marks, a stiff stipple brush was used.

Complementary colors

≪ See pp.118–119

The blues and purples in this painting help create color harmony and mood, while the intense contrast of the bowl of yellow lemons is enhanced by the purple shadows.

Botanical painting

DEPICTING PLANT LIFE ACCURATELY

Sitting somewhere between art and science, botanical art serves both faculties. The botanical illustrator not only depicts the form, color, and botanical structure of a plant as accurately as possible, but also paints with artistic expression.

■ Beautifully accurate

Build up layers gradually, starting with the lighter tones and working to darker ones. Successive washes help create the form of the flower and give a luminosity to the piece. As well as using delicate wet-in-wet brushwork, a drier brush technique (little paint, little water) is best for adding details and darker shadows.

Layer 1

Layer 2

Layer 3

Layer upon layer
Build up rich colors over several carefully applied layers of wet-in-wet washes. Allow each layer to dry completely before applying the next one. This repeated sequence creates form and strengthens color.

Darker details
Highlight detail or deepen shadows with a drier brush. Pick up small amounts of drying paint on the tip of your brush or switch to a smaller brush.

A drier brush works best for details

A moment in time is captured in this study of a fading anemone flower. Such detailed work demands a smooth surface, so a hot press watercolor paper works better than a more textured paper.

You will need

Quinacridone gold · Quinacridone red · Quinacridone magenta · Phthalo blue (green shade) · Mayan dark blue

- No. 6 soft-hair round brush
- Ruling pen
- Masking fluid
- Tracing paper
- Graphite transfer paper
- 8½ x 8½ in (22 x 22 cm) hot press 300 lb (640 gsm) watercolor paper

Fading anemone

1 Posing the subject

Position the main light source in front of the subject but to one side. A secondary light on the other side will act as a backlight to enhance the translucence of the papery petals.

2 Creating the background

Thoroughly wet a larger-than-needed piece of paper. Dab pale mixes of browns and creams into the wet areas. Once dry, trim to include the most successful area.

The mottled appearance echoes fading book pages

3 Transfer the drawing
Working alongside the specimen, draw the flower larger than life size onto tracing paper. Transfer using graphite transfer paper.

4 Protect lighter areas
Apply masking fluid to the central stamens with a ruling pen. Once dry, you can safely wash over the masked shapes to create depth.

5 The wet-in-wet washes
Wet the whole shape, then dab color to create the underlying undulations and forms on one petal at a time. Watch out for dryness.

6 Successive layers

Repeat the wet-in-wet washes, as needed, to build up the form or color. It is not unusual to have to apply several layers at this stage as colors tend to dry paler than when first applied. The golden rule is to not fiddle once the paint starts to dry, then leave to dry completely before working on subsequent layers.

7 Detail on petals

Once you're happy that the petals are looking three-dimensional, switch to a drier brush technique for veining detail and to deepen shadows. "Draw" the detail using small amounts of dried paint color. Make these veins irregular and uneven to reflect the dried, papery feel of the petals.

> "Fading flowers shrink as they dry, so are easier to depict if painted larger than life."

8 Revisit the center
Once you are happy with the depth of color and the paint is dry, rub off the masking fluid with clean fingers to reveal and paint the individual stamens.

9 Leaves next
Experiment with the arrangement of the leafy collar on your tracing paper drawing. Then, transfer this drawing over your painted image.

10 Finishing touches
Assess the whole range of tones from dark to light and adjust. Even tiny areas of dark, where a petal turns over, for instance, can bring a painting to life.

Loose flowers

SUGGESTING FLOWERS SIMPLY

When painting flowers in a loose, fluid style, it is important to be selective about how wet you choose your paper to be. Broad washes of color that flow across the paper provide exciting effects that allow the viewer's imagination to fill in the petals further, but some detail is also needed to give structure and variety.

■ Suggesting depth and detail

Using a mixture of soft and harder edges conveys the three-dimensionality of the flowers, while also stimulating the eye of the viewer with different textures and lines. Strong colors and harder lines advance in the painting, while diffuse washes of similar colors for the background give the idea of a larger number of flowers that cannot be clearly discerned.

Hard and soft edges
A combination of hard and soft edges describes the flowers, yet also invites the viewer to lend their imagination. A detailed botanical approach is not necessary to explain the flowers—suggesting their essence is sufficient.

Hard edge

Suggestive background
A background that is not clearly explained suggests depth to the viewer and invites the sense that there is more to be revealed. Diffuse shapes and diluted colors mean that the background enhances rather than competes.

PUTTING IT INTO PRACTICE

The energy of the strokes in saturated color adds vibrancy to this still life. The random effect of one color flowing into another brings dynamism.

You will need

Madder lake red light	Red ocher	Hooker's green	Rose	Phthalo blue (green shade)	Neutral black

- No. 18 and no. 12 soft-hair mop brushes
- No. 5 synthetic and no. 3 soft-hair round brushes
- 8¼ x 6 in (21 x 15 cm) hot press 140 lb (300 gsm) watercolor paper

Pink lilies

1 First hints at form
Wet the whole sheet with a thick brush, then loosely apply a mix of ocher and madder lake red light where the flowers are. If needed, you can tilt the paper to allow the paint to flow freely.

"**Fluid washes** of color evoke the **freshness** of living flowers while defined marks give **structure**."

2 Leaves and stem structure

When the paper dries out a little but is mostly wet, add structure. For leaves and stems, mix green with black and madder. Where the paper is drier, the strokes will be clearer and where it is wet, they will be blurry.

3 Flowers and buds

When the paper dries a little more, indicate flowers and buds with free strokes, mixing colors as you choose. Use intense colors for line details and less saturated ones for more general color.

4 Finishing touches

When the paper is completely dry, add details with a fine brush. As well as lines, you can apply water and dot on some paint, allowing it to spread slightly.

Add leaves where you like to enhance the composition

Painting faces

CAPTURING A LIKENESS

The first step is to choose a pose that is interesting and relatively easy until you have gained some experience; a slightly turned profile is attractive and you need to paint only one eye rather than trying to match the exact gaze of a full-face portrait. Use natural lighting so the coloring of your subject will be more true to reality.

■ Making a lively portrait

What you leave out of a portrait is as important as what you include. Hair and clothing can be merely suggested; your colors and technique can add more vitality to the subject than painting everything will achieve. Save your finer detail for the focal point, often the eyes.

The eyes
Render the eyes with more controlled strokes, using a thin brush to build shadows on the eyelid, adding fine marks for eyelashes, and leaving crisp, wet-on-dry edges for the pupil.

The hair
Whatever the style, hair can be minimally suggested using just blocks of color with a few strokes painted to describe its general direction.

Shading with color
A successful rendition of skin tone (see pp.220–223) is integral to a good portrait. Try less literal color mixes such as blue with pink, for a lively effect.

PUTTING IT INTO PRACTICE

Breaking the tones down into shapes makes portraits easier to paint as you can more easily see the placing of the features. You need to be decisive early on about what you will paint and what you will omit.

You will need

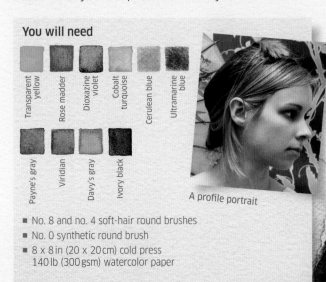

Transparent yellow | Rose madder | Dioxazine violet | Cobalt turquoise | Cerulean blue | Ultramarine blue

Payne's gray | Viridian | Davy's gray | Ivory black

A profile portrait

- No. 8 and no. 4 soft-hair round brushes
- No. 0 synthetic round brush
- 8 x 8in (20 x 20cm) cold press 140lb (300gsm) watercolor paper

Rose madder and cobalt turquoise

Cerulean blue and rose madder

1 Laying shadows
Using the no. 8 round brush, lightly lay pools of rose and turquoise where the shadows on the face are present. Use a slightly cooler mix of cerulean and rose on the forehead, which is on a different plane to the cheek in relation to the light.

Painted negative space emphasizes the shape of the face

2 Framing the face
Use the no. 8 brush to paint the negative space around the face, neck, and hair with Payne's and Davy's gray mixed together. Carefully work around the edges, causing the face to emerge. Allow plenty of space for the hair—remember that the eyes are halfway down the head.

"Natural lighting will give you the truest skin tones in a portrait."

3 Defining the features
Mix yellow, violet, and ultramarine for the hair and build up with the no. 4 brush. Mix viridian and rose with the no. 0 brush to define the darkest areas of the features. Use a touch of black for the pupil and rose for the lips.

4 Shadows and highlights
With the no. 4 brush, mix cerulean, rose, and yellow. Paint the shadows on the skin to create more depth. Add a very diluted wash of yellow to create warmth on the highlights.

5 Finishing touches
Mix Payne's gray and cerulean with the no. 4 brush and repaint the background. Use the no. 0 brush to refine the hair, selecting any strands with ultramarine, violet, and yellow.

Skin tones

PAINTING THE COLORS IN SKIN

Realistic skin tones are best painted with just a few basic colors, since this results in tones that harmonize with each other and provide a natural appearance. All skin tones, from the lightest to the darkest, can be painted with a limited palette of just three colors, with reserved paper providing white for the highlights.

■ Light and shade

Look for the high, mid, and dark tones in your subject's skin, which depend on the direction and strength of the light source. When close to light, the skin may look paler, cooler, or yellower. Using a cool green or purple mix is an effective way to depict shadows, as they will complement the warm reds and yellows in the skin.

■ Flesh tones

Using a basic palette will give you a good starting point for mixing skin tones. Earth colors such as sienna, umber, and ocher often provide a good foundation for flesh tones; you can mix them with primary colors to create warmer or cooler hues according to the high, mid, and dark tones you have identified.

| Cadmium yellow | Yellow ocher | Raw sienna | Burnt sienna | Burnt umber |

| Cadmium red | Alizarin crimson | Cerulean blue | Ultramarine |

Limited palette

Mixing skin tones from a limited palette of colors will help unify your painting. Choosing a warm and cool version of each primary color will ensure that you can create a wide variety of convincing skin tones, no matter the complexion of the subject.

■ Dark skin tones

Dark skin uses burnt sienna in the high tone. Mixing it with cool crimson prevents the skin tone being too orange. Burnt umber in the mid tone gives a warm brown which can make a mauve in darker mid tones.

| High tones | Mid tones | Dark tones |

Burnt sienna	Burnt umber	Burnt umber
+	+	+
Alizarin crimson	Alizarin crimson	Alizarin crimson
		+

Ultramarine

Palette for dark skin

Use burnt sienna with crimson for the high tones, substituting burnt umber for the sienna in the mid tones. For very dark skin, make strong mixes and add ultramarine to cool the color a little so that the crimson does not dominate.

Olive skin tones

Olive skin has raw sienna instead of burnt sienna in the first mix for the high tone. Raw sienna is a yellower color, which is also used in the mid tone to keep the olive complexion from looking too brown.

Light skin tones

Light skin can be painted from pink through to yellow tones by varying the balance of alizarin crimson to yellow ocher in the first mix for the high tone. Use darker tones of the mixes for shadowed areas.

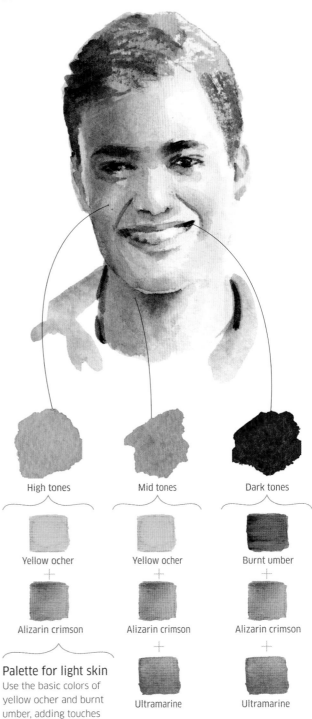

High tones	Mid tones	Dark tones
Raw sienna	Raw sienna	Burnt umber
+	+	+
Alizarin crimson	Burnt sienna	Alizarin crimson
		+
		Ultramarine

High tones	Mid tones	Dark tones
Yellow ocher	Yellow ocher	Burnt umber
+	+	+
Alizarin crimson	Alizarin crimson	Alizarin crimson
	+	+
	Ultramarine	Ultramarine

Palette for olive skin

Lay washes for the overall skin color and tone then use darker tones for shadow areas. For olive skin, use only subtle variations of color and tone to give a convincing effect. Allow washes to dry then build up gradually.

Palette for light skin

Use the basic colors of yellow ocher and burnt umber, adding touches of crimson or ultramarine for warm or cool areas.

PUTTING IT INTO PRACTICE

Portraits rely on a slow build up of washes, because it is easy to add extra paint but undesirable to lift out unwanted edges and marks, since it leaves the skin looking too shiny. Secondary colors are best mixed rather than using manufactured colors.

Cerulean blue and alizarin crimson create a cool lilac shadow

You will need

Yellow ocher · Cadmium yellow · Cadmium red · Alizarin crimson · Burnt sienna · Burnt umber · Cerulean blue · Ultramarine

- No. 12, no. 8, and no. 4 soft-hair round brushes
- Craft knife or razor blade
- 15 x 12 in (38 x 30 cm) cold press linen 140 lb (300 gsm) watercolor paper

A relaxed pose

1 Laying a base color

Paint a mix of crimson and ocher over the face, leaving reserved highlights on the top and side of the head and the beard area. Dilute the wash where the mustache will be. When this wash is dry, use the color again to darken some areas, in particular around the eye sockets, sides of the nose, and under the chin.

 + =

Yellow ocher + Alizarin crimson = First wash color

2 Modeling the head

Mix a wash of crimson, ocher, and cerulean with which to create a three-dimensional tonal image, paying attention to the bone structure of the head. Form the eye sockets, define the nose, and shape the cheek bones. When this is dry, use the same wash a second time to darken the features.

 + + =

Yellow ocher + Alizarin crimson + Cerulean blue = Second wash color

3 Intensify colors

Using ocher, red, cerulean, and crimson, paint the brighter colors of the skin and clothing. Cadmium red mixed with ocher down the center of the nose brings it forward. Dry brush a mix of ocher and cerulean to suggest beard stubble. Drag a mix of cerulean, ocher, and crimson for the eyebrows, beard, and mustache.

4 Darkest tones

Make a mix of ultramarine, crimson, and umber to create a soft black for small details. Use this mix for all the features, varying it to make brown, mauve, and green darks for a lively portrait. Dry brush the mix over the beard in a broken stroke to give the impression of whiskers.

Alizarin crimson + Burnt umber + Ultramarine = Soft black color

5 Lift out details

Once the painting is completely dry, use a sharp blade to lift out just a few of the hairs of the beard that were not possible to reserve.

Expressive portrait

CONTRASTING BOLD AND SUBTLE COLORS

Vibrant color blocks, quick strokes, and subtle layers combine here to create an expressive style of portrait. The skin tones on the face are created from layers of warmer or cooler transparent color.

■ Creative color

The multiple layers of color on the face, the vibrant multi-colored blocks of color flowing into each other on the hair, and the quick free lines on the clothes and hair give the effect of expressive realism. The colors may spread beyond the pencil lines to give the effect of additional dynamism.

Color Gray scale

Colorful tonal range
The hair colors may seem unconventional, but converted to gray scale they can be seen to follow a tonal range: yellow for high tones, red for mid tones, and blue for the darkest tones.

Glazing the skin
Several layers of delicate, transparent washes create a multi-dimensional effect on the skin. They are especially suitable to convey the youth and sensitivity of the subject.

In this technique, the effect of inventive colors, strokes, and lines is important. In contrast, the face and eyes are clearly drawn, giving structure and a focal point respectively.

You will need

Hansa yellow | Yellow ocher | Madder lake red light | Scarlet | Red ocher | Raw sienna | Phthalo blue (green shade) | Ultramarine | Neutral black

- No. 18 and no. 3 soft-hair round brushes
- No. 12 mixed-hair oval wash brush
- No. 5 and no. 2 synthetic round brushes
- 12 x 8 in (30 x 20 cm) cold press 140 lb (300 gsm) watercolor paper

Three-quarter profile

1 Mark highlights and shadows

In your pencil sketch, mark circles where there will be highlights or dark tones. Leave fine lines, but erase excess ones. You can erase some after applying the first layer once it has dried.

2 Apply a base wash

With a thick brush, lay a dilute wash of sienna, leaving white paper for highlights. Lay more paint for dark tones with a mixed oval wash brush. Apply water to lighter areas, blot it, then lift off color with a clean thick brush.

"An expressive portrait allows you to be free and experimental with color rather than trying to describe reality."

Yellow in the hair indicates light falling on the top of the head

Stray bits of hair rather than a smooth outline give a lively effect

3 Block in the hair

Dampen the hair area with clean water. Add ultramarine, yellow mixed with yellow ocher, and scarlet mixed with red ocher. One color can flow a little into another. Be careful not to mix with the layers on the face.

4 Layer the skin colors

When the first layer dries, add a blue and ultramarine mix on the face and eye area. When it is dry, add eyebrows and eyes with a black and ultramarine mix. Use scarlet with red ocher for shadows and the mouth.

5 Finishing touches

Using ultramarine and black for the darker areas, apply thick paint for the hair. Paint the clothes with plenty of water so that everything flows to fit the style of the face.

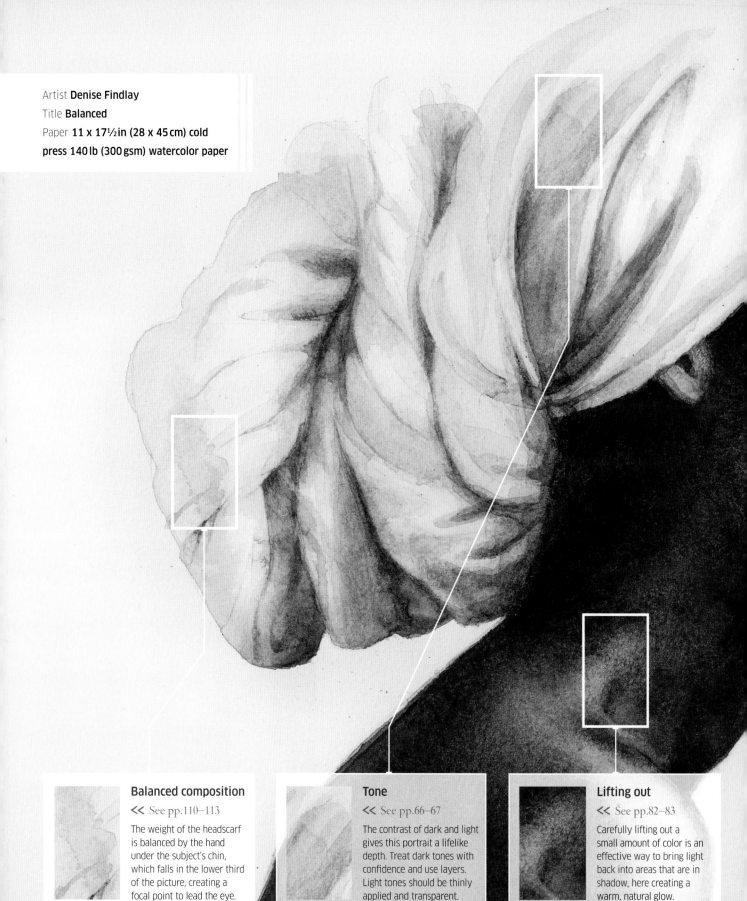

Artist **Denise Findlay**
Title **Balanced**
Paper **11 x 17½in (28 x 45cm) cold press 140lb (300gsm) watercolor paper**

Balanced composition

<< See pp.110–113

The weight of the headscarf is balanced by the hand under the subject's chin, which falls in the lower third of the picture, creating a focal point to lead the eye.

Tone

<< See pp.66–67

The contrast of dark and light gives this portrait a lifelike depth. Treat dark tones with confidence and use layers. Light tones should be thinly applied and transparent.

Lifting out

<< See pp.82–83

Carefully lifting out a small amount of color is an effective way to bring light back into areas that are in shadow, here creating a warm, natural glow.

Showcase painting

This luminous portrait combines a striking composition with a soft, delicate approach to conveying the subtleties of skin tone, light, and shade. Painting a person in profile emphasizes the contours of the face, especially effective against the minimalistic background used here.

Negative spaces

« See pp.114–115

The silhouette of the subject's head and hand create interesting background shapes in the space between and around the form.

Softening edges

« See pp.94–97

A seamless transition between light and dark areas was created by adding water to the edge of a colored wash, then blending with a dry brush.

Single figures

POSE, SETTING, AND COMPOSITION

Successful figure paintings usually create a sense of scale, proportion, and perspective. The best way to achieve this is to think of the figure as part of a setting. Pay attention to the overall composition and spatial relationships between the figure and the other elements in your painting.

■ Scale and relationships

Figures are enhanced when painted in relation to another point of interest. The comparative sizes of the horse and farrier need to be judged to create harmony between the two shapes. The sense of space between them is produced by using warm and cool colors.

Cool colors push the background away from the viewer

Warm colors help the foreground advance and create a sense of depth

Identifying key shapes
The upright shape of the horse gives structure to the top of the painting. Impact comes from the diagonal of the farrier's feet and shoulders, while shadows in the sleeves show the stretch of the arms.

Tonal contrast is important in this painting, because the focal point is where the lightest and darkest tones touch each other. The defined edge of the horse's flank against the blurred background gives perspective to the scene.

Cool cerulean blue

1 Cool background tones
Using cool cerulean blue on the back of the sweatshirt, and a mix of cerulean and ocher behind the forearm, pushes back these areas to create distance. The white of the forearm is reserved to bring it forward.

Warm cadmium orange Warm ultramarine

2 Warm foreground tones
Warm ultramarine is used for the jeans to bring the front leg forward. Allowing the cerulean and ocher mix to bleed into it gives granulation that suggests denim.

You will need

Cadmium yellow

Yellow ocher

Cadmium red

Alizarin crimson

Burnt sienna

Burnt umber

Cerulean blue

Ultramarine

- No. 14 and no. 8 soft-hair round brushes
- 15 x 11 in (38 x 28 cm) cold press linen 140 lb (300 gsm) watercolor paper

Fitting a horseshoe

3 Hard and soft marks

Scale and balance are emphasized by using hard edges toward the front of the farrier and keeping the mark-making soft for painting the horse behind him.

4 Wet-in-wet backdrop

Wet-in-wet painting using cool tones gives some interest in the background while at the same time keeping it visually soft to maintain the sense of distance.

5 Dry-brush texture

A dry-brush technique is used to paint the tail of the horse, giving the impression of movement and the texture of the hairs.

A group of figures

PUTTING PEOPLE IN THE PICTURE

Many artists avoid putting people in their paintings, but figures can make your painting come alive. They needn't be detailed; often a suggestion of a figure is enough. The key to bringing unity to the piece is capturing the proportions of figures within the perspective of the scene.

Capturing people

Focus on the proportions, gesture, and pose of the figures: the way they walk, swing their arms, and lift their legs. Always consider the scale—you don't want figures taller than doorways, for instance. Unless the person is up-close, there is no need to worry about facial features or details of the hands and feet.

PUTTING IT INTO PRACTICE

This painting is more about the figures than the landscape. If you concentrate on the proportions and get the gestures right, you can use surprisingly loose brushwork to convey the sense of a bustling crowd.

You will need

- Pure yellow
- Yellow ocher
- Quinacridone magenta
- Cadmium red
- Perylene maroon
- Caput mortuum violet
- Perylene violet
- Manganese blue
- Ultramarine blue
- Indanthrene
- Phthalo green (blue shade)
- Neutral tint

- No. 10, no. 6, and no. 000 soft-hair mop brushes
- Small Chinese brush
- 12 x 17 in (30 x 43 cm) hot press 300 lb (535 gsm) watercolor paper

Castel Sant'Angelo, Rome

1 Prepare the paper
Using a large mop brush, dampen the paper around the foreground figures and statues. Lay wet-in-wet washes for the background, being careful to leave some light in the foreground. Think about color as it will set the mood of the painting.

2 Background figures
Build up the background figures using a wet-on-dry technique, thoroughly drying each layer as you go. Separate light and dark tones as figures recede; very distant figures can just be silhouetted shapes.

Proportions

A person is generally 7 to 8 "heads" tall. The belly button sits 3 heads down; wrists, crotch, and hips are halfway down; 4 heads down for fingertips; 5 for knee caps. Make sure the head sits on, and does not float above, the shoulders.

Bottom of knee cap is 5 "heads" down

Normal eye level

Standing perspective

On level ground, a crowd of people's heads appear at the same height but their leg-length decreases as they gain distance.

Lower eye level

Seated perspective

If you are sitting, the eye line would be lower and run through the same part of each figure, probably around the chest.

3 Foreground figures

Gently define features of the foreground figures as you build up tone, without being over-fussy with detail—just hint at features.

4 Add shadows and detail

Once each layer is dry, paint in shadows and detail, focusing on ever-smaller shapes every layer.

5 Finishing touches

Add more local color and splatter the foreground for interest. Darker tonal accents will give depth.

Fashion illustration

EXPRESSING CREATIVE IDEAS

Compared to traditional figure painting, fashion illustration allows you to develop a more abstract, simplified approach to a pose. Any medium is suitable but watercolor is especially expressive.

Taking a graphic approach

Your choice of materials is endless, and this is a great opportunity to use mixed media and many expressive watercolor techniques to convey the originality of your designs. Using graphic materials, such as liquid watercolor, fineliner pens, technical pencils, gouache, and collage, will add extra drama to the clothes.

Pen and ink
Technical pens and fine marker pens can be used to either outline an image, or add detail over a dry wash. Scribbles, hatching, and shading can all be used to suggest pattern or fabric sheen.

Watercolor effects
Fluid wet-in-wet blends within a simplified outline, or silhouette, suggest both movement and pattern in fabric. Manipulate blends to suggest garment components, such as sleeves.

PUTTING IT INTO PRACTICE

Inspired by catwalk images, this illustration combines bold, simple colors with added pattern and fine detail to showcase the clothes, using varied tones and blends to add depth and texture.

You will need

Nude · Harvest yellow · Camel · Red · Light gray · Medium gray · Black

Catwalk sketch

- Liquid watercolors (colors above)
- Selection of soft-hair round brushes
- 0.5mm fineliner pen or technical pencil
- Bleach
- Cotton swab
- 12 x 8½ in (30 x 21 cm) cold press 140 lb (300 gsm) watercolor paper

1 Draw outlines and add skin tones
Use a fine pen or pencil to develop your ideas. Include details and outline any areas of different colors. Facial features are kept to a minimum but add hair shape and lips. Start by painting the skin with two or three natural tones and no. 2 and no. 4 brushes, keeping just inside the pencil line.

2 Build color
Fill the colored areas, using undiluted color for solid features, such as the shorts, and ensuring each area dries before adding the next. Use dilutions of black to fill the top.

"Combine graphic drawing skills with painterly effects to develop ideas."

3 Wet-in-wet blends

Use drops of red for the dress, diluting the intensity of the color with water and allowing some natural blending wet-in-wet to occur on the paper. Use lots of water to dilute the wash for highlights.

4 Fine details

Once the main clothes have been added and have dried, continue to add the finer details and the accessories, using a thin no. 1 brush. Paint the feathers with undiluted black. Alternatively, use a fineliner pen.

5 Fabric patterns

To add a dot pattern to both figures, carefully apply drops of bleach with a cotton swab over the watercolor, reapplying the cotton swab each time and using the tip to vary the size of the dots. Some pigments will leave a lighter tone rather than a bright white.

Incidental figures

PORTRAYING FIGURES IN A LANDSCAPE

Figures naturally tend to demand our attention and can dominate a scene. For landscapes, all elements should blend to a harmonious whole. Through careful planning and color choices, you can subdue the impact of figures in various ways to create a balanced composition.

◼ Integrating figures

It is easy to make figures in a landscape too prominent. Remember you are painting a landscape that happens to have figures, not a figure study with a landscape; the figures must blend with the other elements. Try to connect and harmonize the figure with the landscape by merging edges and repeating colors.

PUTTING IT INTO PRACTICE

In this view, the figures are part of the landscape, adding incidental detail to the overall composition. Similar colors and tones from the sea and land help the figures blend with other elements without distraction.

You will need

Azo yellow

Cadmium yellow

Burnt sienna

Quinacridone magenta

Cadmium red

French ultramarine

Phthalo blue (green shade)

- No. 14 soft-hair round brush
- No. 10 soft-hair mop brush
- 10 x 14 in (25 x 35 cm) cold press 140 lb (300 gsm) watercolor paper

1 All-over wash
Paint a blending background wash from top to bottom. Use a mix of phthalo blue with a touch of quinacridone magenta for the sky and sea, and a warm mix of quinacridone magenta and azo yellow for the land. Do not leave space for the figures; nothing is more isolating than a hard edge around every figure.

2 Blend figures to background
Start to gradually define the elements with the second wash, warming the middle ground with cadmium yellow. Use similar tonal values for the figures, carrying touches of burnt sienna in the landscape to create visual connections.

Seafront

Allow some of the figures to partly blend with the background

Blending in
White space or painting a hard edge around a figure will immediately isolate them, as if spotlit. To avoid this, soften edges and partly blend the figure with the background, linking it to other features.

Repeating colors
Try to integrate figures into the rest of the landscape by using the local color for both, and if you must use a strong color such as red in your figure, include it in the landscape, too, to lessen the visual effect.

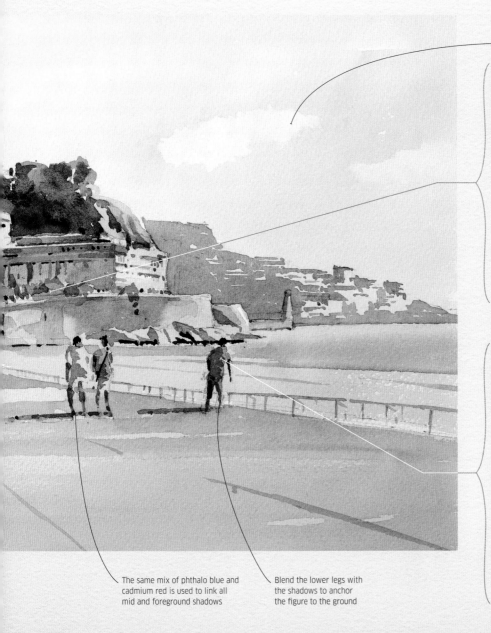

A few light clouds break up the sky wash and balance the composition

The same mix of phthalo blue and cadmium red is used to link all mid and foreground shadows

Blend the lower legs with the shadows to anchor the figure to the ground

3 Connect colors
Repeat every color in the landscape in the figures (and vice versa) to create harmony. Here, the stronger greens and browns of the palm trees link to the clothing in the figures beneath.

4 Tonal balance
Continue to strengthen all colors, adding darks here and there with dots and dashes to create tonal interest. Treat the figures with no more importance than the trees or buildings, using similar tones and color.

Artist **Gilly Marklew**
Title **The Swimmer**
Paper **13 x 18½ in (33 x 47 cm) cold press**
140 lb (300 gsm) watercolor paper

Using masking fluid

≪ See pp.100–101

Masking fluid, applied between colored washes, preserves white and tinted highlights, allowing the artist to apply washes freely without losing light tones.

Layering paint

≪ See pp.58–61

Lighter colors have been applied over large areas, then incrementally smaller sections glazed in translucent washes on top, revealing the previous washes in between.

Lifting out

≪ See pp.82–83

To create glowing highlights on the surface of the water, the masked-off areas were softened by lifting out pigment with a brush when the wash was almost dry.

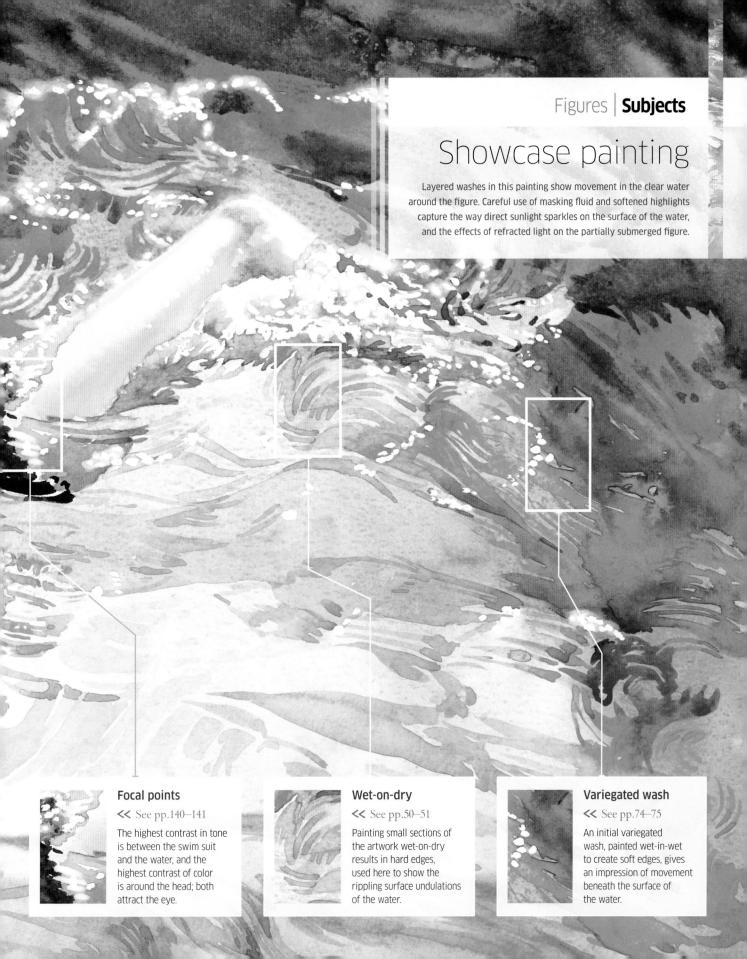

Showcase painting

Layered washes in this painting show movement in the clear water around the figure. Careful use of masking fluid and softened highlights capture the way direct sunlight sparkles on the surface of the water, and the effects of refracted light on the partially submerged figure.

Focal points

≪ See pp.140–141

The highest contrast in tone is between the swim suit and the water, and the highest contrast of color is around the head; both attract the eye.

Wet-on-dry

≪ See pp.50–51

Painting small sections of the artwork wet-on-dry results in hard edges, used here to show the rippling surface undulations of the water.

Variegated wash

≪ See pp.74–75

An initial variegated wash, painted wet-in-wet to create soft edges, gives an impression of movement beneath the surface of the water.

Pet portraits

PAINTING ANIMAL COMPANIONS

Capturing your pet's unique character in watercolor is a challenge, but with a subject that is familiar and a medium that is particularly suited to the soft nature of fur and whiskers, you will soon master pet portraiture. Sketch from life and take lots of reference photos to help choose a pose.

▇ Conveying highlights and textures

A common characteristic of most pets is their fur. Utilize different brushstrokes for fur textures, layering your strokes wet-on-dry to build a sense of density and direction, helping give your pet form. Highlights found in eyes, wet noses, and shiny fur can be incorporated with resist techniques (see pp.100–103).

White highlights
For contrasts in markings you can leave some of the white of the paper showing, or use masking fluid in the early stages to preserve the highlights. Once removed, the masked area will have a defined, crisp edge that can be softened if required.

Fur texture
Chinese brushes are ideal for painting fur as they hold their shape when spread, and you can paint several hairs at the same time. These brushes are very absorbent and will hold a lot of paint, creating fluid strokes.

Wet-on-dry strands
Load a small brush with wet paint and paint on dry paper to achieve strokes with hard edges; ideal for defining strands of fur. This wet-on-dry technique tends to give you more control when working in small areas.

In this pose, the face is painted in detail, making the spaniel's doleful eyes the focus with his direct gaze. The form of the body is conveyed using different brushes, set against a loosely defined background.

You will need

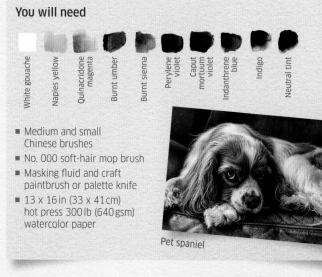

White gouache · Naples yellow · Quinacridone magenta · Burnt umber · Burnt sienna · Perylene violet · Caput mortuum violet · Indanthrene blue · Indigo · Neutral tint

- Medium and small Chinese brushes
- No. 000 soft-hair mop brush
- Masking fluid and craft paintbrush or palette knife
- 13 x 16 in (33 x 41 cm) hot press 300 lb (640 gsm) watercolor paper

Pet spaniel

1 Establish basic proportions
Check the relationship between eyes, nose, and ears to make sure your drawing is accurate. Mask highlights such as the whiskers and eyes, and lay in lightest color areas with a splayed Chinese brush.

2 Underlying form
Notice how the fur follows the underlying form, parting over the muzzle, for example. Mask to keep the areas of lightest paint. Think of masking fluid like paint and consider the marks you're making. Start to build up glazes for the eyes and nose.

3 Background washes
Paint in a loose background with large variegated washes. Mix your colors on the paper not on the palette; they will be much fresher. Use the side and tip of a medium Chinese brush for different, loose marks.

4 Build layers
Add fur color and when dry define the area, following the direction of the fur with your brush. Use a small Chinese brush to build detail wet-on-dry (see left), giving the illusion of layers of fur without overworking.

5 Soften edges
When you feel you have built enough depth in your painting, remove the masking fluid. Use a damp mop brush to soften and blend hard edges as needed. Add final details with a few strokes of white gouache.

Creatures in motion

CAPTURING WILDLIFE CHARACTERISTICS

Careful observation is key to painting animals since you need to capture their essence in nature in just a few brushstrokes. Understanding their anatomy is useful, too, as proportion and balance are equally important for an authentic portrayal.

■ Defining features and form

Experiment with the best techniques to use to express the key features, such as eyes, ears, nose, mouth or beak, and feathers or fur. Certain techniques lend themselves perfectly to describe fur, where you want to give the impression of both texture and density. Layering techniques help build colors that not only describe an animal's pelt but also help suggest the form of the body beneath.

Dry-in-wet
Single, brisk strokes or dabs of dry paint into wet washes produce very effective results for fur, hair, or animal markings. The drier the paint, the more it will hold its form in the wet layer, blurring just enough to give credible effects of fur. Be aware that if paint is not dry enough it might cause runbacks.

Stretching out
Mix a loose wash and paint it lightly over the dried layer. With a slightly damp brush, drag and "stretch" the wet paint into the areas where you want crisp shapes of tone, shadow, or fur. Such "stretching out" allows you to control the sharp edges.

Sharper edges add definition

The interplay of cooler tones contrasting with the warmer tones in this painting aims to thrust the hare forward, emphasizing a sense of urgency and its speed. Loose impressions of fur add vitality.

You will need

Raw sienna | Indian yellow | Raw umber | Van Dyke brown | Burnt sienna | Alizarin crimson | Cadmium red | Dioxazine violet | French ultramarine | Phthalo green (blue shade)

- No. 15 and no. 8 soft-hair round brushes
- 2 in (5 cm) hake brush
- No. 3 synthetic-fiber rigger brush
- 14½ x 20¼ in (36 x 52 cm) cold press 140 lb (300 gsm) watercolor paper

Hare sketches

1 Initial sketch
Sketch the pose, noting the angle and length of the ears (the ears of a hare are surprisingly long). The setting of the ears dictates the pitch of the head. Take care to get the balance right so that the shift of weight on the downward leg would convincingly propel the hare forward. Correct proportion is key.

"Use rapid strokes and loose wet-in-wet mixes to reflect the immediacy of a moving subject."

2 Wet-in-wet variegated wash
Generously wet the paper, leaving some areas dry as highlights. Drop in raw sienna, burnt sienna, and raw umber, alternating the quantities and strengths to establish the initial form and depth.

3 Darker tones
Once the initial glaze layer is dry, rewet areas to establish stronger darker tones using a wet-in-wet wash of Dioxazine violet and Van Dyke brown for the darks, and warmer oranges for the highlights.

4 Dry-in-wet detail
Beginning with a wet-in-wet wash, drop a mix of raw sienna with a hint of Indian yellow into the eye area, leaving a chink unpainted for the highlight. Using the dry-in-wet method (see left), add the pupil with Van Dyke brown and a touch of French ultramarine to deepen the hue.

>

5 Stretch out

When the second glaze is dry, use the purple mix to stretch out and form the deeper tone of the cheek below the eye. Do the same for the shadow inside the ear and the top of the head, using a cooler tone of the phthalo green. The sharp edges help define the anatomy.

6 Dry brush detail

With Van Dyke brown and a dry brush, indicate the nose, taking care not to make it too strong nor to drag attention away from the eye.

7 Fur effects

Suggest the shape of the body through a combination of stretching out and dry-in-wet techniques to create the effect of fur and form. Use a wet-on-dry glaze layer on the body with thicker paint in wetted areas to suggest dense fur.

"When working dry-in-wet, test how dry the paint is on your brush before applying it to the wet paint."

8 Defined details

With a rigger brush, paint the whiskers with dry Van Dyke brown in one swift stroke per whisker, to keep it light and immediate.

Splatters of the background colors add a sense of speed and urgency

Sharp edges resulted from where the color was stretched into dry areas

9 Bringing it together
Finally, add a darker shadow wash with the cooler combination of colors, both to ground the hare and consolidate the painting.

Artist **Julia Cassels**
Title **Puffins**
Paper **20 x 28 in (50 x 70 cm) cold press**
140 lb (300 gsm) watercolor paper

Highlights

≪ See pp.104–105

Jagged, crisp areas of unpainted white paper contrast starkly with the painted areas, catching the eye of the viewer and creating drama.

Balanced composition

≪ See pp.110–113

In this L-shaped composition, the flying puffin in the top left corner is about to land, and leads the viewer's eye fluidly across the foreground to the last puffin on the right.

Wet-in-wet

≪ See pp.52–55

Touches of phthalo turquoise were allowed to merge smoothly into the still-wet black ink, creating a colored sheen on the dark wings.

Showcase painting

Fluid lines, loose washes, and areas of bright color create a sense of liveliness in this painting. The intense contrast between the black ink and crisp white highlights brings the subject to life, while the composition guides the eye smoothly from the flying puffin to those on the ground.

Glazing

≪ See pp.124–125

A glaze of transparent pigment, such as the purple shadow on this bird's front, allows the richer, warmer tones of body color beneath to glow through.

Line and wash

≪ See pp.76–79

The washes of color deliberately do not quite meet the sketched lines of ink around them, producing a sense of life and movement in the painting.

Using inks

≪ See pp.154–155

India ink is water-based, so works well with watercolor; it is useful for intense tone, as seen here in the contrast between the black and white areas of the puffins.

Glossary

*Terms with their own entry are given in **bold** type.*

Aerial perspective
Portraying the illusion of depth, especially in landscapes, by painting distant objects lighter and cooler in tone compared to warmer, brighter, and more detailed foreground objects. Also called atmospheric **perspective**.

Alla prima
Italian for "at first attempt", this term describes a painting finished in one sitting.

Analogous colors
Groups of colors that are next to each other on the **color wheel**— such as red, orange, and yellow.

Blending
A painting method in which two colors gradually merge together.

Body color
Opaque paint, such as gouache, which will obscure underlying areas of paint.

Bristle brush
A brush made from stiff fibers, such as hog hair. Can be used damp in watercolor painting for removing dry paint.

Cockling
Curling and buckling of paper supports, caused by the paper expanding when wet. Can be prevented by **stretching**.

Cold press paper
Medium-textured paper made by being pressed through felt-covered rollers at a cold temperature; also known as NOT (not hot press) paper.

Color wheel
A visual device for showing the relationship between **primary**, **secondary**, **tertiary**, and **complementary colors**.

Complementary colors
Colors located directly opposite each other on the **color wheel**: yellow and purple, red and green, blue and orange. They brighten each other when used together.

Composition
The way in which the various components of a painting, including the main area of focus, are arranged to create a harmonious whole.

Cool colors
Colors with a bluish tint. They tend to appear to recede in a picture, so can be used to create **aerial perspective**.

Crosshatching
A drawing technique in which crisscrossing parallel lines create **tone**. The closer the lines, the denser the tone.

Drybrush
Application technique where a loaded brush is squeezed out and slightly splayed then dragged lightly across the paper surface.

Flat wash
A wash of a single uniform color. Produced by painting overlapping bands of consistent **hue** and dilution strength to create an even layer of color.

Focal points
Points of interest that the eye is drawn to immediately, whether because of the **perspective**, the color, or an intricate shape.

Form
The solid, three-dimensional shape of an object.

Glazing
The application of a **transparent** layer of paint over a layer of paint that has completely dried. Used for adjusting the **hue** or **tone** of layers underneath.

Graduated wash
A wash that fades smoothly between light and dark. Created by laying down bands of progressively diluted paint. Also known as a graded wash.

Granulated wash
A wash in which watercolor **pigments** separate from the binder and water, creating a grainy texture when dry.

Granulating pigments
Pigments with heavy particles that can form a grainy texture on the paper. Examples include French ultramarine, cerulean blue, and Mars black. Also known as sedimentary pigments.

Highlight
The lightest **tone** in a **composition**, occurring on the most brightly lit parts of a subject.

Hot press paper
Paper with a very smooth surface that has been pressed between hot rollers.

Hue
Another word for color.

Key
The overall **tone** of a painting: a predominantly light painting is said to have a high key, while a dark one has a low key.

Layering
Painting one color over another color that is dry.

Lifting out
Removing paint from the surface of the paper, using a damp brush or paper towel, often in order to create soft **highlights**.

Linear perspective
Portraying three dimensions in a painting by ensuring that parallel lines appear to converge in the distance on a horizon.

Masking fluid
A latex fluid that is painted onto paper and resists any watercolor paint put over it. Used to create **highlights**.

Medium
A substance used to modify the fluidity, thickness, or finish of paint. Also describes the materials used to paint, such as watercolor, gouache, or ink.

Mid tones
All variations of **tone** between the darkest and the lightest.

Modeling
Using light and dark **tone** to create a three-dimensional impression of an object.

Monochrome
A painting made with the light to dark tones of only one color.

Negative space
The gaps between objects. Negative space is as important as **positive shape** in creating a satisfying **composition**.

Opaque color
Color that is impervious to light and which obscures anything underneath; the opposite of **transparent**.

Palette
Any suitable mixing surface for paint. Also means the range of colors used for a painting, or an artist's preferred colors.

Pan
A small block of solid watercolor paint designed to fit into a **palette** or paintbox.

Perspective
The method of creating a sense of depth on a flat surface through the use of **modeling**, **linear**, and **aerial perspective**.

Pigment
Particles with inherent color that can be used in paints.

Plein air
Meaning "open air" in French. Describes painting outdoors.

Positive shape
The outline shape of an object.

Primary colors
There are three primary colors—yellow, red, and blue—that cannot be made by mixing any other colors. Any two primaries can be mixed together to make a **secondary color**.

Recession
Moving from the foreground to the background. Color recession is the use of **warm** and **cool colors** to create a sense of depth.

Repelling pigments
Pigments that can prevent **blending** and **merging**, often because of their opacity. Examples include cadmium yellow, orange, and red, and Naples yellow. **Lifting out** these pigments is usually easy.

Reserving whites
Leaving areas of paper unpainted to show the color white. This allows the paper to form the lightest **tones** and **highlights** in the painting, instead of paint.

Resist
A method of preserving **highlights** by applying a material that repels paint, such as **masking fluid**.

Rigger
A long-haired brush for details.

Rough paper
Paper with a highly textured surface that has been left to dry naturally, without pressing.

Rule of thirds
An aid to **composition** that divides a picture into thirds, horizontally and vertically, to make a grid of nine squares. Points of interest are placed on the "thirds" lines, and **focal points** on the intersections.

Runbacks
Irregular shapes, sometimes called blooms or cauliflowers, caused when a weak wash (less pigment) is added to a strong wash (more pigment).

Sable
Sable fur is used in the finest quality paint brushes. The long, dark brown hairs have a great capacity for holding paint and create a fine point.

Scraping
Using a blade or other tool to remove layers of dry paint in order to reveal the white paper below and create **highlights**.

Scumbling
Applying a thin, irregular layer of paint over a previously painted surface, allowing patches of the color underneath to show.

Secondary colors
Colors made by mixing two **primary colors** together. They are: green (mixed from blue and yellow), orange (mixed from red and yellow), and purple (mixed from blue and red).

Separating pigments
Combinations of **pigments** that do not mix fully and separate on the paper, for example cadmium red and phthalo blue. Also describes **granulating pigments** that can separate on drying.

Shadow
The darkness cast when light is obscured, either on an object or by it.

Soft-hair brush
A brush made from soft-textured animal hair, such as **sable**, squirrel, or goat.

Softening
Blending the edges of a paint stroke with a brush dampened with clean water to prevent the paint from drying with a hard edge.

Spattering
Flicking paint from a loaded toothbrush to produce a fine spray of dots.

Splattering
Flicking paint from a loaded paintbrush to produce texture.

Staining pigments
Pigments that leave behind some color when **lifted out**, and cannot be fully removed. Examples include phthalo blue, Prussian blue, and azo yellow.

Stippling
The application of relatively neat dots to form a color field, or to create shading.

Stretching
The process of preparing watercolor paper to lay flat by first wetting and taping or stapling it down then letting it dry to tightness

Support
Any surface onto which paint is laid, such as paper or canvas.

Tertiary colors
The colors between the **primary** and **secondary colors** on a **color wheel**. They are created by mixing an equal proportion of the primary color into the secondary color.

Tone
The relative lightness or darkness of a color. In watercolor, the tone of a paint can be lightened by diluting it with water.

Transparent color
Color that light will shine through easily. When layered, it will not obscure anything underneath. Transparent pigments are ideal for **glazing**.

Underpainting
An initial layer of paint that serves as a base for **composition**.

Value
The **tonal** position of colors on a scale from light to dark.

Variegated wash
A wash that changes from one color to another. A variegated wash may be laid in bands of progressively changing color so that the colors **blend** smoothly, or in random dots and dabs so that the colors mingle.

Warm colors
Colors with a reddish or orange tint. Warm colors appear to come forward in a picture and can be used to create **aerial perspective**.

Wax resist
A method of using candle wax or oil pastel to prevent the surface of the paper from accepting paint. Once applied, the wax or pastel cannot be removed.

Wet-in-wet
Applying paint onto wet paper or onto paint that is still wet.

Wet-on-dry
Adding layers of paint on top of color that has already dried. Painting in this way produces vivid colors with strong edges.

Index

Here Comes the Sun Rod Craig

About the artists

Grahame Booth has won numerous exhibition awards throughout his successful career as a watercolor artist. He now teaches, passing on over 25 years of experience to master the challenges of learning watercolor. Grahame has produced two DVDs and has written three books on watercolor techniques, as well as contributing to many others. He writes regularly for *Artists and Illustrators* magazine and has a popular YouTube painting channel. Grahame is the consultant artist for this book; he wrote "The basics" chapter and his work features on pages 80-81, 122-123, 128-129, 138-139, 172-173, 202-203, and 234-235. www.grahamebooth.com

Alisa Adamsone is a watercolor artist and illustrator, having earned her degree in printmaking from the Art Academy of Latvia. Her work is inspired by the fluidity of nature—flowers and animals being some of her preferred subjects. Alisa's paintings are included in private collections all over the world and she has exhibited both in the UK and in Latvia. Alisa's work features on pages 74-75, 216-217, and 224-225. www.saatchiart.com/alisaadamsone

Veronica Ballart Lilja has been a full-time illustrator since 2007, with a number of high-profile clients mainly in the fields of fashion, packaging, editorial, magazines, advertising, and textiles. Originally from Sweden, she earned her degree in graphic design in Barcelona and spent 15 years in Spain before moving to New York. Her art has been published in several magazines, books, advertising campaigns, and on postage stamps. Veronica's work features on pages 152-153, 156-157, 206-207, and 232-233. www.veronicaballart.com

Glynis Barnes-Mellish has painted since childhood and was particularly drawn to the exciting and fresh approach that watercolor could bring to portraiture. Experimentation with various weights and weaves of paper, and the detailed study of anatomy and physiology have contributed to Glynis' rise as

one of the UK's leading portrait painters. Glynis has won the Daler Rowney Watercolour Award and has been a major contributor to many books on watercolor painting. Glynis' work features on pages 58-61, 220-223, and 228-229. www.barnesmellish.co.uk

Julia Cassels is a well-known wildlife artist, with her work found in collections worldwide. A decade living in Zambia and Tanzania has provided a deep understanding of her artistic subjects to capture the flowing style that is characteristic of her work. Julia has illustrated, written, and contributed to several books, and has been successfully shortlisted for the David Shepherd "Artist of The Year" award for four years running. Julia also runs courses and workshops from her Hampshire studio, and leads painting holidays to Zambia, Spain, and the Camargue. Julia's work features on pages 52-55, 92-93, 240-243, and 244-245. www.juliacassels.com

Rod Craig trained at the West of England College of Art and ran a graphic design consultancy for over 30 years. He now paints full-time, with watercolor being his preferred medium to create the fluid and energetic landscapes that are his trademark. Rod exhibits widely in the UK and has had a solo exhibit in New York. Also a performing musician, he enjoys combining his passions for art and music and names most of his paintings after the music that helped inspire them. Rod's work features on pages 64-65, 104-105, 162-165, 178-179, and 200-201. www.rodcraig.com

Denise Findlay graduated from the Glasgow School of Art in 1996 and went on to produce solo exhibitions throughout Scotland and England. She has won many awards including the Elizabeth Greenshields Award three times. Denise's work features in many private collections and she has appeared on Sky TV's "Portrait Artist of the Year." She believes that "painting is a purely visual experience where the viewer should not be

left unsure of its meaning." Denise's work features on pages 66-67, 94-95, 218-219, and 226-227. www.denisefindlay.com

Eleanor Hardiman works on commercial projects around the world, using watercolor illustration for children's books, magazine covers, packaging, and stationery. She uses a mix of traditional and unconventional watercolor techniques to achieve her distinctive style, and she is particularly inspired by the patterns and prints of William Morris, specimen drawings, and Japanese woodcuts. Eleanor's work features on pages 112-113, 126-127, and 130-131. www.eleanorhardiman.co.uk

Michele Illing is an award-winning artist, with a background in illustration in advertising and publishing. She has shared her passion for art in her classes and workshops for over 17 years and now tutors painting groups abroad in France and Italy. Michele has created several online art video courses in collaboration with ArtTutor.com and has been a featured artist in a number of art magazines. Michele's work features on pages 50-51, 84-85, 86-87, 144-145, 210-211, 230-231, and 238-239. www.micheleilling.co.uk

Gilly Marklew studied graphic design and illustration, going on to work in advertising and for all the major publishing houses in London, as well as the Arkwright museum in Derbyshire, before embarking on a career as a children's book illustrator. Gilly has been exhibiting watercolor paintings since 2003 and teaches watercolor classes at her studio in Norfolk. Gilly's work features on pages 56-57, 68-69, 82-83, 102-103, 208-209, and 236-237. www.goodworks.myzen.co.uk/GillyMarklew/Site/Home.html

Rachel McNaughton has enjoyed drawing and painting from an early age; her interest in art eventually took on a life of its own and she now spends much of her time in her studio, creating watercolors of flowers, landscapes, and animals. Watercolor is Rachel's preferred

medium—she enjoys allowing the paint to run and mix on the paper for the unpredictable effects that result in her loose and expressive style. Rachel's work features on pages 98-99, 116-117, 146-147, 174-175, and 192-193. www.artbyrachel.co.uk

Maria Montiel is a Venezuelan illustrator and graphic designer with a degree from the Instituto Europeo de Diseño, Madrid. Her passion for art is inspired by her family, her childhood in the Caribbean, and her travels. Now based in Barcelona, Maria uses watercolor to create imaginative worlds full of warmth and magic—in particular, her memories of the Latin American jungle, with its vivid colors and rich textures, bloom in her vibrant illustrations. Maria's work features on pages 76, 78-79, 120-121, 148-149, 166-167, 198-199, and 204-205. www.mariamontielstudio.com

Paul O'Kane is a retired architect and now a *plein air* painter. He spends the summer months on painting trips in Europe where he tutors and runs workshops in all art mediums. Paul is also a multi-award winning article writer, a keen urban sketcher, and a regular watercolor tutor to the annual international *plein air* art fair, Art in the Open, in Wexford. Paul's work features on pages 62-63, 76-77, 150-151, 158-161, and 186-187. www.paulokane.co.uk

Ian Ramsay is an internationally recognized watercolor artist and workshop instructor. His work is representational and selectively detailed, reflecting his earlier training and vocation as an architect. Ian's paintings are included in collections around the world and he has been represented by galleries in the US, UK, and Japan. Many of his watercolor images have featured in books and magazine articles on the subject. Ian's work features on pages 134-137, 142-143, 188-189, and 194-197. www.ianramsay.blogspot.com

Chris Robinson is an architect and a painter. He enjoys the spontaneity of working *en plein air* and expressing his love of light and atmosphere in his work. He has featured in international art magazines, has exhibited at

the Royal Academy Summer Exhibition and the Royal West of England Academy, and has been awarded "The Most Innovative Use of Watercolor" by the Royal Institute of Painters in Watercolour. Chris' work features on pages 72-73, 96-97, 106-107, 110-111, 132-133, 140-141, and 176-177. www.chrisrobinsonwatercolours.com

Ingrid Sanchez is a Mexican-British artist and designer best known for her vibrant, nature-inspired watercolors. After working in the graphics industry, she founded CreativeIngrid to focus on developing her signature style for product and surface design, leading to numerous brand partnerships. Ingrid teaches creative workshops around the globe, showcasing her unique style of watercolor and mixed media, and has also developed tailored corporate classes for clients such as Target, Harrods, and Cass Art. Ingrid's work features on pages 100-101, 108-109, and 154-155. www.ingridsanchez.com

Julia Trickey loves to capture the beauty and detail of nature in watercolor, and is particularly drawn to the imperfections in specimens such as autumnal leaves, seed heads, and fading flowers. Exhibiting regularly, Julia has been awarded four RHS gold medals, amongst other awards. She tutors art and runs botanical art workshops around the UK and beyond, teaching as far afield as Moscow, Transylvania, and New York. She has written articles for national art magazines and has produced many resources for aspiring botanical artists. Julia's work features on pages 88-89 and 212-215. www.juliatrickey.co.uk

James Willis is best known for his paintings of architecture and cityscapes. The way that color and light play on buildings and landscapes are essential elements in his paintings. James gathers inspiration for his work through sketching and painting during his travels around Europe. He has exhibited throughout the UK and his work features in both public and private collections around the country. James' work features on pages 70-71, 90-91, 114-115, 118-119, and 182-185. www.jameswillisart.co.uk

Yong Hong Zhong was born in Canton, China and immigrated to the United States when he was twelve years old. He developed a keen interest in drawing at an early age, and attended LaGuardia High School of Music and Arts in New York, followed by a degree in illustration and art history from Pratt Institute. Yong worked for Disney Animation Studios from 1995 to 2008 before taking a different direction to focus on his passion for traditional fine art painting. Yong's work features on pages 124-125, 152, 180-181, and 190-191. www.yonghongzhong.com

Acknowledgments

The publisher would like to thank Nigel Wright at XAB for additional photography; William Collins at the DK Picture Library; Geetika Bhandari, Assistant Picture Researcher; John Friend for proofreading; and Vanessa Bird for creating the index.

We are also grateful to the following for their kind permission to reproduce their photographs. (Key: a-above; b-below/bottom; c-center; f-far; l-left; r-right; t-top)

Picture credits: 4 123RF.com: Andrey Guryanov (br/Reference). 5 iStockphoto.com: PeopleImages / E+ (tr/Reference). 25 iStockphoto.com: PeopleImages / E+ (bc, br/ Reference). 98 Dreamstime.com: Nuli (cra). 99 Dreamstime.com: Nuli (Reference for all 3). 102 123RF.com: Andrey Guryanov (cra). 103 123RF.com: Andrey Guryanov (l/Reference). 170 iStockphoto.com: PeopleImages / E+ (br/ Reference). 220 123RF.com: Volodymyr Melnyk (cr/Reference). 221 123RF.com: dolgachov (cl/Reference). Dreamstime.com: Gstockstudio1 (cr/Reference). 222 iStockphoto.com: PeopleImages / E+ (cra). 222-223 iStockphoto.com: PeopleImages / E+ (Reference for all 6). 226-227 iStockphoto. com: PeopleImages / E+ (Reference for all 6). 238 Pixabay: Fran__ (cra). 238-239 Pixabay: Fran__ (Reference for all 9)

All other images © Dorling Kindersley For further information see: www.dkimages.com